COLOURS OF LONDON

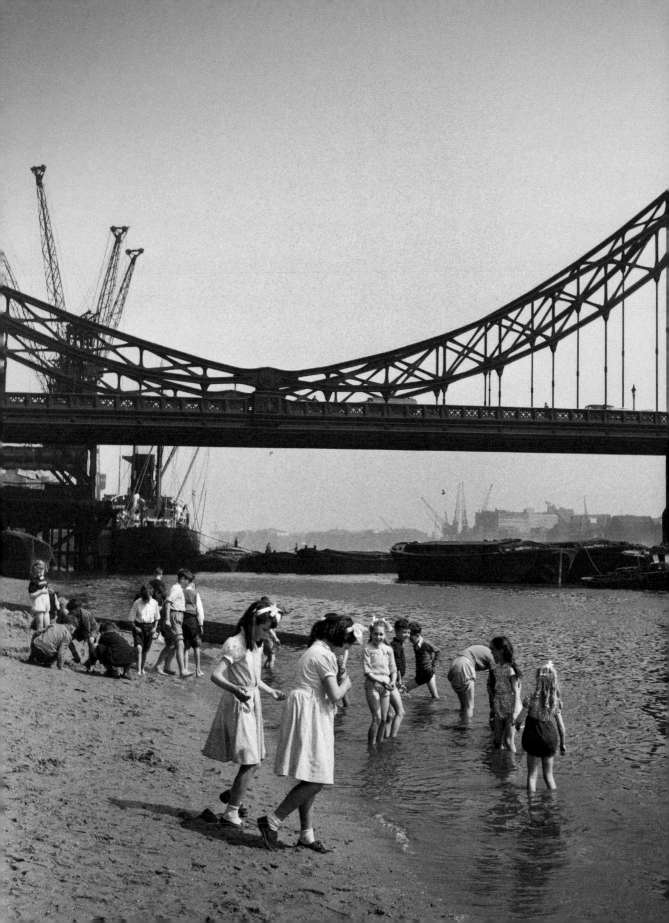

COLOURS
OF LONDON

A HISTORY

PETER ACKROYD

FRANCES
LINCOLN

LIGHT 6

FIRE 18

WHITE 28

GOLD 46

BLUE 68

GREEN 90

RED 120

BROWN 158

GREY 174

BLACK 184

THE NIGHT 204

THE FULL SPECTRUM 220

ABOUT THE COLOURIZED PHOTOGRAPHS 250

INDEX 252

PICTURE CREDITS 255

LIGHT

‘Earth has not anything
to show more fair’

William Wordsworth, ‘Upon Westminster Bridge’

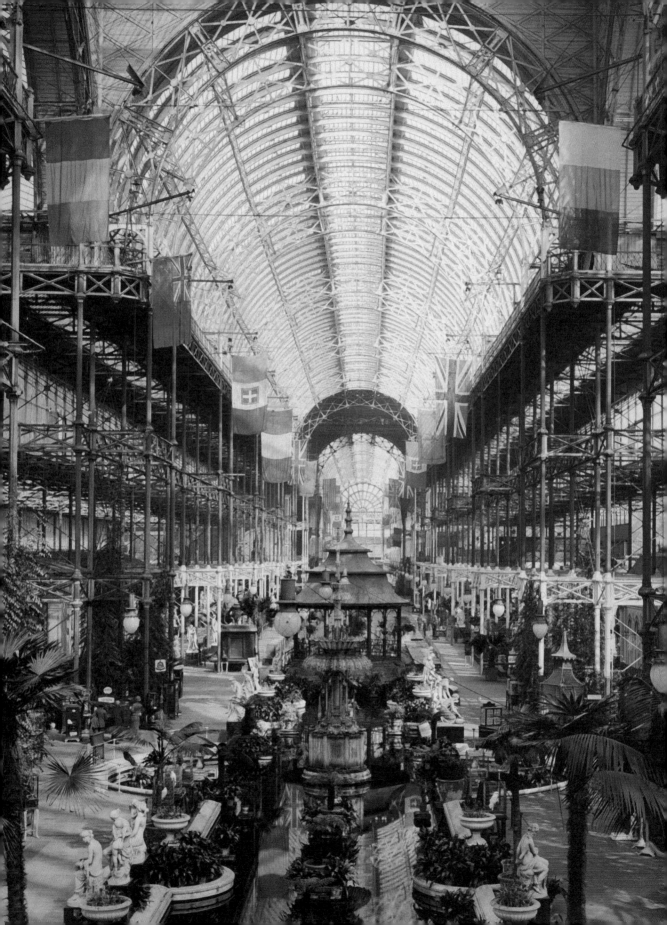

Some people see it as a golden light glowing out of London. But the true colour of the light of the city is elusive. It is tempered light; we can recognize its quality but not its hue. Yet, where there is light there must also be colour, even if it is the colour of grey stone or of shadow. In 1885 Henry James noted 'the way the light comes down leaking and filtering from its cloud-ceiling'; there is a sensation of damp or misty brightness, as if everything were seen through tears. But James also noticed 'the softness and richness of tone, which objects put on in such an atmosphere as soon as they begin to recede.' So the colours of London do not have the clarity or richness of those in Paris or New York. It has been said that nowhere 'is there such a play of light and shade, such a struggle of sun and smoke, such aerial gradations and confusions.'

Claude Monet's *Charing-Cross Bridge in London* was one of his thirty-seven paintings of the bridge and was completed in around 1902; the colours are pale and veiled, with orange, blue, yellow and pearly white suffused in a mist that suggests early morning. All of these paintings of the bridge, like the other London vistas by Monet, represent the varied shades and transitions of the city's light. That was what entranced him, just as it captured the imagination of many other artists. Monet glides softly upon the dreams, for example, of Turner and Whistler.

The uniform uses of colour in Monet's painting suggest that bridge, river and buildings are all one element rather than a collection of objects. The muted colours of blue and pink behave like gossamer, or a milky cataract of something half seen but felt. The more solid blue used to evoke the buildings has more solidity and weight than the pink of the air, but the difference is subtle. The colour palette merges the object and the atmosphere that surrounds it so that, although they are distinct from each other, they create a single sensation; it is the painting of a moment rather than a scene. Faint or indistinct paint then conveys the London light that melts together in the background and foreground.

The natural gradations of light in the city, however, can in fact be recognized by the careful observer, from a yellow sunset to a soft violet in the south-west, from the bright light of summer to the redness of the winter sun. The parks on an autumn evening were once suffused with a pale grey haze, soft and subdued. A faint, blue-green mist was described as the light 'that London takes the day to be', but the quality of daylight changes from area to area, from season to season, and from early morning to late afternoon. An observer in 1914 noted the veils of the London atmosphere 'whose greyness is built up of every colour of the rainbow, whose murkiness gives quality to the silvery greys, and tinges the yellow fog with auburn gold'. In such an atmosphere of mist and moisture, blue and yellow may seem brighter but red will be more subdued. Natural light changes the visual field. In the interiors of shops and houses, lights are cool and shadows warm; in the outdoors of daylight, the lights are warm and the shadows cool. On south

fronts subdued colours will seem to be brighter, and on north fronts bright colours are dulled. Yet what is the natural light of London?

In *After London* Richard Jefferies, in 1885, noticed the aerial gradation from a yellow sunset to an 'indefinite violet' in the south-west; from the dazzling light of summer to the redness of the winter sun when the streets are suffused with a 'fiery glow'. Yet there is also a coldness in the light of the streets, which may be glimpsed in the orange sunsets of autumn, in the grey of winter, in the blue mists of spring and in the haze of summer. Daily light is itself transient, a fugitive array of colours oscillating between what is faintly blue to what is faintly yellow. It has also been determined that healthy cells emit blue light, while diseased cells emanate yellow, which may help to elucidate its charm.

Much of that subdued and fugitive colour has now been dispelled by neon, mercury and general fluorescence so that the city lights up the sky for many miles around and reflects what Hippolyte Taine called the 'huge conglomeration of human creation'. No darkness can obscure these swarms of light. They blaze perpetually. Seen from the air, the lights shine for miles like a boundless web of brightness. The city will never be able to cool down. It will remain incandescent.

The Victorians took full advantage of the London light, in what was considered to be the eighth wonder of the world and the crowning glory of the Empire. The Great Exhibition dominated Hyde Park like a vast cathedral of glass, to which people from all over England would come to worship the latest feats of technology as well as the wares of the globe. The nature of the modern world was indeed its theme and inspiration. As *The Times* put it, 'How much more may be done with steam? How much more with railways? How much better may we offer, and how widely may we diffuse, the intercourse of distant provinces and nations?' Six million visitors came to find answers to these questions.

At the time of its construction over 1850 and 1851 the Crystal Palace, as it soon became known, was the marvel of London. From the planning to its opening was an enterprise of only nine months. Glass had never been employed on so large a scale, stretching over some 226 hectares (560 acres) on the south side of the park

from the Serpentine to Knightsbridge. It was erected on sloping ground in order to accentuate its size

It encompassed two hundred cast-iron girders, three thousand columns and nine hundred thousand square feet of glass; its navvies, or construction workers, used four thousand tons of iron and four hundred tons of glass. The edifice was three times the size of St Paul's Cathedral. Glass is supposed to be a neutral or transparent medium, but the changing light of the morning and afternoon fundamentally changed the reflection on the glistening surfaces.

The Great Exhibition was opened by Queen Victoria on the first day of May, 1851; she wrote in her journal that 'Green Park and Hyde Park were one mass of densely crowded human beings, in the highest good humour and most enthusiastic … A little rain fell, just as we started, but before we neared the Crystal Palace, the sun shone and gleamed upon the gigantic edifice, upon which the flags of every nation were flying.' This was the light of the sun as never before seen in London.

But the radiance concealed an inventive range of colours both upon the exterior and interior surfaces of the glass palace. It was in some respects a multi-coloured extravaganza, dispelling notions that the mid-Victorian era was somehow a dim or subdued phase of London's history. There was colour everywhere, just as there has always been. The exterior of the iron structure was painted in blue and white, while the interior was decorated with strips of yellow and white as well as red and blue; blue, white and yellow were designed to accentuate the verticals while blue, white and red displayed the curving girders, and red, white and yellow marked out the roof bars.

As *The Daily News* noted at the time:

Few sights have been accounted fairer or more striking than that of the Crystal Palace when illumined by the rays of the morning sun, diffusing its light through the brilliantly decorated facades, or glistening on the swelling ribs of the transept as of old on the armour of knighthood. The prospect is almost too dazzling to the sight, and both a change and relief are sought below the sobered light, and in the bluey vistas of the interior of the building. Beneath the vanishing perspectives of the azure vault are arrayed a host of sculptured forms, a perfect army or avalanche of heroes, in marble, in stone, and in metal. Their forms stand forth prominently from the gorgeous hues and varied objects which surround them. The whole is blended in one vast harmony, over which the blue colouring of the girders has albeit a predominating influence … The partial reduction of the yellows is gratefully acknowledged, and though the same can scarcely be said of the virulent reds, with which the under parts of the girders are mapped out, still we notice with satisfaction that the nature of the structure itself has in no slight measure served to counteract the noxious introduction of red into shadowy beams.

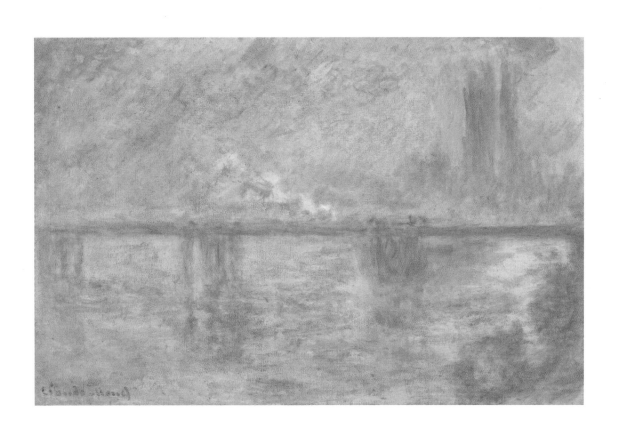

Above: *Charing-Cross Bridge in London* (c.1902) by Claude Monet.

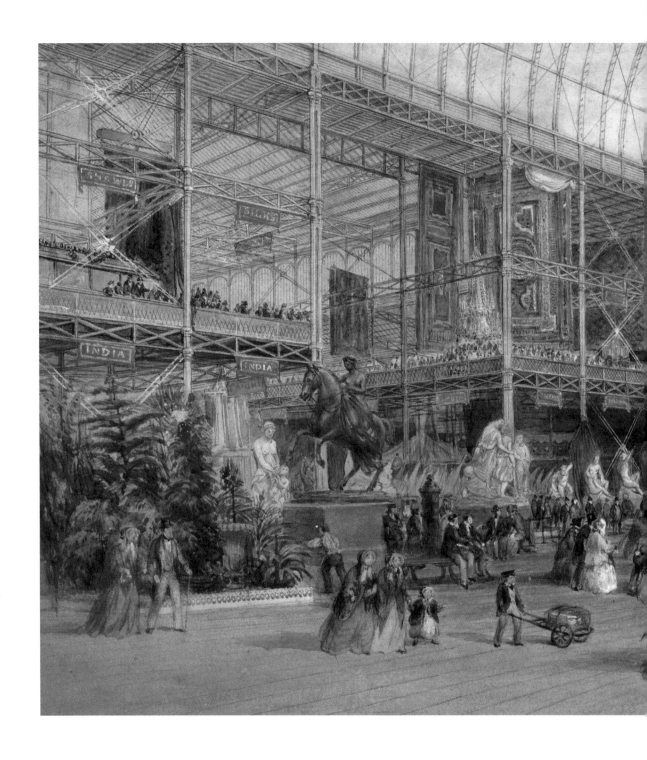

Above: *Queen Victoria Visiting
the Great Exhibition of 1851*
(1855), watercolour painting
by Thomas Abiel Prior.

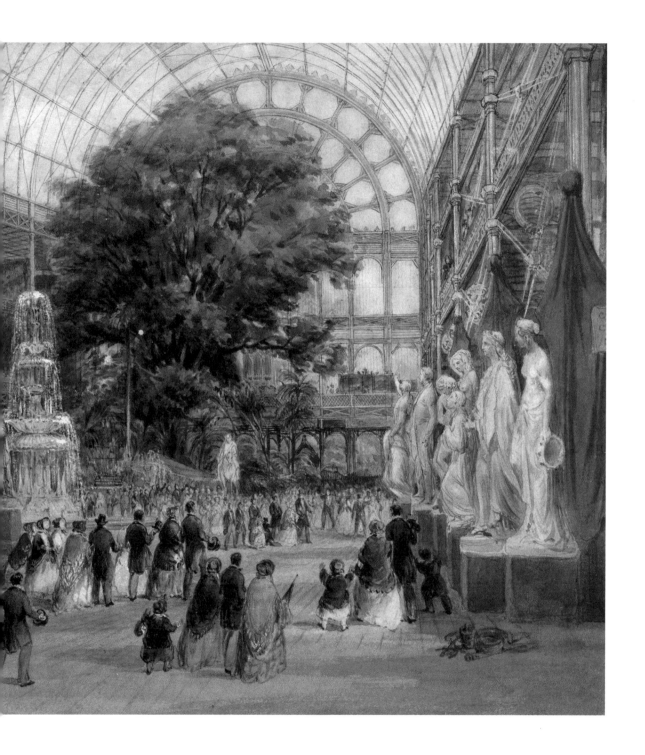

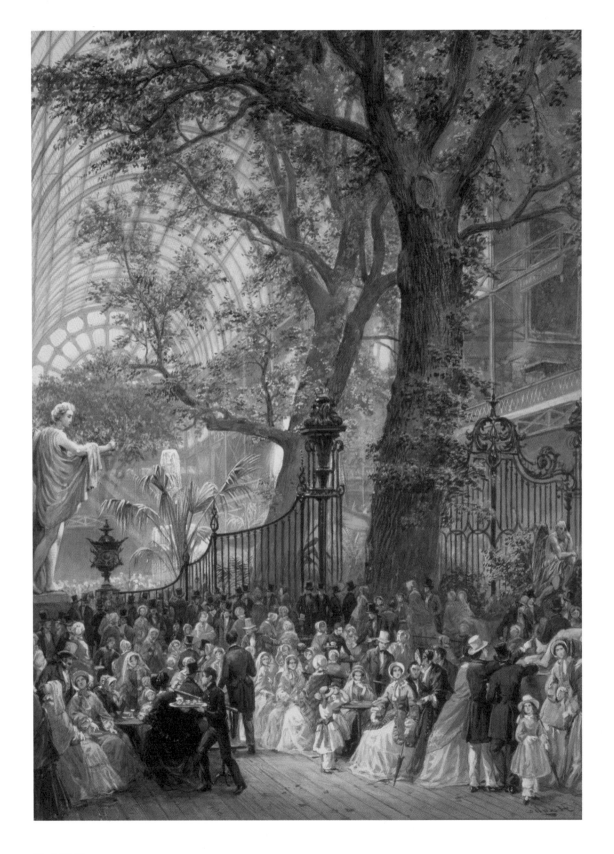

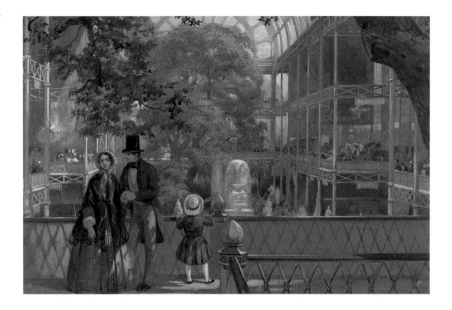

Contemporary watercolours display people wandering through spaces draped in cloths of red, green and gold. It was reported that the exhibition contained one hundred thousand exhibits, which were apportioned into four great schemes; the first was a survey of the raw materials of the earth, the second of machinery and mechanical inventions, while the third was devoted to manufactures and the fourth to sculpture and plastic art.

The 'church furniture' group, for example, could be seen together with the 'fine arts court'; objects and furniture made of variously coloured papier mâché were rivalled by Sèvres porcelain and marble statues of heroic figures. Beds, thrones, vases and mirrors – each with their own particular drapery – were everywhere, in a mixture of hues and shades that could be seen nowhere else on earth. Russia, Turkey and China, together with many other countries, had their own courts to display their wares. It could be said that all human life, or at least all the components of human life, were represented.

The most expressive use of colour coding was not employed again until the building of the Pompidou Centre in Paris. The colours seemed to be the components, rather than the hues, of the building.

It is difficult now to measure the surprise with which the Crystal Palace was greeted. It was superb but it was also delicate; it was solid but also spectral; it was highly structured but living with the fluid movement of the sky painting its glass surface. Blue was often associated with sadness, but glass structures evince freshness and expansiveness as a result of their relationship with the sky. The Crystal Palace resembled a magic lantern that burned as brightly as the day. In this respect it astonished and eventually changed architectural taste.

The use of glass itself allowed the environmental conditions of the city to become part of the building; time, weather and temperature were woven into its fabric. The elm trees that grew beneath its semi-circular glass domes were a reminder of the natural world that helped to create this artifice. That is perhaps one reason why, almost two hundred years later, glass is the major component of London's tallest buildings. Eventually the Crystal Palace was moved to Sydenham, where in 1936 it was destroyed by fire. Thus the glass itself returned to one of its natural elements. Yet in its original purity it offered a glimpse of the future and of progress as if they were indeed a vision on a hill.

FIRE

'… the wonderful smoky beauty
of a sunset over London'

Bram Stoker, *Dracula*

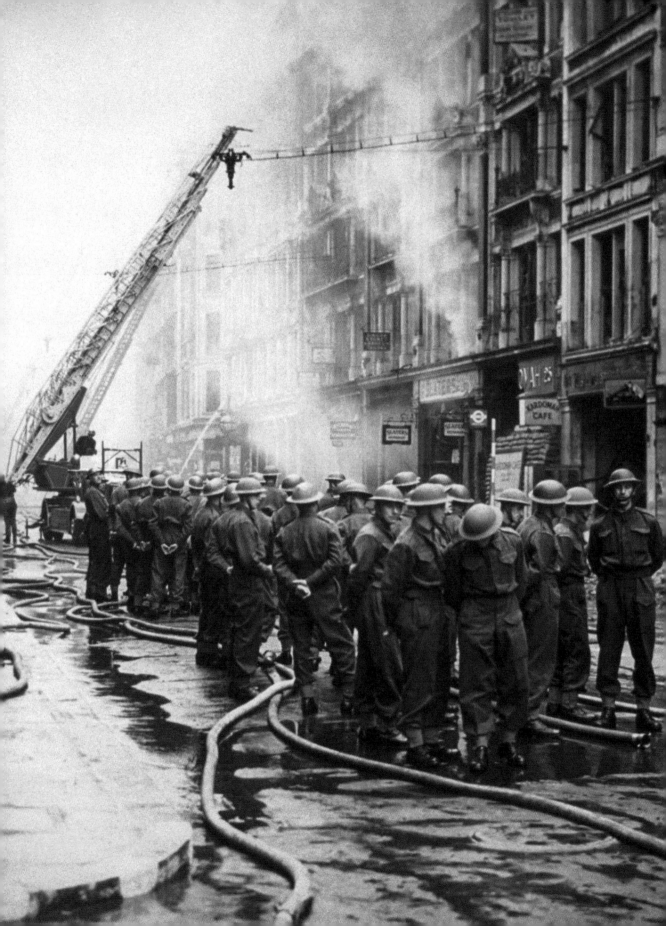

f London is a city of light, it has also been known for many centuries as the city of fire, of red and orange and yellow and blue flame. Fire has always been one of London's properties, or qualities. From the 1850s, London had the smoky and blackened appearance of a city that had already been burned. Three decades later, a Frenchman believed that the entire capital was 'a temple of fire-worshippers'. In the London paintings by Monet at the end of that century the sun is depicted, in his own words, as 'setting in an enormous ball of fire behind Parliament'; in some of that artist's paintings, London seems to live and breathe within an atmosphere of fire surrounding all streets and buildings with the same unearthly glow.

For others the scenes of London on fire made it seem that the gates of an awful furnace had opened, with an orange luminescence that sometimes stretched around the capital for miles. Most of the public buildings were at some stage in their existence burned down or partially destroyed by fire; their conflagration was one of the permanent spectacles of London.

Certain areas of London seem always to attract fire. Arthur Hardwick's *Memorable Fires in London* revealed Watling Street to be 'the region in the heart of the City that has always been a "fiery" zone, while Aldersgate and Silver Street have "the reputation of the 'danger zone'"'. Cheapside, Broad Street and Wood Street have long been considered to be 'fiery' so that London itself may be divided into red zones.

One of the most spectacular fires of London erupted on the evening of 16 October 1834, when the 'mother of parliaments', the House of Lords and the House of Commons, was destroyed in a blaze during which night was transformed into the light of noon. Warnings had already been made about the hazards in this labyrinthine building and the architect of its redesign, John Soane, had stated six years before the conflagration that 'the want of security from fire, the narrow, gloomy and unhealthy passages, and the insufficiency of the accommodations in this building are important objections which call loudly for revision and speedy amendment.' As seems to be usual in parliamentary matters, nothing particular was done.

It began with 'tally sticks', small pieces of wood used to calculate votes, which had been lying scattered in one of the lower floors. Once they had been replaced by the use of paper it was ordered that they should be collected and burned in the furnaces of the House of Lords. The task was assigned to two labourers on the morning of 16 October. The furnaces had been constructed to burn coal rather than wood, however, and the flues were already in a weakened state; so the flames climbed ever higher; by that afternoon, smoke and the smell of burning permeated the Lords' quarters. The fire could not now be prevented, and sparks from the damaged flues lit the woodwork above them. The first flames were glimpsed at six that evening, and half an hour later a great fire-ball or 'flashover' destroyed the entire Chamber.

The *Manchester Guardian* reported that,

… within a short hour, the interior of the house of lords was filled with one vast flame, casting its lurid glare far over the horizon, spreading over the silent Thames a vast sheet of crimson that seemed to smother the more feeble rays of the rising moon – bringing out the stately and majestic towers of the abbey in strong relief against the deep blue western sky, playing with seemingly wayward and fantastic scintillations on the inimitable fretwork of the Seventh Harry's chapel.

The parish fire engines, and emergency hand-pumps, were called but no amount of water could now control the blaze. Within an hour the roof of the House of Lords had collapsed before the flame crept towards the Commons where, according to the *Manchester Guardian*, 'the roof ignited, the woodwork of which being old and dry, [and] the flames spread with the rapidity of wild fire. In a very short time indeed, the whole of the roof fell in with a tremendous crash, emitting millions of sparks and flakes of fire.'

It was in effect a tremendous spectacle, the like of which had not been seen since 1666 and would not be experienced again until December 1940. Large crowds gathered on Westminster Bridge or took to boats along this stretch of the Thames, which glowed bright red. The fascinated spectators packed Parliament

Square where, according to a reporter from *The Times*, 'vast gangs of the light-fingered gentry in attendance, who doubtless reaped a rich harvest, and [who] did not fail to commit several desperate outrages'. But the mood of the crowds was one of jubilation rather than horror as the great centre of established politics and rival parties crumbled in front of them.

In an era when radical change was being advocated by the Chartists and a harsh new Poor Law was being imposed, the fire and destruction were greeted with satisfaction. When sections of the building tumbled down, many applauded; the artist, Benjamin Haydon, commented that 'the feeling among the people was extraordinary – jokes and radicalism universal.' Thomas Carlyle watched the spectacle and noted that

The crowd was quiet, rather pleased than otherwise; *whew'd* and whistled when the breeze came as if to encourage it: 'There's a *flare-up* (what we call *shine*) for the House o' Lords.' – 'A judgement for the Poor Law Bill!' – 'There go their *hacts* (acts)!' Such exclamations seemed to be the prevailing ones. A man *sorry* I did not anywhere see.

Among the crowds was J.M.W. Turner. He had recently travelled to Oxford and to Brussels in search of suitable subjects but now there was a more spectacular scene much closer to home. He made

'… within a short hour, the interior of the House of Lords was filled with one vast flame, casting its lurid glare far over the horizon'.
Manchester Guardian, 18 October 1834

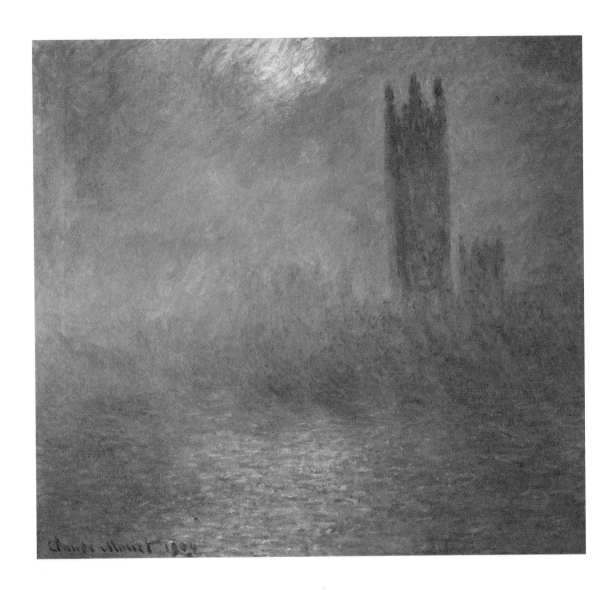

Above: *The Houses of Parliament, London* (1904) by Claude Monet.

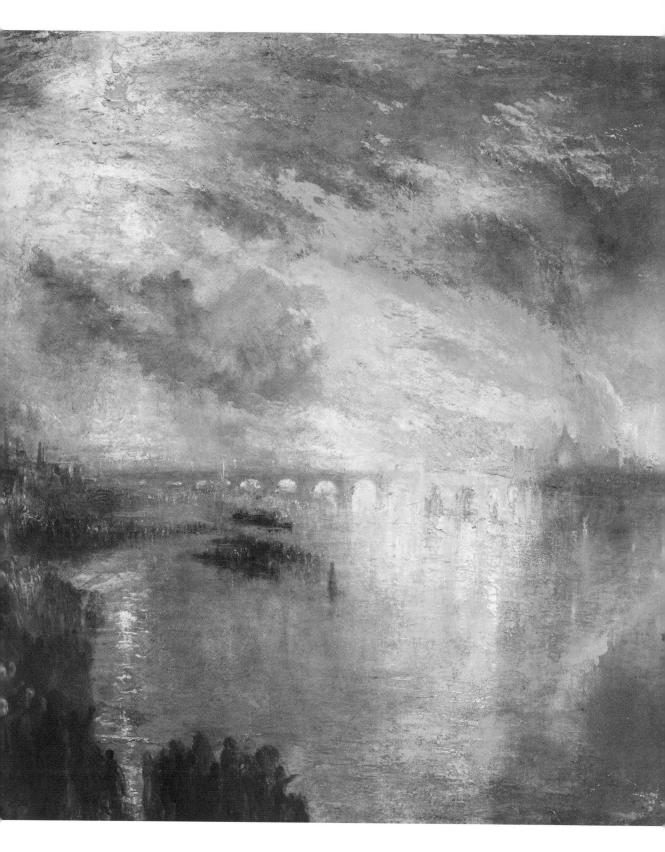

some sketches from Westminster Bridge and Waterloo Bridge, and in his studio he used these to create two separate oil paintings. Turner was literally in his element.

On varnishing day at the Royal Academy he had worked for hours a few inches away from the canvas of one painting, *The Burning of the Houses of Lords and Commons*, and never stepped back to see the general effect; nor did he look at the other paintings being prepared for display. As soon as he had finished he walked out without looking back. That painting has been described as the pictorial equivalent of Romantic opera, with smoke and shadow as the counterpoint to the glaring luminescence of red and orange when the flaming sheet of fire billows across the canvas. The critic of *The Morning Chronicle* observed that 'the Academy ought, now and then, at least, to throw a wet blanket or some such damper over either this fire King or his works'. One of his biographers also remarked that the 'Parliament works allowed him to express to the full his liking for dramatic contrasts of warm and cold colours, the reds and oranges of the flapping flags of flame and the quiet blues of the sky'. The burning of Parliament became the most popular subject of the century for various artists and engravers, but Turner's two paintings are the most dazzling and accomplished.

When Turner's other painting, with an identical title, was exhibited at the British Institution in the same year it was praised not for its accuracy but for its magnificence. It was a visionary scene of glorious incandescence. *The Spectator* noted that 'Turner's picture transcends its neighbours as the sun eclipses the moon and stars. The burst of light in the body of the flame, and the flood of fiery radiance that forms a luminous atmosphere around all the subjects near, cannot be surpassed for truth'. Turner, like any true Londoner, loved fire. It was part of his inheritance, in which flame expressed a truth about the fabric of the world.

Left: *The Burning of the Houses of Lords and Commons, 16 October 1834* (1835) by J.M.W. Turner.

In 1919, Virginia Woolf described the city as 'eternally burnt' where it 'seemed dreadful that the town should blaze for ever in the same spot'. The London sky seemed to share in this turmoil, where flames of red, orange, blue, yellow and white leap up and seem to be reflected, with the darker smoke hanging low. The city was popularly known as the 'Great Oven'.

The photographs of the Blitz of December 1940 bring that metaphor to vivid and dreadful life. The image of the dome of St Paul's Cathedral ringed with fire evokes one aspect of London's incandescent fever. A contemporary noted that 'the whole of London seemed alight! We were hemmed in by a wall of flame in every direction. St Paul's Cathedral was ringed with fire but escaped destruction.' 'No one who saw,' another wrote, 'will ever forget their emotions on the night when London was burning and the dome seemed to ride the sea of fire.'

The contrasts between flames of different kinds and hues, together with the lights in the sky, afforded an almost theatrical pageant like the backdrop of a pantomime. London firemen claimed that, in this period, half their time was spent in dispersing crowds of interested spectators rather than in fighting the conflagrations.

At a later date the capital became known as an 'urban heat island' and was depicted as red. Many dark buildings retain their heat, and the vertical surfaces of the modern city are better equipped to catch the low-lying sun. The city's pollution has the effect of trapping warmth within its streets while, paradoxically, at the same time obscuring the sun's rays. So it makes its own system of orange and yellow warmth.

Right: A colour photograph of St Paul's Cathedral during a bombardment by German planes on the night of 29 December 1940.

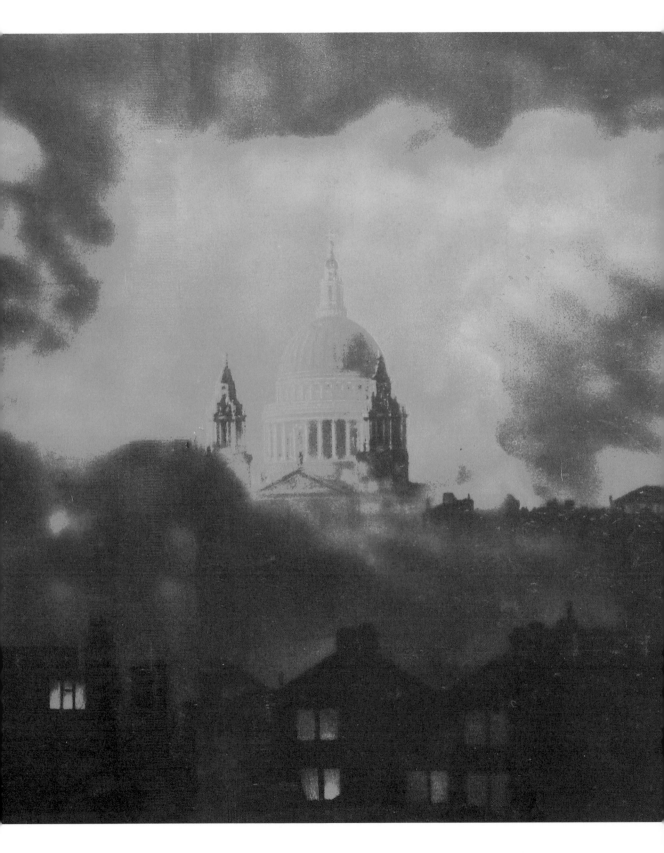

WHITE

..

'O, welcome, pure-ey'd Faith,
white-handed Hope'

John Milton, *Comus*

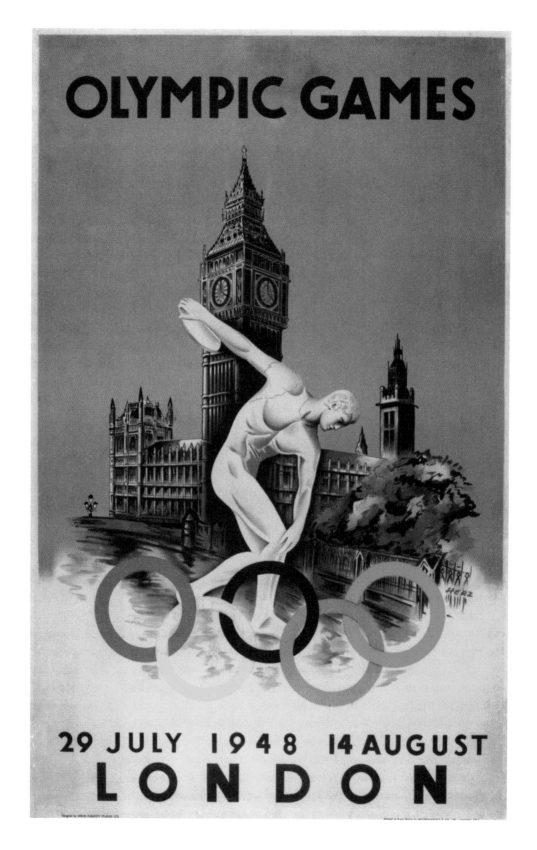

White is every colour and no colour. White is all colours in one, just as white noise comprises every sound. It was used to delineate the frozen Thames as if to emphasize its status as a caprice of nature. Yet it is also the colour of frost and snow falling, which sometimes covers London with a brilliant sheen that seems to obscure city life and activity. The clouds that drift in the London sky are white because they are composed of water droplets that scatter the colours of the sky preserving the white light of the sun; the ice crystals of snow do the same. White is associated with purity and holiness, neither of which are virtues that London can claim as its own. It is the colour of innocence. It is also associated with sacredness or mystical power, which may help to interpret G.K. Chesterton's belief that '… white is not a mere absence of colour. It is a shining and affirmative thing, as fierce as red, as definite as black …'.

The Olympic flag is essentially white emblazoned with five circles in blue, yellow, black, green and red. But white predominates, and in the London Olympics of 1908 and 1948 the contestants and officials of the Games characteristically dressed in white. The 1908 Summer Olympics, officially known as the Games of the IV Olympiad, and more popularly as 'London 1908', was the first occasion when this international event was held in the United Kingdom. It was also the longest in Olympic history, lasting from 27 April to 31 October. The competition was originally intended for Rome but the sudden eruption of Mount Vesuvius two years before persuaded the Italian authorities to reconstruct Naples rather than construct a stadium and swimming pool. This was not an era when sporting events took precedence. Under the benign authority of Edward VII and the new prime minister, Herbert Asquith, the preparations were completed relatively quickly. A new stadium was erected in West London and was promptly named 'the white city' or henceforth White City. Twelve other venues were used, including Wimbledon, Henley and the Solent. But the new stadium was the centrepiece. It took ten months to build, was clad in marble, and was designed to hold 66,000 spectators with the same number standing on the terraces. It included a swimming pool and cycle track as well as facilities for track and field athletics.

On the morning of 27 April Edward VII and Queen Alexandra opened the proceedings, after which the twenty-two nations marched under their respective national flags. This was the first time that nations, rather than individuals, were selected for notice. Altogether, some two thousand athletes were in competition. The 1908 Games were also first in other respects. It represented the first time that women were allowed to compete, with thirty-seven women taking part in archery and tennis. It was the first time winter sports were included, most of them taking place at the Prince's Skating Club in Knightsbridge.

Right above: Vintage postcard showing the White City Stadium and part of the Franco-British Exhibition in May 1908. Right below: Mughal-style buildings adorn the Court of Honour at the Coronation Exhibition at White City in 1911.

The four skating events took place in the last days of the Games. This was the first occasion when a marathon was run, the length of the course from Windsor Castle to White City becoming the standard measure for all subsequent marathons at a length of 42.1 kilometres (26 miles and 385 yards). The three countries taking part for the first time were New Zealand, Finland and Turkey. If white can be regarded as all colours in one, so the Olympic white may be interpreted as all countries in one.

If it was the longest Games, it was also the wettest. *The Times* reported that intense heat and constant rain turned the road through the exhibition grounds into 'a sea of liquid mud'. It was also the most controversial Games and was beset by difficulties. Disputes and problems, for example, complicated the opening ceremony. The trumpeters of the Household Cavalry sounded a fanfare, the Olympic flag was raised, seven thousand pigeons were released to swoop and flutter around the stadium and a salute of twenty-one guns heralded the arrival in the arena of the Olympic flame. The bowl was solemnly kindled in front of a hoarding with a famous quotation from Baron de Coubertin, founder of the modern Olympics, in words which had a certain irony to them in the circumstances: 'The important thing in the Olympic Games is not winning but taking part. The essential thing in life is not conquering but fighting well.'

But all was not well. The Irish team argued that they should not be grouped under the flag of the United Kingdom, while the athletes from the United States were incensed by the absence of their flag among the others in the stadium; it was explained that the officials could not find one of the appropriate size.

As a result the team decided to take part in the opening procession without lowering their flag before Edward VII. The bearer of the flag, a discus thrower, announced that 'this flag dips to no earthly king'. Finland was then governed by Russia, and its competitors were informed that they would be obliged to parade under the Russian flag. The athletes from that country decided that they would rather have no flag at all.

There were around one hundred events, most of which survive into the twenty-first century. Among them were diving, discus throwing, running, rowing, riding, swimming, long jump and pole vaulting, all of which had already reached their classic style. Some were not fated to last, however, and the tug-of-war was not repeated. In the silent films of the era officials are wearing top hats, bowlers or boaters; they carry long megaphones and stop-watches. The more casual spectators at the London marathon, by the side of the road, are content with their flat caps and pipes.

The marathon itself was responsible for the most famous incident of the Games when the front runner in the race, Dorando Pietri of Italy, entered the stadium and promptly fell to the ground. He was literally on his last legs. He was promptly hauled to his feet by the umpires, and was helped up again four more times. After an appeal from other competitors he was

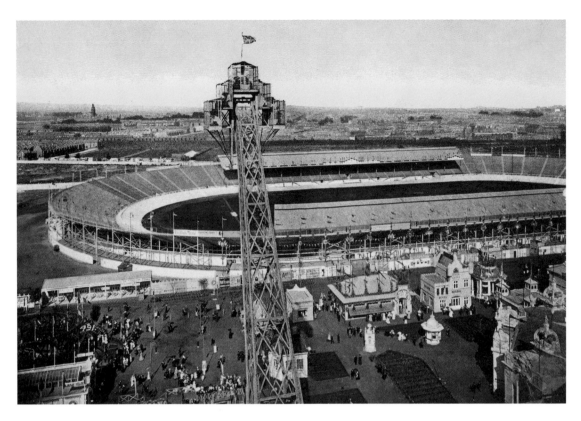

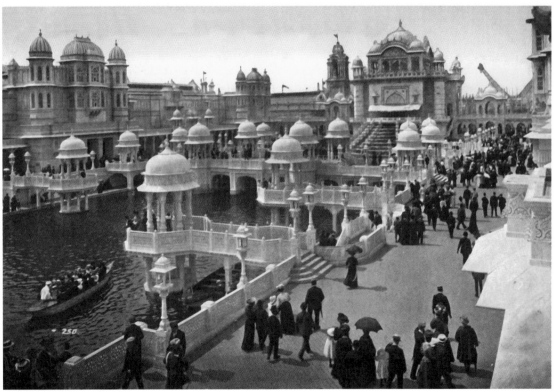

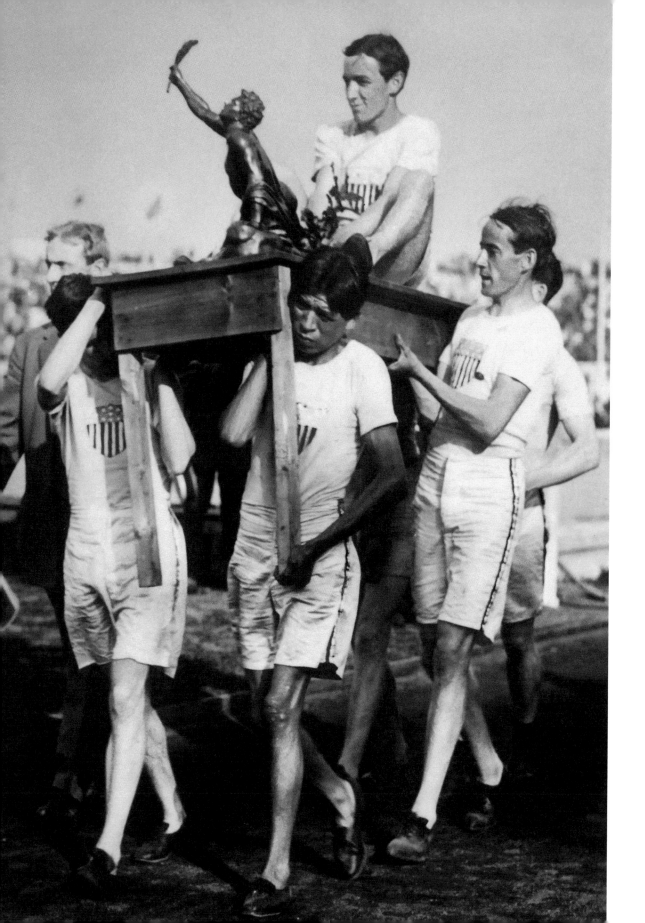

disqualified, but was later given a token silver cup by Queen Alexandra for his valiant, if unavailing efforts.

It was perhaps inevitable that this was the only Olympic Games in which Great Britain won the majority of medals, with some fifty-six compared to the United States, their nearest competitor, who earned twenty-three. Doubts were then raised about the impartiality of the host nation's judges, and the International Olympic Committee agreed that in future the judges would come from a range of countries.

The Olympic Games of 1948 were less contentious but also perhaps less exciting. Coming so soon after the Second World War it was described as the 'Austerity Games'; London had been originally chosen for the Games of 1944, but external crises rendered that impossible. So the city obtained its second chance four years later, all the more justifiable for its formidable role in the Second World War.

Yet Britain was still suffering from privation and rationing, and it was believed by some that the country did not have the energy or enthusiasm to house such a spectacle. It was even considered that the United States should be chosen as a substitute, but King George VI stated that the Games could provide the opportunity for Britain to be renewed and restored after the hardships of the war and its aftermath. There was not much need for new building. Wembley Stadium, often known as the Empire Stadium, and its adjacent Arena were available without the need for expensive refurbishment. The British athletes trained in the facilities of Butlin's at Clacton-on-Sea in Essex. The male athletes of all nations were housed in army camps, instead of the prisoner-of-war camps originally envisaged, and the female contestants were settled in college premises where they were obliged to stitch and mend their own uniforms. There was also an 'Olympic Village' in Richmond Park, which was some distance from the venue at Wembley.

So at 4 p.m. on 29 July 1948, after the national teams had paraded around the stadium in front of eighty-five thousand spectators, the king proclaimed the beginning of the XIV Olympiad. Around 2,500 pigeons were set loose into the bright sky, the Olympic

Left: Colourized photograph of John J. Hayes celebrating after winning the marathon at the London 1908 Olympic Games. Right: Tickets to the athletics at the London 1948 Olympic Games at Wembley Stadium.

flag rose high and the royal horse artillery sounded a twenty-one-gun salute. The final runner of the Torch Relay from Olympia to London climbed the steps of the Olympic Cauldron to open the proceedings with fire. Lord Burghley, chairman of the organizing committee and himself a renowned athlete, declared that 'a visionary dream has today become a glorious reality. At the end of the worldwide struggle in 1945, many institutions and associations were found to have withered and only the strongest had survived. How, many wondered, had the great Olympic Movement prospered?' He went on to say that the Games represented a 'warm flame of hope for a better understanding in the world which has burned so low'.

Some national teams were not present. Germany and Japan had not been invited, for obvious reasons, and the USSR chose not to attend. Nevertheless, an unprecedented fifty-nine nations were represented by 4,104 athletes – 3,714 men and 390 women – taking part in nineteen disciplines. The athletes were allowed 'extra' rations for the duration, amounting to twice the calories given to the ordinary population, and equivalent to that given to essential workers such as the miners and dockers. They were also advised to bring their own foods with them, while it was reported that the boxers maintained their fitness by gorging on custard and jelly. They were also asked to bring their own towels. The Horlicks tablets, however, were free.

The Games themselves proceeded without any difficulties except, perhaps, for heavy showers during the pole vaulting and the final of the 5,000 metres. Rain, in London, hardly ever stops play. It was an inspiring, if not an exciting, interlude in which the fewest Olympic records were set in the history of the Games. But the seventeen days, from 29 July to 14 August, had served their purpose as a reminder that the grey aftermath of the war would not endure for ever. White, the symbol of hygiene and purity, might prevail.

In 1925, Le Corbusier argued that all interior walls ought to be whitewashed to act as a form of moral or spiritual renewal. It has been argued that whiteness alone has the authority to announce that 'all is well'. That is why the majority of London churches, rebuilt after the Great Fire of 1666, have white interiors. The best response must surely come from Herman Melville who in the forty-second chapter of *Moby Dick*, 'The Whiteness of the Whale', writes that 'there yet lurks an elusive something in the foremost idea of this hue, which strikes more of panic to the soul than that redness which affrights in blood'. A white floor, for example, holds an implicit warning that you should not tread on it. A white corpse is an object of horror. That is one reason why John Ruskin and William Morris wished to scrape off the plaster and stucco from older buildings in order to restore their original colourful identity.

But there are various forms of white from titanium white to radiant white or zinc white, from lead white to ivory. Yet white also steals its shades from

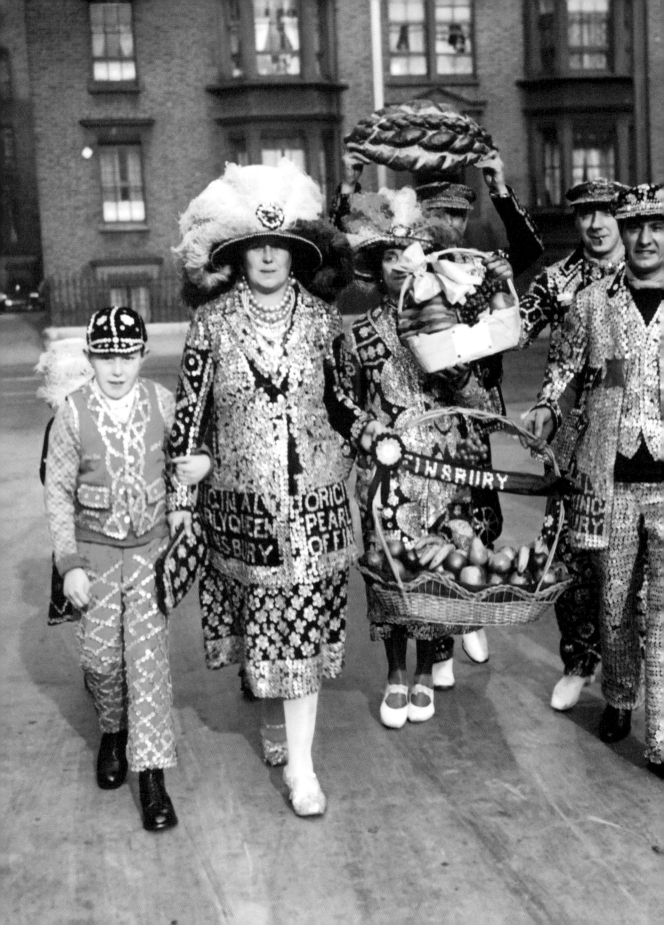

circumambient colour, from the blue of the sky to the dark shadows on the ground. It can be seen to shimmer with the green of trees and grass. The silver birch, for example, is one of the most common trees of London. Its name is perhaps a misnomer, since it shows white most of the year. But like the plane, the elm, the oak and the fruit trees, it lends a vivid streak to the great, grey city. The hawthorn, too, may have a blossom of creamy white, or old ivory, and is to be seen across the capital.

In London, too, the whiteness of pearl can never be neglected since it is the home of the pearly kingdom. The pearly kings and queens of London, their costumes richly decorated and embroidered with pearls, their hats with peaks or feathers, are part of a tradition of working-class charity that began in the nineteenth century. The first 'pearly' was an orphan who had become a street sweeper. Henry Croft was born in a St Pancras workhouse and raised at an orphanage in Somers Town. So he knew at first hand the dire poverty and distress all over London, and had decided to assist those who were even more unfortunate than himself. He had been brought up among costermonger, or 'costers' – a person who sells goods from a street cart – who wore pearls stitched into the seams of their trousers, and he adopted that tradition as his own. Henry Mayhew, the chronicler of the city streets, had noted that 'mother-of-pearl buttons are preferred' only for fabrics 'of a dark rat-skin hue', and that on other suits 'plain brass' or 'sporting buttons' were favoured. Croft picked up the stray pearls that had dropped from other clothes or from cheap jewellery, and sewed sixty thousand white or grey pearls into his second-hand dress suit and top hat. He wove into them symbols and slogans, such as 'All for charity and pity the poor', as the best way of drawing attention to his attempts to raise money. In fact his costume, as it soon became, was so intensely embroidered and

Left: Colourized photograph showing pearly kings and queens carrying fruit and bread to St Mary Magdalen Church Bermondsey, for the Costers Harvest Festival, 13 October 1935.

We have White City, Whitechapel, Whitehall, White Hart Lane, White Conduit Street, Whitefriars, Whitecross Street.

bejewelled that it became known as the 'smothered suit'. The name, and phenomenon, survive.

The costermongers had a tradition of mutual aid and assistance in times of sickness or distress, and Croft used that model to organize his own work. He even began to ask the costers themselves for their help in raising much needed funds. In 1911 the first 'pearly society' was established. At his funeral it was said that he had raised five thousand pounds for those people who languished in the city's hospitals. This very large sum acted as an inspiration to other Cockney street traders, who formed themselves into local groups or divisions in the various city boroughs. Croft's original society is known as the London Pearly Kings and Queens Association but there is also the Pearly Guild, which began in 1902, the London Pearly Kings and Queens Society as well as the Pearly Kings and Queens Guild. Each of the twenty-eight boroughs also has their own king and queen. Rivalries have of course arisen between them, but they are all devoted to London charities and are associated with specific London churches. The pearls became ever more lavish and extensive and, in modern times, flashes of colour have also been introduced. Pink feathers and pink costume jewellery are familiar accessories. It was originally a way of copying, and at the same time mocking, the expensive dress of the rich, with their pearls and decorative flummery, but now it has acquired an identity and authenticity of its own.

There are traditional rules and customs, as you would expect in Cockney London. Only those who come from the original families who worked with Croft are able to become 'pearlies', and the parents instruct their children in the lore and language of their calling. They teach them how to make their costumes, and how to interpret the symbols attached to them. And so the pearly kings and queens survive, although few outside their number are aware of their original role and purpose. They have become, in a sense, the ghost of London's colourful past.

But white is most pervasive in London by virtue of naming. We have White City, Whitechapel, Whitehall, White Hart Lane, White Conduit Street, Whitefriars, Whitecross Street; the list could be prolonged but the weight of names suggests the impression that the colour has made upon the city. It may be remarked, in general, that in painting and in photography white is the colour of silent London.

But in troubled times white can become a symbol of exclusivity, hatred and prejudice. Those who claim that England is a 'white civilization' know little of its history, a fact that was affirmed at the close of the 1940s. It began quietly enough. When the *Empire Windrush* docked at Tilbury on the misty morning of 22 June 1948, five hundred arrivals from Kingston, Jamaica disembarked to begin a new life. Some had paid their way and some had hitched a lift, while many of them

were ex-servicemen who had served during the war. They had heard of the 'mother country', as it was still known, but few had visited it. They were the first to come in response to the British government's campaign to recruit workers from the Commonwealth to compensate for post-war scarcity in state enterprises such as the National Health Service and London Transport. England needed them. There was another suggestion that the ship had docked at Kingston for the simple reason that it needed more passengers; the captain had placed an advertisement in the local newspapers offering cheap passage to London at £48.00 for cabin class and £28.00 for the troop deck. Whatever the reason, the new arrivals had come. The *Manchester Guardian* of 23 June asked 'what manner of men are these the *Empire Windrush* has brought to Britain? This morning, on the decks, one spoke with the following: a builder, a carpenter, an apprentice accountant, a farm worker, a tailor, a welder, a spray-painter, a boxer, a musician, a mechanic, a valet, a calypso singer, and a law student.'

They were met at first with placards bearing the legend, 'Welcome to Britain'. But it was not clear what, if any, welcome lay behind the placards and the smiles. The more fortunate found jobs and accommodation, but approximately 230 were placed in what had been a deep air-raid shelter under Clapham Common. This was not what they had expected. Nor was the reception they received from the predominantly white population. One ex-soldier recalled that:

> when we arrived at Tilbury, a few people, political people, mostly Communists, you know, tried to befriend us ... But all it needed at the time was who hadn't got any place to go to, wants somewhere to go, and that was uppermost in our minds ... you've got to go around and look, because in those days, it's either two or three of you in a room, in those days, as a black man, it's very hard to get a room, you wouldn't get one.

Right: Colourized photograph of immigrants aboard the *Empire Windrush*, 2 June 1948.

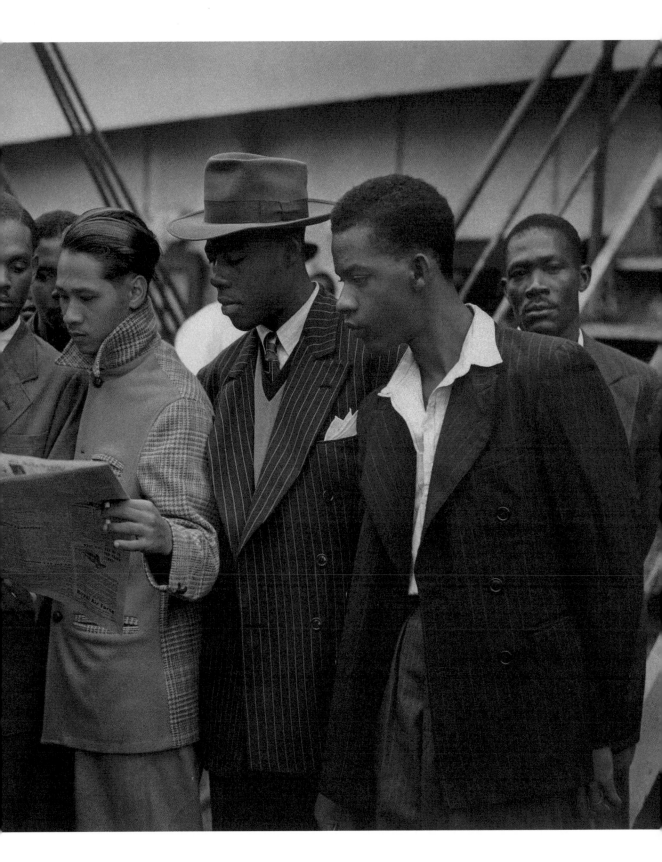

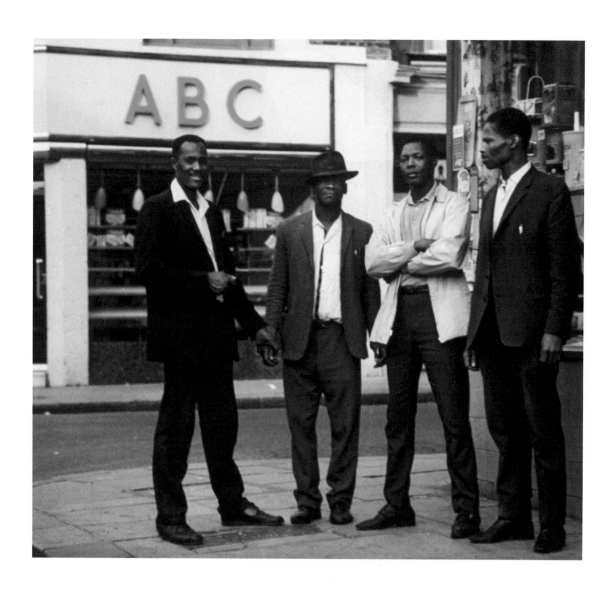

Above: Four African Caribbean
men in Notting Hill, 1960s.

The mother country was not maternal at all. The experience for the immigrants was dislocating in many senses. You arrived, and then you moved, and, more often than not, moved again. Any skin pigmentation darker than pink was often refused bed or board. The England to which they had come was in fact disillusioned and worn down. The proud, imperial nation of rumour or propaganda could be discerned with difficulty in a small, cramped island, still gasping from the blows of a war it had nearly lost. The promise of 'diamond streets' was belied by ones that seemed paved with lead, gashed by bomb sites, beside grey houses interchangeable in size and shape, and in a population that seemed old. Along with anxiety, fear and relief, the immigrants sometimes felt a certain pity for the nation that had adopted them.

War films of the time, and the later cinema, show little or nothing of black men and women contributing to the country in any way. But for the immigrants, visibility could prove a curse. One of them, Tryphena Anderson, recalled that 'You're not thinking of your skin, but you feel other people are thinking of it.' Then there was the cold, which could steal through the thickest clothing, let alone the light but formal dress favoured by the new arrivals. For many it was difficult to determine which was harsher or more dispiriting, the coldness of the climate or the coldness of the people.

Theirs was not solely, however, a tale of dislocation and prejudice. Warmth and friendliness could be found, often in the most surprising places. One immigrant remembered a visit to a butcher where 'I got a mixture of genuine affection and a lot of curiosity. I always remember going into my first Dewhurst butcher's shop, when I was about seven, and this big, large lady looked at me. She kept looking at me and then she turned to the butcher, and said, "Ooh, I could eat him". I'll always remember Dewhurst butchers' shops'.

It is easy to forget that while England might have wanted cheap labour, the early immigrants had other concerns, with education not the least of them. Among other blandishments, England had been touted as the land of educational opportunity, yet not all found it such. Vince Reid, the only teenager on the *Windrush*, recalled that:

I was a boy. And I wasn't expecting anything. But how I was received was when I went to school, first of all, I was a subject of curiosity, which is quite surprising when you think that you had black soldiers in England. And, you know, people would come up and rub your skin and see if it would rub off the black, and rub your hair and, you know, it's really insulting.

In truth the Empire had been an abstraction to most; now it was made flesh. Englishmen and women had new neighbours and new influences to accommodate. The best in all major parties acknowledged a duty of care to the immigrants, whether because one should pay a debt of reparation to those colonized or because one does not let down old friends. But few leaders could afford to shout out the benefits of a multi-racial community. Nevertheless the *Empire Windrush* inaugurated a new era in British history.

GOLD

'found the word golden.'

William Blake, journal entry, 23 May 1810

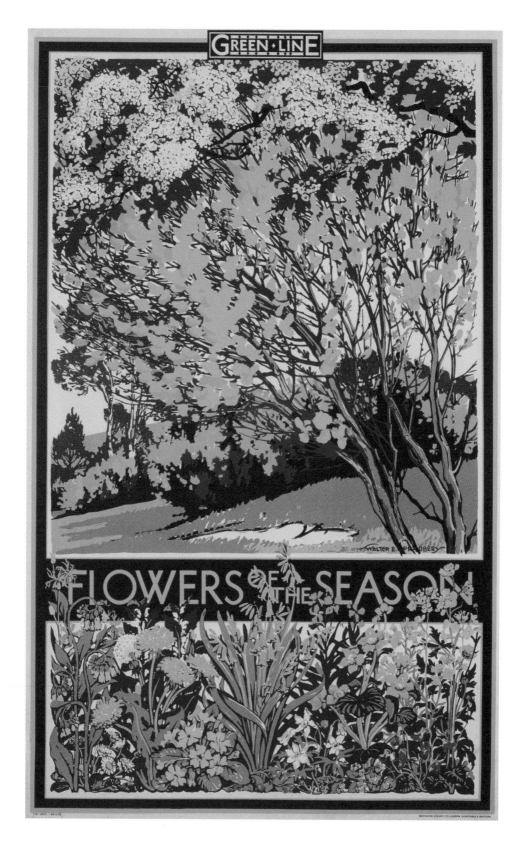

Yellow is the sun of life. It is the component of fire, light and air that is sprinkled over the London spectrum, and so it permeates all the stir and bustle of existence. It has been associated with cowardice and sickness, in all the pus and faeces that are expelled from the human body, together with the process of ageing into 'into the sear – the yellow leaf'. Perhaps its association with earthen colours explains its connection with the nature of mortality. It is necessarily a fragile colour, easily bruised or changed. In its conventional hues, such as canary yellow or lemon yellow, it not a natural colour for Londoners. Their taxis are never yellow, as in other cities, but characteristically black. Estate agents tell prospective sellers to avoid yellow front doors.

Chinese immigrants to Limehouse and elsewhere were known as the 'yellow peril'. In the late nineteenth century it was associated with decadence; Oscar Wilde carried a yellow book with him when he was arrested on 5 April 1885. 'Yellow' journalism was considered disreputable. It was the colour of disengagement, of dandyism and of rebellion. The period became known as the 'Yellow Nineties'. Never has a colour been so reviled and so glorified.

Its true nature, however, lies in its radiance. That is why it is generally associated with happiness. It was believed to be the colour of the sun and, for Turner, the sun was god. He was obsessed with, and experimented with, his favourite colour. He used yellow as his private furnace.

That brightness or effulgence is perhaps best seen in its incarnation as gold. Gold is the colour of London power. It is known as the most noble of the noble metals. It is a pure metal, signifying the most sacred and the most royal. Royal events such as marriages and funerals, births and coronations, are part of the very texture of London. Royal processions, conventionally dressed in gold, stimulate the pageantry and theatricality of the city. It embodied the old cry of 'Show! Show! Show! Show!' to be heard in settings as diverse as Bartholomew Fair and Astley's Amphitheatre.

Gold was never far off in the city. The alchemists believed that the colour of gold was red rather than yellow. It is the context in which gold has, by association, also become the colour of London. The stock brick of the city is or was yellow, which may seem gold in the rays of the declining or advancing sun. The weathering steel of 4 Pancras Square is slowly turning into an orange or yellow gold. Gold is the emblem of desire and a token of awe. The city is the home of golden cocks and golden dragons, close relations to the golden cross and golden ball on the dome of St Paul's Cathedral. Gold can be found on the top of the Monument, in the frames of the art galleries, in the interiors of old theatres, in the vaults of the Bank of England, in the jewellers of Hatton Garden, in Chinatown, in the leaves of city parks, in the sky on bright mornings and of course, according to legend, in the streets of London. That golden atmosphere,

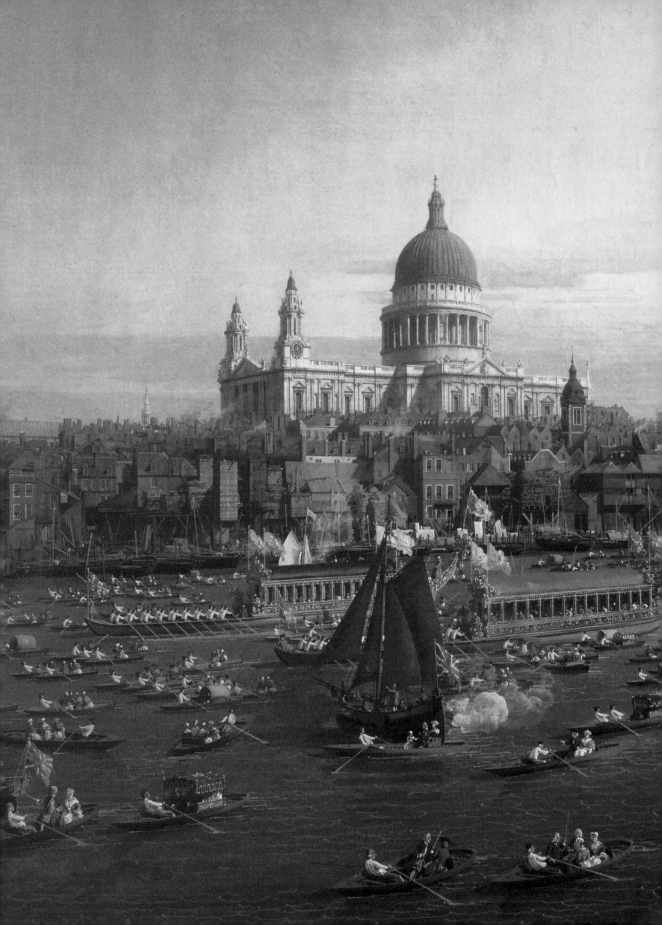

Left: The River Thames with
St Paul's Cathedral on Lord
Mayor's Day (c.1747–8) by
Canaletto.

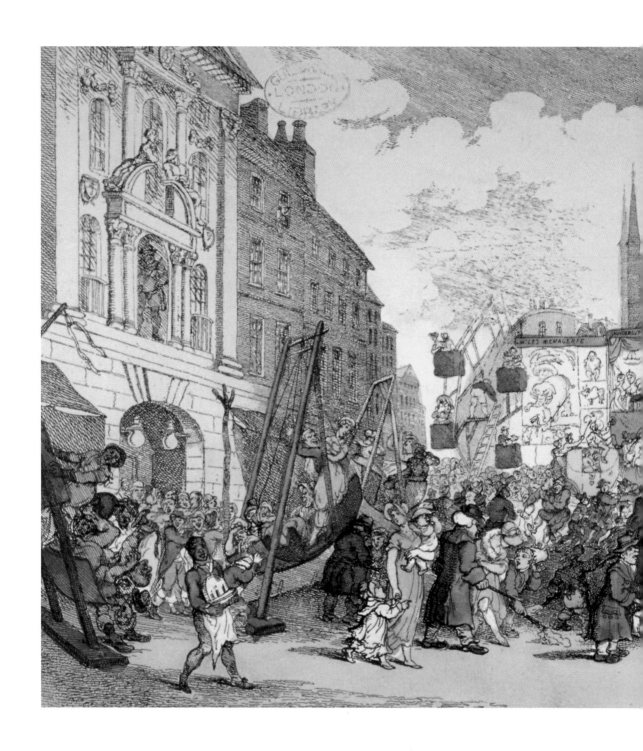

Above: *Bartholomew Fair, West
Smithfield, City of London* (1813)
by Thomas Rowlandson.

providing light as well as a sense of warmth, is rarely noticed by Londoners themselves. But it is there. For Wordsworth the city was an emporium of 'golden expectations' and for Byron it issued 'the magic vapour of some alchymic furnace'. Joseph Conrad described its air as evincing 'an atmosphere of powdered gold'.

One of the most imposing of the city's statues, covered in gold leaf, is that of Albert, Prince Consort of Queen Victoria. It was part of what became known as the Albert Memorial. On the evening of 14 December 1861, Prince Albert died in the Blue Room of Windsor Castle after a marriage to Victoria that, through various crises and confrontations, had continued unscathed for twenty-one years. It was said that they had behaved as king and queen, which in terms of protocol was ill-judged, but it was generally believed that Albert took care of ministerial and managerial matters in which his wife was not wholly interested.

But she had regretted placing such burdens on what she called 'his poor dear stomach'. For many years the prince consort had suffered from a nervous stomach, which did not allow him to digest his food properly and provoked painful spasms. The signs were already there. It is now believed that he suffered from abdominal cancer or Crohn's disease, an inflammatory condition of the bowel, but at the time his demise was attributed to typhoid fever contracted from the bad sanitation at Windsor. It was also suggested that he worked too hard and that he suffered from nervous exhaustion in managing his impulsive and volatile wife. He was only forty-two, but he may have known that the end was coming. This was not the kind of news that could be intimated to the queen. 'I do not cling to life', he had told her, 'You do; but I set no store by it.'

Victoria was called to his bed. 'Oh yes, this is death,' she said. 'I know it. I have seen it before.' She recalled some eleven years later that 'two or three long but perfectly gentle breaths were drawn, the

hand clasping mine and … *all, all*, was over … I stood up, kissed his dear heavenly forehead & called out in a bitter and agonising cry "Oh! my dear Darling!" and then dropped on my knees in mute, distracted despair, unable to utter a word or shed a tear!'

The Times on Tuesday 16 December was given a black border and told its readers that:

> The nation has just sustained the greatest loss that could possibly have fallen upon it. Prince Albert, who a week ago gave every promise that his valuable life would be lengthened to a period long enough to enable him to enjoy, even in this world, the fruit of a virtuous youth and a well-spent manhood, the affection of a devoted wife and of a family of which any father might well be proud – this man, the very centre of our social system, the pillar of our State – is suddenly snatched from us, without even warning sufficient to prepare us for a blow so abrupt and so terrible. We shall need time fully to appreciate the magnitude of the loss we have sustained. Every day will make us more conscious of it.

For the queen herself it was the beginning of a mourning that lasted for several years, accentuated by the fact that she wore black for the rest of her life. *The Illustrated London News* revealed after Albert's death that his 'express desire' was for his funeral at Windsor to be 'of the plainest and most private character'. He did not wish for a state funeral and did not permit his body to lie in state for the crowds of curious mourners. So the ceremony was a relatively modest affair. His

mortal remains were carried to the entrance of the Royal Vault in St George's Chapel at Windsor, where the funeral service was conducted on 23 December. The queen was too overcome to attend it. The prince's corpse was then taken for burial to the new Royal Mausoleum at Frogmore, some half-mile from Windsor Castle. The hearse itself was drawn the short distance by six horses. Four carriages followed. The most well-known painting of the scene is modestly low-key, with hearse and attendant mourners in subdued colours, the hearse and horses dark, and with the attendant Second Regiment of Life Guards in the palest red.

Victoria herself entered a state of almost cataleptic grief. If anyone dared to console or advise her, she responded with fury. Her only thought was of cherishing the memory of Albert with statues, parks and monuments. She ventured out only to unveil images of her dead husband, and the most striking was that covered in gold leaf, which is to be found at the centre of the Albert Memorial.

The golden image was that of a seated Albert, holding a catalogue of the Great Exhibition in his right hand, with a resplendent podium beneath and a canopy above. At its first unveiling in March 1876, the gold leaf was so bright as to be dazzling, and one critic believed that 'no nobler work in metal for architectural purposes has, so far as I know, been produced in our own, or, probably – considering its scale and extent – in any other age'. Gold was the key to its eminence, and to its representation of royal duty. The stone itself seemed to reflect the glory of the gold, and *The Builder* commented that 'the polished granite flashes back the sunlight like a mirror, and the huge blocks and shafts rest in their places without a splinter or a crack'.

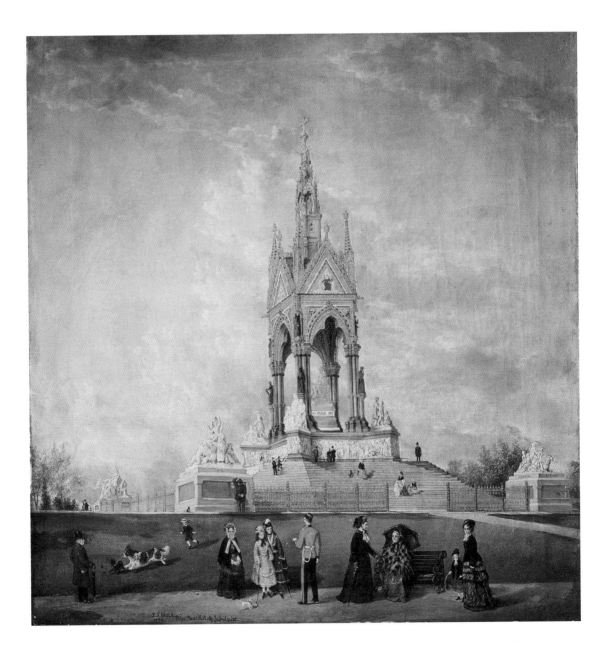

The memorial is on the south side of Hyde Park, in what is called Kensington Gardens, and is placed directly opposite the Royal Albert Hall, which had opened in 1871. The Queen was delighted with it, describing it as 'really magnificent' even though her visits were often melancholy. 'All the time I felt a longing,' she wrote in her diary, 'to tell my dearest Albert all about it and to hear his words and remarks!'

The Albert Memorial itself is one of the classics of Victorian design. It is a masterpiece of nineteenth-century Gothic, at least, which was designed by Sir George Gilbert Scott in what became known as the Gothic Revival style, bringing with it suggestions of elaborate excess and overpowering amplitude, of quasi-religious yearning and monumentality. By the late 1870s it also possesses the consolation of supposed antiquity; in a city which seemed to be advancing beyond all familiar or predictable bounds (as the glittering glass palace of the Great Exhibition itself had demonstrated) it offered the reassurance of history and permanence.

Scott himself noted that the memorial 'was designed in some degree on the principles of the ancient shrines. These shrines were models of imaginary buildings, such as had never in reality been erected; and my idea was to realise one of these imaginary structures with its precious materials, its inlaying, its enamels … this was an idea so new as to provoke much opposition.' But there have always been, and always will be, shrines of gold.

For the coronation procession of George VI on 12 May 1937, the capital was once more ablaze with appropriately regal gold. The pageantry was all the more necessary in order to bolster the popular appeal and magnificence of the monarchy after the unhappy period that culminated in the abdication of Edward VIII. This was a solemn event to extol the power and permanence of the British royal family with all the riches and resources of the Empire at its command. In a rare colour film of the event, the dominant colours on the day were seen to be gold and a red that comprised blood red, scarlet, crimson and vermillion. These two major colours were highlighted and contrasted with less resplendent hues – white, black, yellow (including the sand spread on the roads), brown, grey (the sky) and silver (the jewellery). Sometimes blue was introduced in cloths and flags within Westminster Abbey, and along the stands erected on the streets, but this was juxtaposed to the red and white of the robes and thus echoed the Union Jacks that also lined the route. But the dominant red and gold had associations older than the British flag; they evoked suggestions of royal blood, the red outer petals of the Tudor rose and the Field of Cloth of Gold. While the gold dazzled, the red conveyed antiquity, sacrifice, continuity and tradition.

A double line of long flowing pennants, alternating in red, white and blue, stretched along the Mall; the official stands on each side of this avenue were decorated in a triple border of red, gold and blue. Whitehall, according to The Times of the following

day, was resplendent with a 'profuse variety of decoration'. Parliament Square was dressed 'in a silver grey relieved with a key pattern in red'. The principal buildings along the processional route were floodlit at night.

Through this kaleidoscope a golden coach, accompanied by yeomen of the guard in red and gold uniforms and by a score of attendant grooms in similar dress, made its way. The dukes on their horses wore green sashes, while the pedestrian island in the middle of Piccadilly was bedizened by blue, white, gold and red; the pavement masts were coloured red, white and gold just as the buildings along the route were decorated in blue and white. It resembled a more than usually lavish stage set to suit the mood of Londoners anxious to regain their sense both of pre-eminence and of permanence.

It was a dull spring morning, with overcast sky, but the attention of the massed crowds was inevitably drawn to the gold state coach pulled by eight Windsor Grey horses wearing harnesses of Red Morocco; the interior was lined with red velvet and satin, while an image of the occasion in *The Illustrated London News* depicted the interior of the Abbey as a confluence of blue, gold and crimson together with the subdued light or glow coming from the rose window of the south transept.

In its account of the varied congregation of the noble, the notable and the privileged, *The Times* noted that:

… every moment was filled with interest, such was the constant movement and change of colour in the brilliant scene. Even the peeresses had to be in their places by 8.30 a.m. Many arrived at least an hour earlier than this, their lovely robes soon forming a mosaic of colour and their sparkling jewels scintillating from a thousand points. Since the dresses worn beneath the velvet and ermine kirtles and robes were of white, silver or pale gold materials, there was no great display of vivid colours in the peeresses' galleries, but rather the impression of a set design of checked crimson, black and white. Every head bore its tiara, the majority of massive all-round design. Necklaces of diamonds and pearls and richly jewelled corsage ornaments added further brilliance to the scene. In the seats above the choir stalls gorgeous saris, rich Eastern robes of golden tissues, others in vivid pinks, orange or greens marked the presence of distinguished oriental visitors. In other parts of the Abbey where Court dress was worn, feathery white plumes and filmy veils provided patches of snowy whiteness allied to dresses of all shades imaginable … the climax of beauty and magnificence was reached with the arrival of the Queen. The elaborate golden embroideries on her English satin gown were designed to incorporate the emblems of the British Isles together with those of the Dominions. Flounces of old lace were draped from the sleeves and were lightly embroidered with oak leaves. Moulding the lines of the figure, the dress was cut with a square neckline. As her Majesty passed slowly up the nave gleams of light were reflected in her necklaces and corsage ornaments.

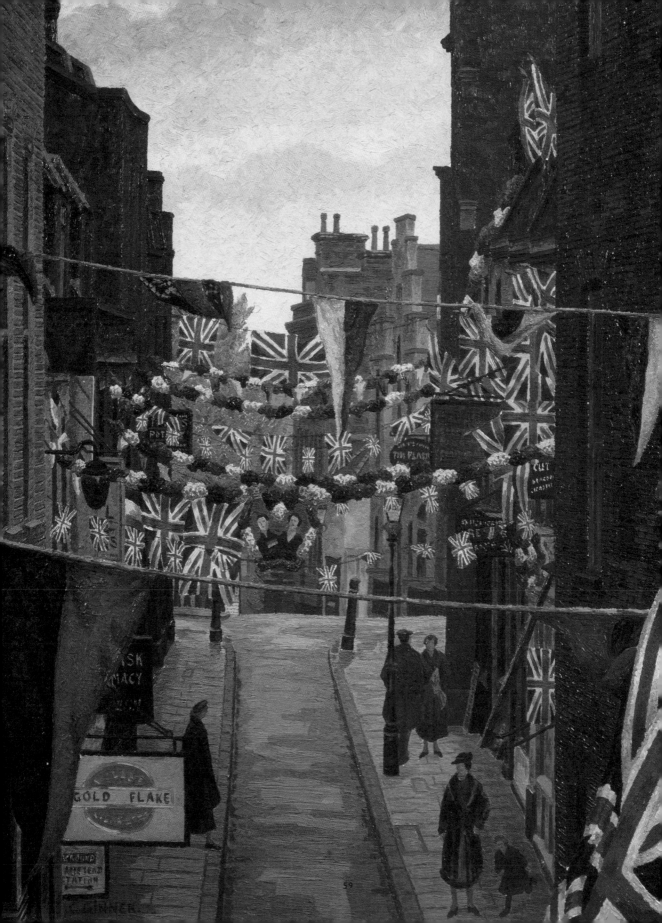

Below: Queen Elizabeth II
rides in the Gold State Coach
towards Buckingham Palace
on 2 June 1953.

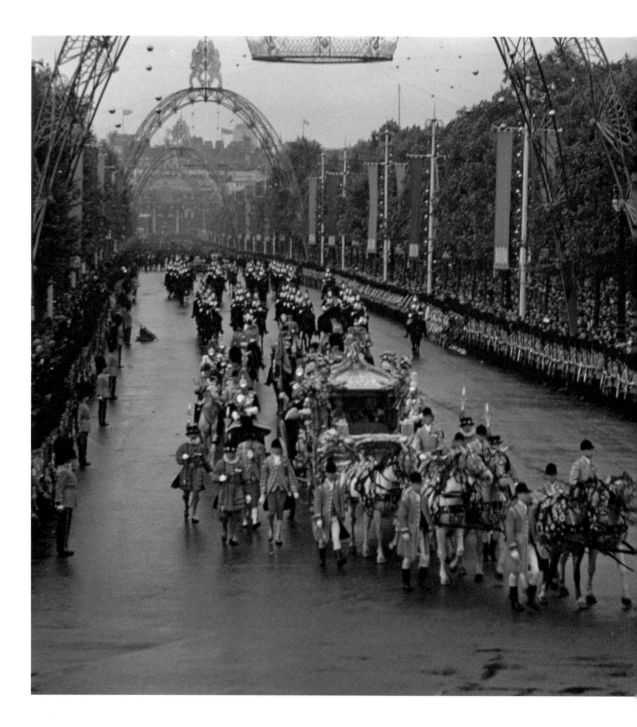

The city itself became a kaleidoscope. *The Times* also reported that 'London has become for the Coronation a city richly decorated with colour. For the past week or so the daily life of the streets, surrounded by garlands and banners, has been something of a pageant'. Whistler himself might have described it, in his usual style, as a symphony of red and gold. Charles Ginner's painting of Flask Walk, Hampstead, on that coronation day was composed from his bedroom window. It displays the pennants, half in gold, decorating the street that are nicely complemented by a bright advertisement for Gold Flake tobacco. In the year before the coronation Adam's Gate in Green Park, made of ornate wrought iron, was freshly painted in gold. It was a festival of gold.

But perhaps no royal occasion of the century could surpass the coronation of Elizabeth II. It was the golden coronation that would, it was hoped, inaugurate a new era. It would mark the beginning of another Elizabethan age that might even rival the first. The coronation of the young queen was if anything more panoplied and pearled than that of her father. It took place on 2 June 1953 at Westminster Abbey, the familiar and appropriate setting for the ceremony. Elizabeth II had in fact acceded to the throne on 6 February 1952, upon the death of George VI. She was then twenty-five. The delay was considered suitable for the required period of mourning. It also provided time for the intensive preparations that were considered to be necessary. The day itself was chosen because the meteorologists forecast that the day would be a fine one; predictably, perhaps, it rained.

On the morning of 2 June the Queen, with the Duke of Edinburgh, was driven from Buckingham Palace to Westminster Abbey in the Gold State Coach pulled by eight grey geldings, which were presumed to be

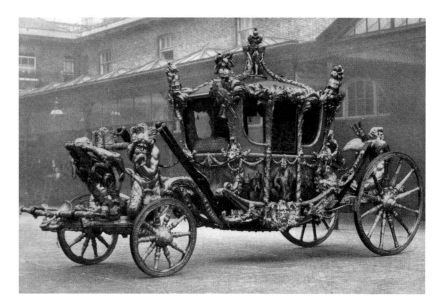

Left: The Gold State Coach, colour photograph from *The Illustrated London News*, 1937. Below: The scene inside Westminster Abbey during the Coronation of Queen Elizabeth II, 2 June 1953. Right: Colourized photograph of coronation decorations going up in a street in North London, May 1937.

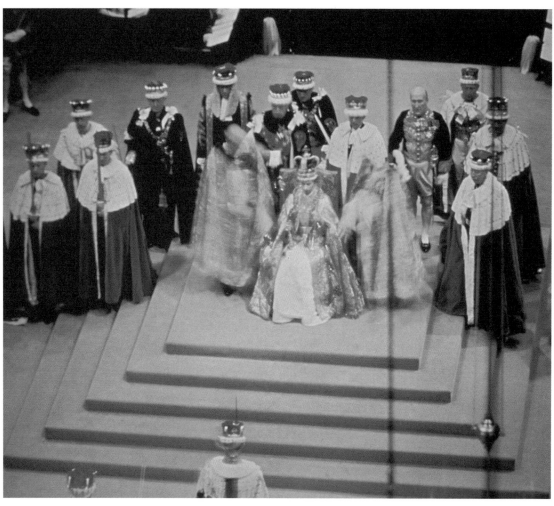

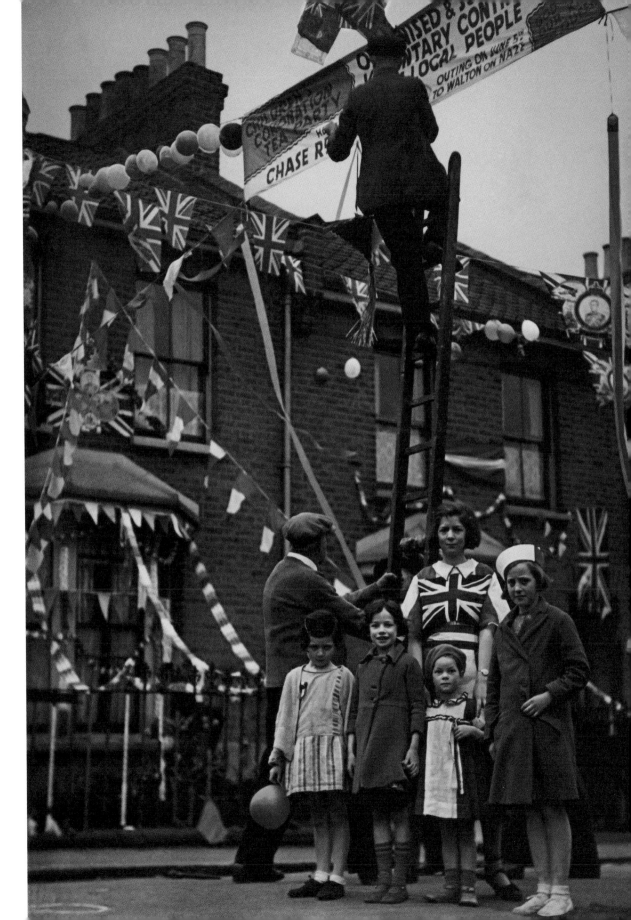

calmer in front of crowds. Some of the spectators had waited all night under trees or makeshift shelters for the occasion as, preceded by Guards and escorted by Cavalry, the golden coach was drawn down the Mall to Trafalgar Square and Northumberland Avenue before proceeding along the Embankment to the Abbey. The predominant colours seem to have been gold and scarlet, contrasting with the light green trees of early summer. It was reported that half a million people lined the streets and avenues.

When she stepped out of her coach into the Great West Door of the Abbey it seems that her robes were hindered by the dark blue carpet that had been unrolled for the occasion and it was reported that she asked the Archbishop of Canterbury, Geoffrey Fisher, to 'get me started!' The ritual then proceeded without incident. The coronation ceremony was of course slow and solemn, consisting of the six stages of the recognition, the oath, the anointing, the investiture or coronation, the enthronement and the homage. It lasted for almost three hours. Only the anointing of the monarch remained mysterious, hidden from cameras and spectators, with a golden canopy held over the queen as she was anointed with oils of orange, rose, cinnamon, musk and ambergris.

The queen was then given the sword of state, glittering in the television lights, followed by bracelets, the Stole Royal, the Robe Royal and the Sovereign's Orb, followed by the Queen's Ring, the Sovereign's Sceptre with Cross and the Sovereign's Sceptre with Dove. Holding the golden orb and sceptre she was prepared for the climactic moment of the ceremony when St Edward's Crown – with its solid gold frame, it is employed only for a coronation – was placed upon her head as the trumpets blared and the congregation chanted three times 'God save the Queen!'; at the same moment, a twenty-one gun salute was fired from the Tower of London. It was done.

For those with ears to hear it, however, a new and sombre note had been struck. The new monarch of Great Britain was not the Empress of India, and that title was omitted from the coronation oath. Her declared devotion to 'our great Imperial family' was celebrated, but it was not as it was. Yet the spectators in the Abbey did not register such things. It was enough that the day had passed without hindrance and that the new queen was in her rightful place. Now wearing once again the Imperial State Crown and holding the Sovereign's Sceptre with Cross and the Orb, and as the gathered

The Abbey itself was the appropriate setting for all the pomp and circumstance, the pageantry and the courtly dance of protocol. That part of the Abbey in which the coronation was to be held was known as 'the theatre'; a slightly raised platform with a gold carpet, and this was indeed the great theatre of state. It was the fourth and last coronation of the twentieth century, but was the only one to have been fully televised. This had been against the express wishes of the prime minister, Winston Churchill, who had not wanted television to intrude upon the mysteries of monarchy; but the queen did not take his advice, in the belief that the people should see the crowning of their monarch.

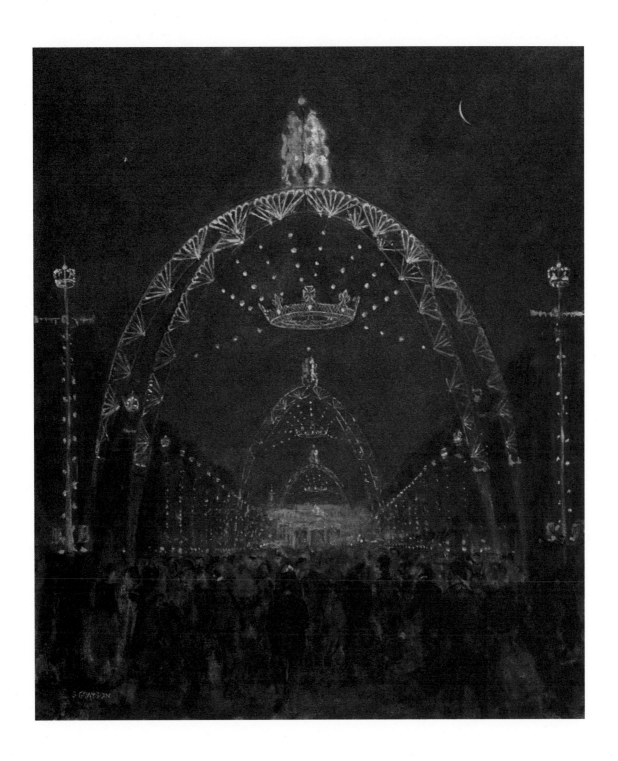

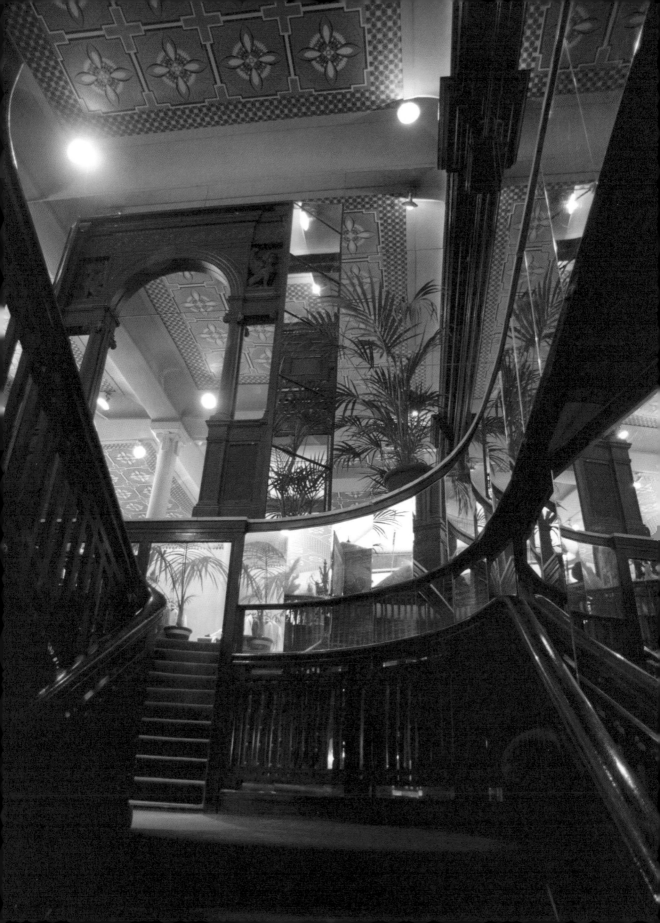

Left: The staircase of the
BIBA fashion store in the
1960s, with mirrored walls
and ornate ceiling.

Gold is also London's colour, in its association both with the gold coins, which were in use until 1917, and with the gold bullion stored in the City banks.

guests sang 'God Save the Queen', Elizabeth left Westminster Abbey through the Great West Door.

On the queen's return to Buckingham Palace the processional march was arranged so that the maximum number of people could see the newly crowned monarch. It was guarded by some sixteen thousand service personnel, forming a line that stretched for 3.2 kilometres (2 miles). The route of 7 kilometres (4½ miles) took two hours to complete, while the procession itself stretched for almost two miles. The spectators would have to wait for forty-five minutes to watch it pass. It was perhaps the last spectacle of its kind, a golden moment for queen and people. No one could have predicted that the second Elizabethan age would still endure after seventy years.

Stanley Clare Grayson's image of *Coronation Night, The Mall* displays a vista of gold with its line of lights, crowns, arches and insignia emblazoned against the background of the night sky as if the city itself had become a golden crown. The brilliance outshines the crescent moon and the solitary star. The people milling beneath the elaborate display also seem to glow.

Gold is also London's colour, in its association both with the gold coins, which were in use until 1917, and with the gold bullion stored in the City banks. The gold sovereign is still legal tender. Its bright sheen is not easily tarnished. In the Lord Mayor's Show there is always much gold in the mayor's own robes, otherwise in scarlet and ermine, and in the gold braid on his three-cornered hat; it signifies his association with the capital.

If you look carefully at the streets you will see the same deep, rich yellow everywhere, from the shop signs to the shop windows, from the packaging of luxury goods to the advertisements on hoardings or in neon. The BIBA store of the 1960s made lavish use of gold in its interior as well as its lights, fabrics, carpets and furnishings. Its advertisements and signage were often conceived in golden letters, so that it became an enclave of gold along what might otherwise have been grey streets. It became a modern symbol of the city. It was once said that London's streets were paved with gold, and there is still a Golden Lane and a Golden Square, a Golden Court and a Golden Crescent.

BLUE

'The lights burn blue.
It is now dead midnight.'

William Shakespeare, *Richard III*

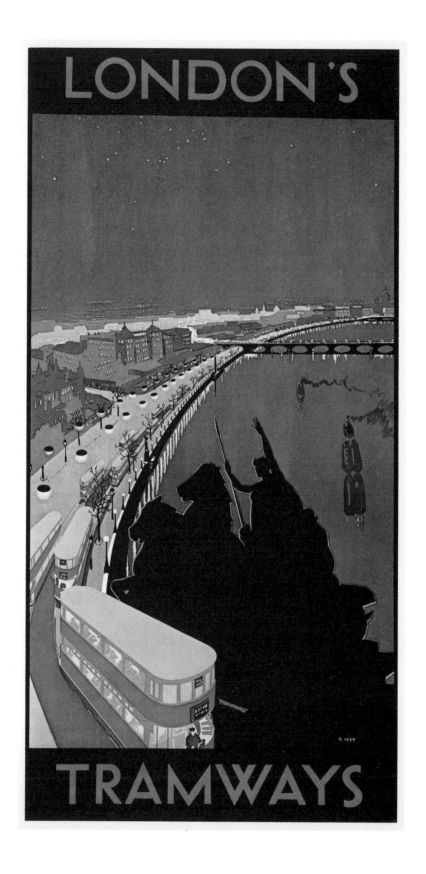

Blue, in London, is in certain respects the colour of an idea. The canopy of the clear blue sky is a token of infinite and unstained distance, and as a result it cannot be said to touch ground level. Blue is seldom considered to be part of the urban colour chart, but it lingers everywhere. But where is the true blue of London? It may be said to dominate the urban world, with the sky and the river, but it is rarely visible in the city fabric. It is always beyond reach. It is classified as a cold colour, with a short wavelength, but it is a token of peacefulness and concord. Blue is also the emblem of trustfulness, which may be the reason for the dark blue of police uniforms. Blue also suggests calm, comfort and tranquillity. That is why it is the most popular of all colours. We are back in the world of connotation and symbolism, which is the true home of blue. In Monet's *Houses of Parliament* of 1904 a blue fog or mist swirls up from the water of the Thames and throws a cerulean shade over the buildings so that they loom out of the blue haze.

A blue sky, without a hint of cloud or mist, suggests a tranquil and agreeable day. It may be that the great expanse of blue above leads to the neglect of blue below. It may not even be perceived, as can be seen in a particular example of the London cityscape. The suspension chains for the fixed bridges of Tower Bridge are pale blue, while the main deck structures and their balustrades on either side of the towers are painted royal blue. The outer faces of the central swinging opening blades are in pale blue, as are the steel arches of the towers and their various ironworks, fences and details. The high level footway is pale blue and white with gold detailing. It is the most singular blue structure in London, but its colour is rarely noticed. It is as if it were not there. The Great Exhibition included blue girders, and some of its external ironwork was decorated in the same colour. But that detail was overwhelmed by the shining and transparent glass. That is why blue may be said to be a fugitive colour in the London spectrum. The light of the London day has a bluish tinge, but it is impalpable and untouchable.

In the advertising posters for the London tram system in the 1920s the Thames is depicted in a dark blue, almost a violet, while the surrounding cityscape is portrayed in light blue. Advertisements for London's transport generally used a bright blue to emphasize the sky above outlying parks and green spaces within London's orbit. A watercolour of 1835, John Orlando Parry's *The Poster Man*, is singular for the touches of blue that are pasted on the wall, including notices for Drury Lane and Vauxhall Gardens. In the foreground of the picture stands a hussar in blue and a policeman in a swallow-tailed jacket of blue. Hence the slang word for the police as 'bluebottles'. So it can be found, even if only in vignettes or vistas. It does not seem to be a natural London colour. We seek it here, and we seek it there, but it is not found everywhere. Blue is believed to reduce the racing pulse, and to

encourage contemplation or relaxation. It is said that a predominantly blue environment deters crime, and is therefore associated with honesty and reliability. This may be debated.

Do we consider the sky to be blue? That is true only in certain conditions and at certain times. The lower levels of the sky often seem golden as they reflect the brilliance of the glowing lights; they can be perceived as almost white before they gradually dissolve into blue and darker blue still. Sometimes they are grey or white, opaque, impenetrable, with the clouds almost hugging the tops of the buildings. As the sun descends towards the horizon the blue sky becomes yellow before moving to orange, red, pink, purple, until it is once more permeated by blue. The changing chromatic canopy is rarely noticed, even though it can move from blue to white and from violet to black in an instant. It is generally regarded and depicted as blue simply because every human being can detect the shorter wavelengths of that colour.

The sky in London, like the city's weather, seems to have different orders of magnitude. In some streets, which are the canyons of the city, it becomes infinitely remote; it is a distant prospect continually crowded by rooftops and towers. Yet in certain large squares, where the houses are low, or in the council estates located in various quarters of the city, the city is a vast canopy cloaking all of the adjacent areas. 'In this low damp area,' V.S. Pritchett wrote of Camden Town, 'the sky means a great deal to us'. That is perhaps the reason why the typical London sky seems close and tactile, part of the city itself and its thousand stray shadows and gleams. According to G.K. Chesterton, 'all the forces which have produced the London sky have made something which all Londoners know, and which no one who has never seen London has ever seen'.

The weather, and the colour of the weather, are the subjects of endless conversation. By the mid-nineteenth century the word on everyone's lips was fog, the 'London particular', the 'pea-souper', which was described by one nineteenth-century painter as a compound 'from the effusions of gas pipes, tan yards, chimneys, dyers, blanket scourers, breweries, sugar bakers, and soap boilers', not to mention the coal fires, the furnaces and the gas works. Londoners were often both alarmed and impressed by the city's impenetrable gloom, but others were enchanted by it. Monet said that 'without the fog London would not be a beautiful city. It is the fog which gives it its magnificent amplitude'.

Opinions varied on the colour of the fog. Some considered it as black as soot, from which it was partly comprised, 'simply darkness complete and intense at midday'; for others it was bottle-green or yellow 'which seemed to choke you'. It could also become 'a rich lurid brown, like the light of some strange conflagration'. It might be simply grey, or an 'orange-coloured vapour', or a 'dark chocolate-coloured

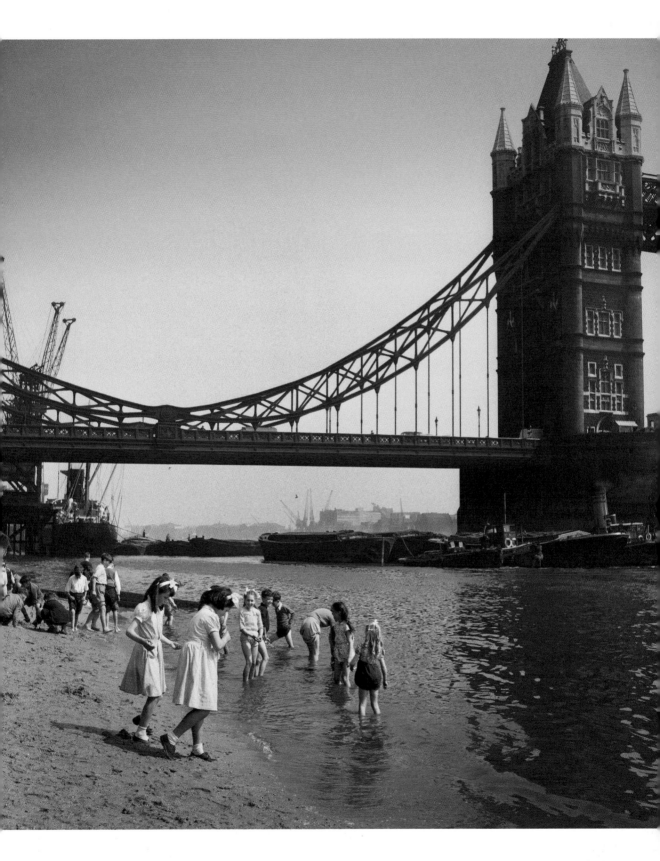

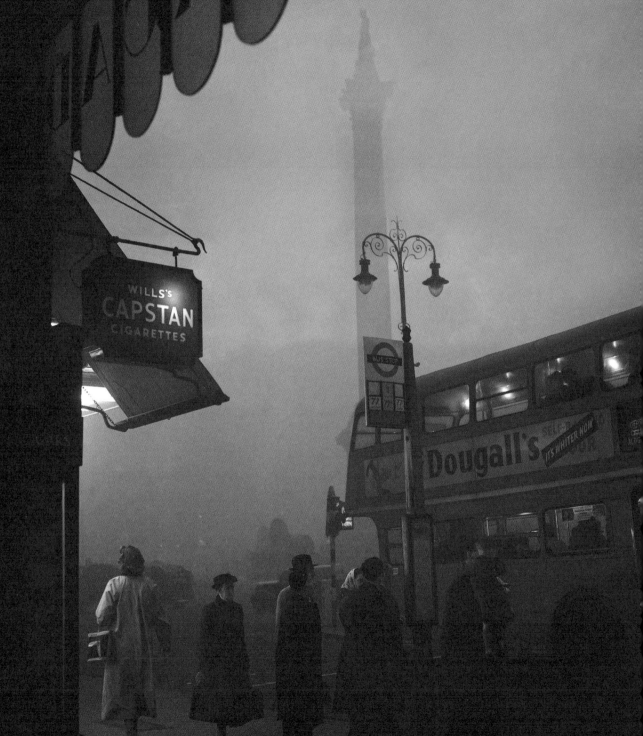

'Look out this window, Watson.
See how the figures loom up, are
dimly seen, and then blend once
more into the cloud-bank.'
Arthur Conan Doyle, 'The Adventure of the
Bruce-Partington Plans'

pall'. 'So heavy was the gloom,' Nathaniel Hawthorne wrote in December 1857, 'that gas was lighted in all the shop windows; and the little charcoal furnaces of the women and boys roasting chestnuts threw a ruddy misty glow around them.' Towards the close of December 1904, the fog was pure white and nothing could be seen within it; yet this was also the period when Monet saw, or thought he saw, violet, gold and green in the enveloping vapour. He painted mauve and purple, too, so strong that they obscured the buildings along the river.

The colours of the fog altered with its changes of density when wreaths of one colour would mingle with another, getting heavier and darker as they approached the heart of the city where 'misty black' gathered at the dead centre. The cabs were rimmed with the haloes emanating from their carriage lamps, and the people faded into grey. That is one of the reasons why houses and buildings were covered in red brick or terracotta, to stand out within the drapery of soot and filth. The veil of smoke was always apparent. It became the name of a colour known as 'London smoke' and

used for fabrics; it was a compound of yellow ochre, ultramarine blue and lamp black, which some believed to be 'dingy'. Yet it added to the atmosphere of the city.

Arthur Conan Doyle, in a Sherlock Holmes story published in 1908, writes that 'we saw the greasy, heavy brown swirl still drifting past us and condensing in oily drops upon the window-pane ... "look out this window, Watson. See how the figures loom up, are dimly seen, and then blend once more into the cloud-bank. The thief or the murderer could roam London on such a day as the tiger does the jungle, unseen until he pounces, and then evident only to his victim."' Robert Louis Stevenson had written more than twenty years earlier that 'a great chocolate-coloured pall lowered over heaven ... there would be a glow of rich, lurid brown, like the light of some strange conflagration'. For Nathaniel Hawthorne the fog was 'very black, indeed, more like a distillation of mud than anything else', while of course for Dickens 'the fog filled every nook and corner with a thick dense cloud. Every object was obscured at one or two yards' distance.'

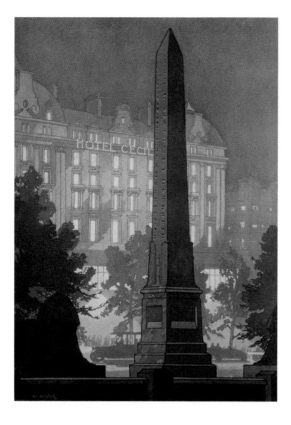

Left: An advertisement for
the Hotel Cecil featuring
Cleopatra's Needle, which
appeared in *The Sphere*,
23 November 1925.
Right: *The Nerves of the World*
(*c*.1930) by C.R.W. Nevinson.

When the fog was overtaken by the smoke and industrial pollution of the twentieth century there emerged the phenomenon of smog, as widespread and deadly as any disease. It was created out of chemicals rather than droplets of water; it was noxious, had a distinct odour and, unlike fog, persisted in the air. It affected the lungs, the throat, the heart and eyes. It could be grey or orange in colour, or yellowish brown as in the colour of sulphur. Sometimes it smelled sulphureous. In the Great Smog of 1952 it is estimated that four thousand Londoners died of its effects, and an unknown number became ill. Between 4 and 8 December, the measurements suggested that the PM concentration, or the amount of noxious particles in the air, was fifty-six times more than average and that the levels of sulphur dioxide in the air were multiplied by seven. On 5 December, the *Manchester Guardian* reported that 'the first real fog of the year has enveloped London today, an old-fashioned pea-souper: thick, drab, yellow, disgusting.' It was not a 'pea-souper', but something different. Smog was fog and mist compounded by atmospheric pollutants or

gases, often generated by the burning of coal and by the emissions both of industry and of transport. Its arrival in turn led to the Clean Air Act of 1956, which was meant to banish centuries of smoke. It was not wholly successful, since a smog returned to the capital ten years later. But the worst was over.

Rain is also the weather of London, the endless dank, misty rain that drifts across the city in grey or pearl-white clouds. The artist C.R.W. Nevinson noted in 1930 'the streets, shiny with rain, converted to canals far more romantic than Venice … silhouetted against blue mist buildings, more mysterious than any palaces, floating in atmosphere'. The buildings of London need the rain just as much as the grass and trees. They need its iridescence and its softness.

The same may be said of the mist embraced by Whistler and by Monet. Wilde observed that 'where, if not from the Impressionists, do we get those wonderful brown fogs that come creeping down our streets, blurring the gas lamps and changing the houses

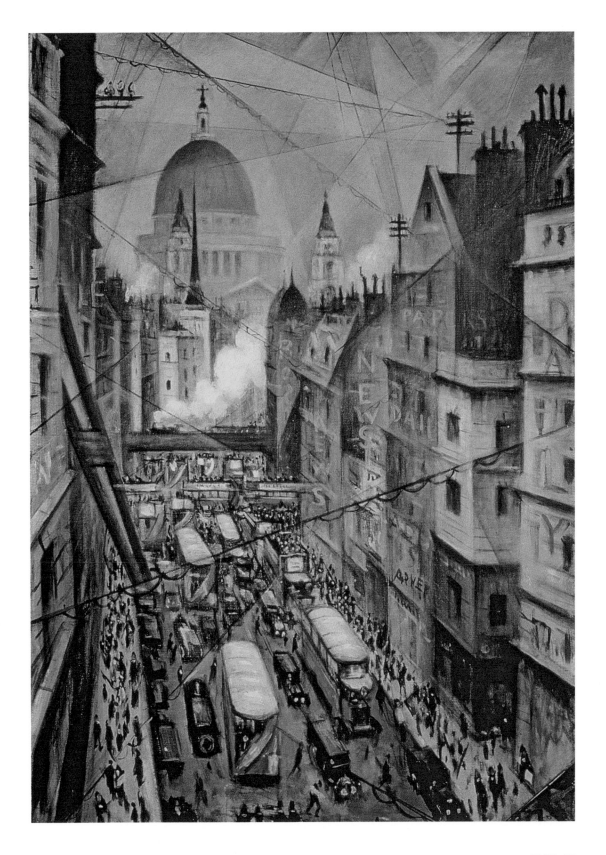

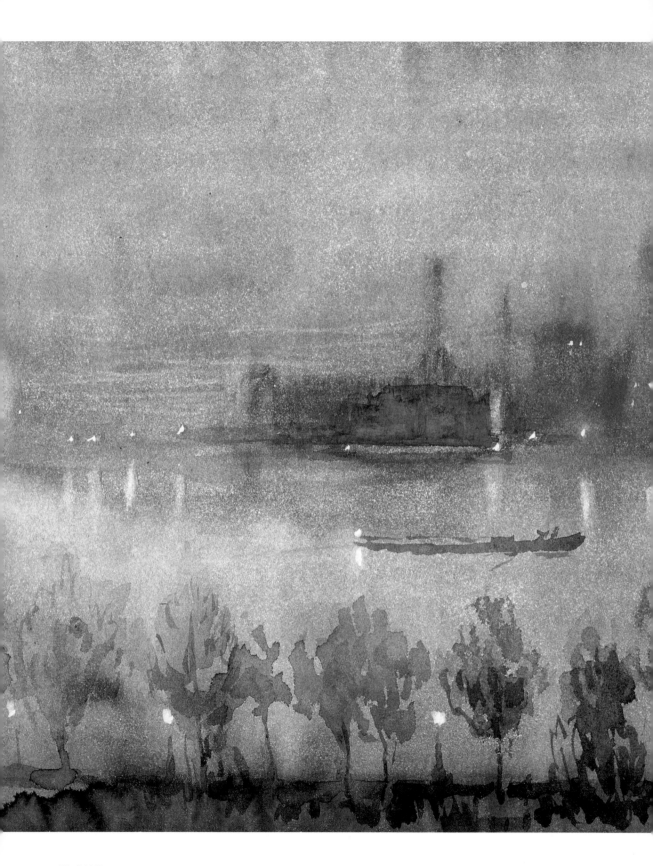

into monstrous shadows? To whom, if not to them and their master, do we owe the lovely silver mists that brood over our river, and turn to faint forms of fading grace curved bridge and swaying barge?' Whistler's commentary on the London mist is well known when he observed that it clothed 'with poetry, as with a veil, and the poor buildings lose themselves in the dim sky, and the tall chimneys become campanile, and the warehouses are palaces in the night'. The mist lingers on the river or floats among the trees. The mist of London is the poetry of London.

The London sky, like the weather, has different orders of magnitude. It is itself low, damp and tactile, part of the city itself and its thousand stray lights and gleams. The quality of cloud cover, which may or may not bring rain, and the subtle gradations of blue and violet in the evening sky, are sensible reminders of the unique atmospherics of the city. The prevailing wind is westerly or south-westerly so that the south and west facades of St Paul's, for example, have been cleansed and seem to be washed or weather-beaten. That westward passage of grey and white cloud can give the city enormous space and lightness so that the city itself seems to breathe. It is no longer a tangle of buildings beneath a narrow strip of sky but an open city whose tall buildings beckon towards the empyrean. There are also the vertiginous skies when at sunset the west is all on fire, reflected in the shifting mass of cloud. Outward

Left: *Blue Night, London* (c.1900) by Joseph Pennell.

events can also shape the sky. After the explosion of Krakatoa in 1883, for example, the sunsets of London were vivid in their flaring orange and red.

It is curious that, although there are days of cloudless sky in London, the sky in London paintings seems generally to contain clouds, dark or bright, dusky red or pearly grey, pink or violet or orange; they may be light blue or light yellow, turning to violet closer to the horizon; they are every hue or shade of blue from cobalt to cerulean, from indigo to ultramarine; some extensive cloud covers reveal a range of effects, from verdigris to ash and from lilac to turquoise.

But, then, is the Thames blue? The Thames is generally depicted as that colour on maps of the city, for example, when in truth it has a hundred different hues. It is also employed for reservoirs, canals and docks despite the evident and obvious variations in the real hue. Blue also replaces red in the symbols of the boats used by Transport for London, and it is some indication of the historical significance of the river that four underground lines are lent that colour. This may allude to the purpose of the river as the medium of movement, and perhaps to the presence of the subterranean rivers that weave through the underground system.

In the indispensable 'A to Z' maps of the city, the river is a light blue; but in paintings of the late nineteenth and twentieth centuries it is predominantly grey, silver or brown with glimpses or slivers of the fugitive blue. Whistler's *Nocturne: Blue and Silver – Chelsea* of 1871 portrays Chelsea from the Battersea shore. It was painted over a dark grey background with the thin layers of blue and silver pigments traced over the wooden panel so that it conveys both transience and luminosity. In the moonlight the sky and the water seem to cast light on one another, and the reflections of the bankside dwellings in the river lend that atmosphere of peacefulness with which blue is often associated.

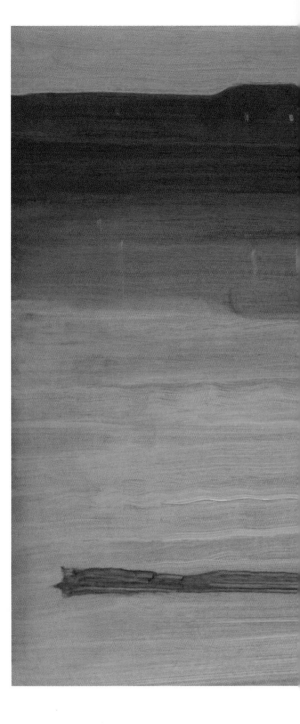

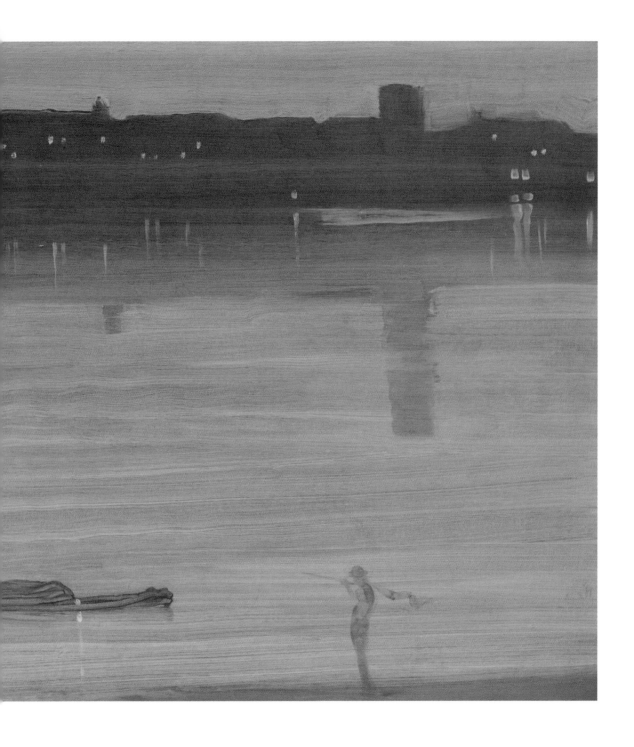

Above: *Nocturne: Blue and Silver – Chelsea* (1871) by James Abbot McNeill Whistler.

Overleaf: Colourized photograph of St Paul's Cathedral from the South Bank of the Thames, c.1875.

The colour of London cannot be separated from the permanent presence of the river, but its colour changes continually. Many of the great public buildings, from Somerset House to the Tower, take their hue from the restless water. The colours shift constantly, even at night, explaining Monet's lament on his Thames paintings concerning 'a succession of varying aspects! I had up to a hundred canvases on the go – for one single subject.' The Thames last froze in February 1895, when the white ice turned the river into what was once called a 'frost fair', and of course streaks and glimmers of white have always been part of the river's vocabulary, just as its ripples along the banks may take the appearance of white foam.

During the Second World War it became a lurid red river. On 7 September 1940, all the docks and warehouses, with the exception of Tilbury, were consumed in flame. Ships and barges were on fire, drifting dangerously in the tide against jetties and quays. The river burned so brightly that is could be seen from a distance of 19 kilometres (12 miles). On the following night it seemed to be no longer the Thames but a flow of molten lava from some unknown source. The water was covered with a thin blue film of burning oil, and billows of black smoke belched out from every part of the shore. The rum was also alight upon the water, and the warehouses of wool had become white furnaces. The London Pool – part of the Tideway of the Thames – was a lake of brilliance, and areas like Lambeth and Rotherhithe were bathed in a radiance that was like the light of day. When we contemplate the lost colours of London, these are some of the scenes that spring immediately to mind.

Depending on light and weather the colour of the contemporary river also changes continually, sometimes lightening under the impress of the sun and sometimes darkening as the sun retreats behind the cover of cloud. The light often plays on the surface of the water, creating sparkles or sheets of white and emerald greens surrounded by deep iridescent shades as well as the shadows of ripples caused by wind. From a distance it may seem light blue or emerald blue but on closer inspection it may turn to a muddy brown or a cloudy green. In some lights the blue is supplanted by a greyish green, while at other times it is a fathomless grey as reflection becomes absorption. The colours ripple and unfold, break apart and yield one to another. In the shadow of a bridge, it will sometimes seem to have become blue. Deep water emanates a light different from shallow water. The mass of buildings that has come to dominate both banks of the river seems to have taken on the task of reflection, leaving the river itself dulled; the original greens and browns of the Thames can no longer compete with the polychromatic variety all around it.

Yet the 'pea soup' of its deep waters is transformed into many unclouded hues as it makes its way towards the sea. It may seem purple changing to indigo. It can be the deepest green or the palest silver. In the early evening it can be both light and dark as the radiance

of the sky shifts, and with the approach of night it becomes black and gold. As the sun sets it can be transformed into a translucent sheet of brightness dappled with the shadows of buildings and bridges. It had once been described as 'the silver streaming Thames' or 'the silver-footed Thamesis', and that gleam has returned to the centre of the city. The water within the estuary of the Thames sometimes seems to be covered by a skin of phosphorescence, and the brilliant surface of the water breaks into a thousand points of light when it is disturbed. Now, in the first decades of a new century, it can never be wholly dark as it winds through London. The street lights, and the light blazing in innumerable adjacent buildings, keep it continually illuminated.

There are its bridges, also, that light its way. Cannon Street Bridge has been painted in a variety of colours, but now has settled in an olive green. Southwark Bridge is green and yellow, with piers of grey. Westminster Bridge is green, while the original Blackfriars Bridge was black before turning into green with its pillars bright red; the colour change was designed to deter suicides. Waterloo Bridge is constructed of Portland stone and grey Cornish granite, and cannot therefore be described as colourful, while Hungerford Bridge is decorated with white cables. The colour of Lambeth Bridge is black and red, while Vauxhall Bridge is red and yellow. Chelsea Bridge is red, white and blue, while Albert Bridge was first painted green and then yellow. Battersea Bridge was

last painted in black and yellow, but Wandsworth Bridge is decorated in varying shades of blue. Hammersmith Bridge is dark green and gold. But these bridges of contentment tend to change at night, when they are lit up by variously coloured illuminations. Yet the water below cannot be said to be blue.

The river itself can be neither safe nor peaceful, and the Thames is sometimes a treacherous ally of the city. There have been floods throughout the tempestuous history of both, and in the nineteenth century six major floods caused much destruction of life and property. The first recorded on film occurred at the beginning of 1928 when the tide peaked at its highest recorded level of 5.5 metres (18 feet and 3 inches). It was provoked by a number of causes. In late December of the previous year heavy snow fell in the Cotswolds where Thames Head is to be found; on New Year's Eve there was a thaw, followed by very heavy rain, which magnified the problem by doubling the amount of water rushing downstream. This was exacerbated by a high spring tide. On 6 January a storm in the North Sea created a tidal surge that raised the waters of the river even higher. There was of course no Thames Barrier to withstand the force, and the defensive walls of the Embankment were breached at Hammersmith and at Millbank. The embankment had been erected to a height of 2.4 metres (8 feet) to protect the capital, but the water rose by another 27.5 centimetres (11 inches). That was enough to ensure disaster. Just after midnight on 7 January, the familiar cry or wail of 'water's over!' went up.

The river itself can be neither safe nor peaceful, and the Thames is sometimes a treacherous ally of the city.

Twenty-three metres (seventy-five feet) of the Chelsea embankment were destroyed and the basement of the Tate Gallery, situated on the north bank in a perilous position, was flooded to a depth of 2.4 metres (8 feet); some important paintings (including those of Turner) were submerged. The area of Millbank itself was so badly affected that it had to be rebuilt; the old dwellings and warehouses were washed away or damaged beyond repair. The embankment near Lambeth Bridge also gave way against the river's attack, and the poor quarters of that bridge's Westminster side were devastated. The water in the streets reached a height of 1.2 metres (4 feet), and the basements of the houses were flooded at the cost of ten deaths. There were other fatalities in Hammersmith and Fulham. The narrow lanes, courts and alleys with their tenements, between Southwark and Blackfriars bridges, were also inundated. *The Times* reported that the 'police went door-to-door urging residents to leave. Many of them were taken away on carts … The water was rising so quickly that many who were roused from their sleep simply threw a blanket round their shoulders and made their escape in their night attire'.

The Times gave details of individual fatalities:

Some appear to have been drowned almost as soon as they were awakened. No warning reached the house, facing the river, in which four sisters named Harding lived until their basement bedroom was so deep in water that rescue was impossible. One youth who was drowned in a basement in Horseferry-road had been roused too late to escape by the normal means, for the weight of water held his bedroom door fast, and the window was equally useless as an avenue of escape, since it was closely barred. Efforts to bend the bars and let him out were made by a party of neighbours, and would have succeeded had the water risen less quickly. As their work near completion the rescuers, working already in water that reached

Right: Colourized photograph of the London floods of 1928.

their necks, heard his cries for help die away,
and soon the basement was quite full of the
muddy waters.

The *Manchester Guardian* commented on the
fate of public spaces and buildings. It reported that:

… at the Houses of Parliament the water
'cataracted' over the parapet into the open
space at the foot of Big Ben. The floods
penetrated into Old Palace Yard, which shortly
after one o'clock was about a foot under water in
parts. Flooding was worst at Charing Cross and
Waterloo bridges, where the river sweeps
round. Water poured over the Embankment,
and the road was covered in a depth of several
inches. At intervals along the Embankment stood
tramcars derelict and deserted. Later attempts
were made to tow them through the floods by
means of motor-lorries. Taxicabs and motor-
cars splashed along the far side of the road. The
public subway, Westminster Bridge, was flooded
to a depth of four feet.

The tunnels at Blackwall and Rotherhithe were also
under the water. The moat around the Tower of
London was filled for the first time in eight decades.
Parts of central London resembled Venice. Altogether
some four thousand Londoners were rendered
homeless. It seemed more than likely that the same

catastrophe could happen again, but in fact the great
flood of January 1928 was the last major inundation
of central London.

There is also the phenomenon of what came to be
known as 'the blue fever', instigated by the Oxford
and Cambridge Boat Race. The annual competition
between the two ancient universities has been
conducted for so long that it has become a national
institution to be seen on television or heard on radio,
or watched along the banks of the river itself. Yet its
previous popularity among all the citizens of London,
poor or affluent, has perhaps been forgotten. It had
been initiated in 1829 as a race from Hambledon Lock
to Henley, and this first race was the progenitor of the
Henley Regatta. The course was then moved to the
stretch of river from Wimbledon to Putney, but within
a few years the crowds of spectators became so large
that in 1845 it was taken upriver to run from Mortlake
to Putney. This new venue guaranteed its success.
From 1856 it has been held annually, except for the
period of the world wars.

By the middle of the nineteenth century it had
become something of a Cockney festival, perhaps
surprising for a race essentially between what were
known as 'toffs'. On an early April morning every
Londoner, or at least every young Cockney, seemed
to be involved with the 'light blues' (Cambridge) or
the 'dark blues' (Oxford). The Cambridge team were

about to wear white before the second race but a piece of 'Eton ribbon' or light blue was substituted for luck; it made the day and was preserved. The darker Oxford blue came from Christ Church College of that university. The day became a public holiday and the ribbons of variegated blue were fastened around the necks of costermongers' donkeys, tied around dust-carts, fastened to the whips of cab-men, or worn as scarves by boys selling matches or 'lucifers' and by other 'gutter children'. The river was filled with steamers and barges, launchers and rowing boats, packed with enthusiastic spectators; the towpaths and banks pullulated with mechanics, shop-keepers, street-sellers, families and the whole panoply of London life.

There are drawings and paintings of the railway and pedestrian bridges, packed to the point of danger, with the more courageous spectators perched high above the water on the parapets and arches. It had become a great popular ritual, and the combativeness of the medieval tilt-matches on the Thames had been transferred to this university pursuit. It had become part of what the Victorians knew as 'the battle of life'. The fastest time was achieved by Cambridge in a win of just over sixteen minutes in 1998; Oxford has proved victorious on eighty-one occasions, while Cambridge has come first on eighty-five, with one dead heat. It has been suggested that light blue is more joyous than dark blue. Yet in fact the racing honours are, more or less, even.

GREEN

‘the parks be “the lungs of London”’

Charles Dickens, *Sketches by Boz*

The colours of London from the air are grey and green, white and green, red and green. It is perhaps surprising that the photographs show a predominance, or at least a prevalence, of green in what is one of the most urbanized spaces in the world. But it has been calculated that London is made up of 47 per cent green space, so it has an honoured position as one of London's often forgotten colours. According to a recent land cover map taken from the Landsat satellite, 'over a third' of London's total area is 'semi-natural or mown grass, tilled land and deciduous woodland'. Once upon a time Brick Lane stopped abruptly in meadows, and Henrietta Street led directly into fields.

The ancient lanes emphasize the fact that the natural world, on which the city is laid, is green. It still glows in parks and squares and fields, in groves and woods, in gardens and rows of trees, and in all that is annihilated to a green thought in a green shade. That is, of course, the reason for its adoption by the environmental movement; it is believed to be a peaceful colour like its close neighbour, blue.

It may also be an abiding memory of a 'green and pleasant land', but it has always been a token of youth, hope and growth; in verse it is associated with joy and mirth. Green is also the colour most tranquil to the eye. Consider the shades from almond green to Amazon, from aquamarine to moss green. The London parks display green abundance with trees of lime and pear, rowan and horse chestnut. The green

leaves of the oak and the London plane are instantly recognizable, with the grass and moss as the carpet of health. In paintings they sometimes become the fluorescent stage or setting for a myriad of human activities, from lounging to flirting, from boating to sunbathing. To the alert observer, the trees and bushes are all of a different shade, while the swards of grass become varying pools of lightness on a spring morning. When the summer sun brightens the upper leaves and branches of the trees, light green and dark green dapple the landscape.

Chlorophyll, which turns light into energy, is derived from the Greek for a pale green leaf. It can be seen, therefore, as a conduit of life; in London many memorials of copper or brass or bronze are decorated with a patina of verdigris or vibrant green. There are twenty-seven shades of green with which birds are associated. If a person is said to be green, in English, it implies inexperience, while in German it suggests hopefulness. Green is the colour of youthfulness and fertility, of new life and expectation. The colour signal for 'Go' is of course a token invitation.

Yet green can also be the colour of bad luck. No boats on the Thames will be painted green, and no waterman or sailor will wear green, since it is believed to invite storm and lightning. Green must never be worn at weddings. It has also been denoted as the colour of jealousy and avarice, which might represent another aspect of the city. It can be seen as a symbol for poison. Green was associated with the colour of

Left: Eighteenth-century
illustration of Vauxhall
Gardens, Lambeth.
Right: *See Them in London's
Country* (1929), an
advertisement for London
Underground by D. Mullock.

money, and therefore with London, the green pound
note once at its centre.

But these associations have now been supplanted
by the garden squares, council parks, forests,
commons, cemeteries, heathlands and pathways
scattered through the city. This is not to forget the
number and variety of front gardens and back gardens
that are an integral part of London's life. The window
boxes and window pots should not be forgotten in
this array of green. The craze for 'window gardening'
in the 1880s represented only the most prominent
manifestation of the delight in green window dressing
to be seen in almost all prints of London from
generation to generation.

Albert Camus wrote, in the middle of the
twentieth century, that 'I remember London as a city
of gardens where the birds woke me in the morning.'
The first painting of a London garden was exhibited
in 1750. In the western area of London almost every
house either has its own garden or shares a communal
garden; in the southern suburbs, gardens are an
integral feature of the urban landscape. The London
allotments are an extension of the garden. In spring,
summer and autumn, the allotment is a carnival. The
scarlet flowers of the humble runner, the mottled
green of cabbage and other brassicas, the blue and
white petals of the broad bean, the cadmium yellow

of courgette and pumpkin flowers, the deep, woody
green of broccoli, with its strands of purple, and the
bright cream flowers of the potato are all arrayed.
There are tomatoes of course, but 'red' is too thin a
word for what may be seen. Here we have crimson,
scarlet, russet, striped, green, yellow and even black.
The glossy, black aubergine fruit has its trumpeters in
flowers of imperial purple. There are the white orbs
that grow on leeks after too long, like huge dandelions,
the lettuce pale as the May queen, the burnt red and
fruity green of rhubarb. And, most unexpectedly, the
passer-by will see great sunflowers crane and nod in the
middle of sunless London.

There are seventy-three 'secret gardens' within
the City itself, sometimes comprising only a few yards
of grass or bush or tree, many of them dating from the
medieval or Saxon periods. So we have the grey of the sky
and the green of the parks and the trees in the streets.
This apparently unpromising contrast represents, in
fact, an ideal complement, a perfect marriage. The grey,
oppressive sky brings out all the different greens from
the various shrubs, bushes and trees.

It has been suggested that the token of a great city
is the amount of space it gives to parkland. The notion is
not universally applicable, but it does apply to London.
The city has three thousand 'open spaces', and almost 20
per cent of the urban world is given over to grass, shrub,

tree and flower. In George William Joy's *The Bayswater Omnibus* of 1895 the various passengers, concerned with their own business, are seen passing the green vistas of Hyde Park or perhaps Kensington Gardens; they do not glance out of the window because such views are commonplace. Sometimes there was a more direct response. When the horse-drawn omnibuses, going from Notting Hill Gate to Marble Arch, travelled beside Hyde Park 'hands on the upper deck would greedily snatch at a twig to take to the City'. But, more than 125 years later, the general indifference to London's greenery is still the same. Only when the Londoner seeks out the parks and green spaces for rest, recreation or sunbathing, are they seen for what they are. They were once called 'the lungs of London', a metaphor that comes to life in the myriad green acres of Hampstead Heath, Regent's Park, Green Park, Victoria Park, St James's Park and countless others. Monet's painting of *Hyde Park* in 1871 was painted from the vantage of a slight hill, on what seems to be a cloudy morning in spring when the light gently amplifies the different shades of the grass and bush. The clothes of the strollers are in a darker hue so that the various greens are more visible. It is a peaceful setting, offset by the buildings of the contemporary city in the background of the scene. The grass and trees closest to the spectator are more intense but the vista turns to a paler green as it moves towards the urban fringe. The park itself gives an impression of great size, and in fact it is the largest royal park in central London.

Female bicyclists became fashionable in London parks through the 1890s, and they also took full notice of their surroundings. They often dressed in green

Right: *The Bayswater Omnibus*
(1895) by George William Joy.

as the most appropriate costume. A print from *Vanity Fair* of 1898 is entitled 'Society Ladies Cycling in Hyde Park'. It depicts ladies dressed in mutton sleeve jackets and full skirts in forest green or Lincoln green together with sailor hats or more picturesque, if still discreet, headwear. There was a slight change in fashion with the introduction of the tailored jacket and the skirt cut long in the front, but green was still the predominant colour.

The trees of London are also a token. Ford Madox Ford once observed that 'London begins where tree trunks commence to be black'. But that is not altogether true. The plane tree is London's own tree because it has the ability to slough off its sooty or darkened bark. There are photographs of horse chestnuts in Watford and of cedars in Highgate.

Yet the greenest or the most intense green spot in London was the fruit and vegetable market of Covent Garden. It became the most famous market in England and, given its unique trading status in the capital of the world, it was endlessly reproduced in drawings, engravings and paintings. Once it was truly a garden, filled with herbs and fruit, and soon became the kitchen garden of Westminster Abbey. But the market itself sprang from the desire to build an ornamented and ornamental piazza or square in the suburbs of the old City. On the south side of the square, beside the garden wall, sprang up a number of sheds and stalls selling fruit and vegetables. In 1670 the Bedford estate, which owned the land, obtained a charter authorizing a market 'for the buying and selling of all manner of fruits, flowers and herbs'. Thirty-five years later, permanent single-storey shops were set up in two rows. Gradually, inexorably, the market spread across the piazza.

By the middle of the nineteenth century its whole aspect had changed. In 1830 a permanent market, with avenues and colonnades and conservatories in three parallel ranges, was completed with vegetables to the south, fruit to the north and flowers to the north-west. It became customary for Londoners to come and look upon the cut flowers, stealing a few moments from the grey London day to 'drink in' the colours. They gazed at the daffodils, roses, pinks, carnations and wallflowers

while all around them was the usual noise and uproar of the porters, traders and customers. Wheelbarrows were filled with cabbages and turnips and carrots and coconuts, alongside mobile stalls with apples and pears and strawberries and plums. It offered a sanctuary of colour and brightness in what had become central London.

The social historian Henry Mayhew commented that:

> ... on a Saturday – the coster's business day – it is computed that as many as 2,000 donkey barrows, and upwards of 3,000 women with shallows and head-baskets visit this market during the forenoon. About six o'clock in the morning is the best time for viewing the wonderful restlessness of the place, for then not only is the 'Garden' itself all bustle and activity, but the buyers and sellers stream to and from it in all directions ... The sky is red and golden with the newly-risen sun, and the rays falling on the fresh and vivid colours of the fruit and vegetables, brighten up the picture as with a coat of varnish.

Mayhew also noted the multitude of colours with:

> ... the broccoli tied up in square packets, the white heads tinged slightly red, as it were, with the sunshine, – the crimson love-apples, polished like china – the bundles of white glossy leeks, their roots dangling like fringe, – the celery, with its pink stalks and bright green tops – the dark purple pickling-cabbages – the scarlet carrots – the white knobs of turnips – the bright yellow balls of oranges, and the rich brown coats of the chestnuts – attract the eye on every side. Then there are the apple-merchants, with their fruit of all colours, from the pale yellow green to the bright crimson.

Left: Colourized photograph of Covent Garden Underground station, c.1927.

Here were cabbages from Battersea and onions from Deptford, celery from Chelsea and peas from Charlton, asparagus from Mortlake and turnips from Hammersmith. The palest shade of green to the richest and deepest hue of that colour were everywhere. Everything was in life and motion, from the young boy struggling with a basket of green apples to the middle-aged female trader who portioned out her deep green herbs in bundles. Greenness was generally considered to be a sign of freshness, cleanliness and health.

A guidebook of Victorian London notices of Covent Garden that 'in January, bouquets of geraniums, chrysanthemums, euphorbias, and other flowers, may be had at two shillings and sixpence, and five shillings each, and violets at sixpence a bunch.' The panorama should also include the flower girls with their primroses, the flagstones stained green with the vegetables crushed beneath hurrying buyers, the pinpoints of gas light illuminating the shops in the shadow of the arcades, the bundles of rhubarb and more exotic fruit; it was said that you were more likely to find a pineapple in Covent Garden than in Jamaica or Calcutta. But despite the bustle of business there was no uproar, only a low murmuring hum like that of an interior sea.

It was a favoured theme of novelists and poets. In *Little Dorrit*, Charles Dicken described it as 'a place of past and present mystery, romance, abundance, want, beauty, ugliness, fair country gardens, and foul street gutters; all confused together'. In *The Picture of Dorian Gray* Oscar Wilde describes how 'a long line of boys carrying crates of striped tulips, and of yellow and red roses, defiled in front of him, threading their way through the huge jade-green piles of vegetables.' Colour photographs of the Market in its final days at Covent Garden show the lighted interiors of shops, where outside are piled great heaps of green Brussels sprouts and white cauliflowers, or of orange satsumas, tangerines and clementines. In the early morning are stacked large cardboard boxes of asparagus or potatoes, together with bouquets of various flowers wrapped

Right: *Covent Garden Flower Market*, colour lithograph by Edward Bawden, from *The London Market*, 1947.

in cellophane. The Central Market with pillars and window frames of pale green iron, is packed to bursting with produce. The Apple Market accommodates fruits and vegetables, while the Floral Hall is the space where foreign fruits are sold. The primary colours are pale green, pale blue, brown and white.

The porters still balanced boxes, seven or eight at once, on their heads. Others carried bundles of carrots and cabbages, or dragged wooden carts piled high with mesh bags of green bananas or runner beans. There were watercress growers and sellers of strawberries. Boxes of 'Year Round Chrysanthemums' were stacked beside 'Guernsey Flowers'. The dress was colourful and casual but, in the fifties, the porters wore plain trousers and tweed caps while the salesmen wore bowler hats and stiff collars.

The New Market, as it was paradoxically known for 140 years, flourished on this hallowed site until it was removed to Nine Elms in Battersea where it continues to this day. The bustle of the old trades has gone from Covent Garden but the spirit of the market survives in the new life of the piazza where the street musicians, jugglers, acrobats, as well as the shops and restaurants of the present consumer period, still thrive.

It is perhaps less well known that the suffragettes of the early twentieth century chose green as one of their primary colours. They might be said to have anticipated the equally controversial movement of the environmentalists. On Sunday, 21 June 1908, the largest demonstration ever known in London was held at Hyde Park. It became known as 'Women's Sunday' because the thousands of women assembled there were demanding that females (or their 'sisters' as they were sometimes known) should be allowed to vote in national elections. An official programme and souvenir was printed, with its clear headline of 'Votes For Women'. Mass meetings were held in Caxton Hall and the Royal Albert Hall, while Trafalgar Square was filled to capacity. All the royal parks, and even Brompton Cemetery, were overflowing. In other processions and demonstrations in various regions and different cities, 'suffrage processions' were flanked by policemen and led by brass bands.

Five months earlier, the House of Commons blocked a woman's suffrage bill after its second reading, so the mood and temper of the demonstrators was already at a high pitch. The banners themselves were often incandescent. A red image of the 'Bugler Girl', looking very much like Britannia, was outlined in red and orange with 'WOMEN'S SUFFRAGE' emblazoned across it. Hundreds of banners, and scores of marching bands, accompanied the protests so that London was considered to be in 'turmoil'. Some banners represented the National Union of Women's Suffrage Societies while others displayed images of such notable women as Jane Austen, Florence Nightingale and Queen Victoria. Various groups of eminent females also took part in the marches, including doctors, teachers and actors. The crowds in Hyde Park and elsewhere were immense and

almost overwhelming. Some were titled, some were the wives and daughters of prominent business men and parliamentarians, while others were of the poorer sort. One seller of muffins, who was used to street life, had a placard stating that 'We Can Make Things Hot For You'. The colour prints and engravings show a variety of colours and styles, with yellow and red, violet and green, as the favourite combinations. But the green was striking. Some participants wore elaborate dresses and fanciful hats, while others were more plainly dressed; some wore tartan, and others wore ties to emphasize their attempts to rival their male contemporaries.

For the demonstrations of 1908 the official colours were purple, white and green. As one of the driving forces of the movement, Emmeline Pankhurst, stated, 'purple … stands for the royal blood that flows in the veins of every suffragette … white stands for purity in private and public life … green is the colour of hope and the emblem of spring'. Women were asked to sport these colours 'as a duty and a privilege'. The three colours were displayed on hat ribbons, badges, bags, shoes, dresses and even bars of soap. Selfridges and Liberty were among department stores that stocked such items. But green was everywhere. The song sheets, the banners, the handbills and the placards were all decorated or embellished with the colour. The point was that the suffragettes were eager to display their sense of new life as well as their radicalism and fervour. They were well-dressed

members of what were known as the 'middling sort'. In the same year as the demonstrations, the newspaper, *Votes for Women*, suggested that 'The suffragette of today is dainty and precise in her dress.'

A mass meeting in Manchester was decorated with flags and banners displaying slogans such as 'Thro' Thick and Thin When We Begin', 'Arise Go Forth & Conquer', 'The Bill, the Whole Bill, Nothing But The Bill'. The *Evening Standard* of London published a photography of women standing beneath a banner citing 'Women's Will Beats Asquith's Won't'. The images of marchers and protesters were often delineated against a background of green.

It is unsurprising that the suffragist movement grew in the Edwardian era or that it became more radical in character. In 1903 Emmeline Pankhurst, along with her daughters, Christabel and Sylvia, established the Women's Social and Political Union. The WSPU differed from previous suffragist organizations. 'We resolved to limit our membership exclusively to women', Pankhurst declared, 'to keep ourselves absolutely free from party affiliation, and to be satisfied with nothing but action. "Deeds, not words" was our motto'. When the *Daily Mail* derisively dubbed WSPU members 'suffragettes', they confidently appropriated and altered the term, pronouncing it 'suffra*gets*', to emphasize their determination to obtain the vote. What the suffragettes wanted to 'get' was not a vote for every woman, regardless of class and property, since this was also denied to men. They demanded

that their sex ceased to be a disqualification for the franchise. Votes on the same terms as men would enfranchise only middle-class female householders. Establishing the principle of votes for women was the key issue.

In the autumn of 1908 *The Times*, under the headline of 'THE SUFFRAGISTS, RIOTOUS SCENES AT WESTMINSTER', reported that:

> …extraordinary scenes were witnessed last night at Westminster. The militant suffragists attempted to fulfil their threat to 'rush' the House of Commons, and elaborate police precautions were necessary to prevent them from carrying out their object. The main 'attack' was delivered by determined bands of women at the junction of Victoria Street near the Westminster Hospital. Here a series of conflicts with the police took place, when 23 women and 12 men were arrested. Early in the evening a suffragist created a sensation by entering the House of Commons and making her way up the floor towards the Speaker's chair.

Two years after 'Women's Sunday' the ranks and financial resources of the suffragettes had grown rapidly. Yet the growing strength of the movement did not result in greater parliamentary influence. Some backbenchers openly mocked the idea of women voting, while the leading figures of the day were divided on the issue. Asquith believed that women's 'sphere was not the turmoil and dust of politics, but the circle of social and domestic life.' His wife and daughter, who as aristocrats did not require the vote to wield political influence, shared his contempt for 'petticoat politics', and physically restrained suffragette protestors who attempted to approach him. The king also dismissed the suffragettes as 'dreadful women'. On the other hand, Balfour and Lloyd George expressed guarded sympathy for the cause, while some Labour MPs championed it despite the ambivalent official response of their party.

From 1911 onwards the suffragette movement became more militant. Activists set post boxes alight, chained themselves to railings, broke the windows of shops and male clubs, and destroyed public flower beds and slashed cushions on trains. They also wrote graffiti on public buildings, and vandalized paintings that depicted women as objects of male desire. Not all suffragists advocated these tactics, yet Emmeline Pankhurst was convinced that violence was the only option. From 1913 suffragettes also carried out arson attacks, setting light to some 350 buildings over the next eighteen months in a carefully organized campaign. Leading suffragettes supplied instructions and flammable material to the incendiaries, who manufactured crude bombs and left them in prominent public places. Some of the devices failed to explode, but others damaged buildings, including Lloyd George's house.

'Green is the colour of hope and the emblem of spring.'
Emmeline Pankhurst, 1908

Right: Handbill advertising
the Women's Coronation
Procession on Saturday,
17 June 1911.

On 4 June 1913 Emily Davison provided the campaign with its most potent symbol. Striding out on to the race track during the Epsom Derby, she was knocked down and killed by a horse belonging to George V. Some historians suggest that Davison intended to pin a green suffragette banner or rosette onto the animal, but there is a strong possibility that she was intent on martyrdom. 'To re-enact the tragedy of Calvary for generations yet unborn,' Davison had written in a newspaper article, 'is the last consummate sacrifice of the Militant.' Immediately after Davison's death, the suffragettes claimed her as a martyr; over fifty thousand sympathizers attended her funeral.

The weak Liberal government once again found itself in unknown territory; once again, its instinct was to respond with coercion. Asquith imprisoned approximately one thousand suffragettes, while denying them the status of political prisoners. This prompted many of the incarcerated women to go on hunger strikes. Fearing that they might die in prison and be applauded as martyrs, he insisted they be strapped to chairs and fed via tubes inserted into their stomachs.

The treatment of the suffragette prisoners caused public outrage. In the Commons the recently elected Labour MP, George Lansbury, told Asquith that 'you are beneath contempt ... you will go down in history as the man who tortured innocent women.' The prime minister responded to criticism with legislation, just as he had done during the recent strikes. He introduced a bill that put an end to force-feeding in prison, and

allowed enfeebled hunger strikers to be released temporarily in order to recover their health at home, before resuming their sentences. The bill became known as the 'Cat and Mouse Act', after the cat's fondness of toying with its prey, and the Liberals accompanied it with a counter-propaganda campaign. They caricatured the suffragettes as a small group of wealthy and unbalanced eccentrics intent on subverting law and order, rather than a mass movement with a popular political agenda.

Some historians argue that the government's response was effective in the short term; the suffragette campaign decreased in militancy and extent in the early months of 1914. Yet government repression had undoubtedly aroused public sympathy for the women; it also gave their cause invaluable publicity. From a modern perspective, it is the brutality of the Liberal government that is conspicuous along with its myopia. 'Those who read the history of the movement,' Emmeline Pankhurst predicted, 'will wonder at the blindness that led the Government to obstinately resist so simple and so obvious a measure of justice.' And of course their own green movement prevailed.

A poster advertising the Festival of Britain in 1951 is conceived in different shades of green as a means of emphasizing its novelty and its clean break with the past. It suggests green shoots and green growth. On 3 May 1951, it was opened by George VI at a service

THE PROCESSION will march to Kensington, where great meetings in the ROYAL ALBERT HALL and in the EMPRESS ROOMS will be held by the Women's Social and Political Union, at 8.30 p.m., in support of the Woman Suffrage Bill.

Speakers :

Mrs. PANKHURST, Mrs. PETHICK LAWRENCE, Miss VIDA GOLDSTEIN, Miss CHRISTABEL PANKHURST, and others.

Tickets for the Meeting in the EMPRESS ROOMS for Numbered and Reserved Seats, price 2s. 6d. and 1s., can be obtained from The Ticket Secretary, W.S.P.U., 4, Clements Inn, W.C.

For all further plans and particulars read the weekly newspaper VOTES FOR WOMEN. (Price One Penny.) It can be obtained at all newsagents and bookstalls.

Printed by ST. CLEMENTS PRESS, LIMITED, Portugal Street, Kingsway, London, W.C.

OF SCIENCE

19 51

SOUTH KENSINGTON

of dedication beside the Royal Festival Hall which, as
the name still suggests, was the centre of what was
supposed to be the greatest national display since the
Great Exhibition one hundred years before. But it did,
in fact, have one more recent predecessor.

The British Empire Exhibition of 1924 was in part
devised to boost morale in a country still deflated
after victory in the First World War. The pleasures
of peace had dissipated soon enough. England's
economic success had come to an end abruptly, 'like the
stopping of a clock,' as one contemporary put it; the
country's industrial activity fell sharply and as a result
unemployment rose above two million. Japan and the
United States were already racing ahead of the newly
created United Kingdom. Something had to be done
to bolster morale.

So, in 1920, the administration decided to site a
British Empire Exhibition at Wembley Park in north-
west London; it was designed as both entertainment
and celebration. It was to strengthen the ties within the
various countries of the Empire and to assert England's
pre-eminent status, while at the same time acting as a
fairground and circus for a domestic public. It was also in
part supposed to be a trade exhibition in order to revive
a flagging economy. In the official language its purpose
was 'to stimulate trade, strengthen bonds that bind
Mother Country to her Sister States and Daughters,
to bring into closer contact the one with each other, to
enable all who owe allegiance to the British flag to meet
on common ground and learn to know each other'.

It took four years to conceive and complete.
Two thousand men were employed in constructing
the Exhibition buildings during 1923–4, each of which
displayed the culture of a component nation. The Indian
pavilion, for example, was decorated with towers and
domes, while the West African pavilion resembled an
Arab fort; the Burmese pavilion became a temple and
the South African building was a paradigm of Dutch
architecture. Others were devoted to the products
and designs of Australia, Canada, Fiji, Newfoundland
and Palestine along with fifty other imperial territories
including Malta and the Falkland Islands. It was in many
respects an extravaganza of power and domination
stretching over more than 80 hectares (200 acres).
It also housed palaces of Engineering, Industry and
Arts, and something known as the HM Government
Building that contained a series of historical scenes
and pageants. The structures were built of reinforced
concrete, then known as 'ferro-concrete' and the
complex became known as the first 'concrete city'
in the world.

In addition, a 'great national sports ground' was
designed for the occasion, and in 1923 became the
Wembley Stadium. The stadium could accommodate
125,000 people, and was considered to be an amalgam
of imperial Roman style and the architecture of the
Mughal Empire of seventeenth and eighteenth century
India. The emphasis was clearly on Empire itself. It was
appropriate that the Exhibition's roads were named
by Rudyard Kipling. Various kiosks were in place in

Above: Site map for the
British Empire Exhibition,
Wembley, 1924.

order to entice customers for specific products, such as cigarettes or tea, the most famous of which was the Pear's Palace of Beauty sponsored, of course, by Pear's Soap. One of its attractions consisted of ten separate sound-proofed glass rooms in which sat an actress impersonating a famous beauty of the past; among them were Helen of Troy, Cleopatra, Mary, Queen of Scots and Nell Gwyn.

There were other attractions for those who were not interested in history of whatever hue. Fair rides such as the Chute, the Dodgem, the Racer and the Flying Machine were available. The sign above some of them read 'Please Hold Your Hats'. In an era when hats were indispensable, ranging from the male bowler and straw hat to the female cloche hat, the advice was invaluable. Two miniature railways were also in operation, one of them advertised as 'the never-stop railway'. In cinema broadcasts a circus, complete with clowns and elephants, can be seen entertaining the crowds; bands, pageants, parades, choirs, tattoos and fireworks were part of the extensive and intensive entertainment. It must have been hard to know whether it was a jamboree or a serious display of imperial administration.

The Exhibition was officially opened by King George V on 23 April 1924, which was of course St George's Day. He pressed a gold button and announced that this was an exhibition to 'show off the fruits of Empire'. The king also despatched a telegram that circulated the world in, what was then, an astonishing one minute and twenty seconds before being given back to him by a messenger boy.

The entire cost came to twelve million pounds, and was undoubtedly the largest exhibition ever staged in London. It attracted twenty-seven million visitors, at price of 1s 6d for adults and 9d for children. On one productive day, some three hundred thousand visitors were admitted. Nevertheless it was not a financial

AUSTRALIA PAVILION FROM LAKE.

Above: Postcard illustrating the Australia Pavilion at the British Empire Exhibition, Wembley, 1924.

success. The project ended that season without making any profit and, in an attempt to raise more money, a decision was made to extend the life of the Exhibition by reopening it in 1925. This second coming was even less fortunate and *Variety* claimed that it was the world's biggest outdoor failure.

But not all was lost. Many of the concrete buildings lasted into the 1970s, and of course Wembley Stadium (rebuilt in 2002) became the greatest fixture in the country's sporting calendar. Yet in a sense it was a wasted effort. The long, low, withdrawing murmur of Empire continued as more colonies asserted their independence, while the General Strike of 1926 emphasized the political and economic decline of the country. The British Empire Exhibition of 1924 was a 'last hurrah' on a grand scale.

The times were quieter for the Festival of Britain in 1951, pockets shallower and the people less inclined to triumphalism, but the bunting fluttered and the beer flowed. The Festival inaugurated, too, the establishment of the South Bank as one of London's cultural centres. Beside the Hall stood the great Dome of Discovery paired with the Skylon, a cigar-shaped steel tower that had no real purpose except for being there. They became the instant visual symbols of the Festival itself. A director of the demolition company that was eventually to dismantle both the dome and the Skylon, noted that 'it was a phallic symbol really, the

dome and the thrusting spire. Every exhibition has to have something like this'. The Dome of Discovery, the most dramatic contribution to the site, was the largest dome in the world at that time and in fact represented a remarkable technical accomplishment.

Battersea Park was used to accommodate the Festival Pleasure Gardens, designed with help from Osbert Lancaster, John Piper and others. With its amphitheatre, grotto, fountains and beer gardens, along with a tree-walk and a miniature railway, it proved to be a great success and renewed the atmosphere of the eighteenth-century gardens of Vauxhall and Ranelagh that had also adorned the banks of the Thames. It was another way of incorporating and redefining the green history of the city.

Hugh Casson, the director of architecture for the Festival remarked that it was:

> ... a device, really, for getting the South Bank done. Herbert Morrison, a tremendously keen South Londoner, had said that 'nobody goes to the South Bank, they try not to go to the South Bank, it's because it's nothing but mud and rotting wharves, and rubble, and industry, and warehouses, misery and poverty, and railway lines. And we must clear it up.' This was about October, and we were rather excited about this. And we went down, and it was, in fact, a very romantic place. There was no embankment wall. There was one tree, which is still there, near the

Festival Hall now. It was bisected by a railway line, and, under the arches, were people bashing out mudguards and selling disused motor bikes and that sort of thing. And the railway divided the site almost exactly in half.'

One director of the Festival offered a note of caution. He remarked that 'one mistake we should not make, we should not fall into the error of supposing we were going to produce anything conclusive. In this sceptical age, the glorious assurance of the mid-Victorians would find no echo'. The results, however, were considered to be satisfactory. Harold Nicolson wrote that he and his family were 'entranced from the first moment. It is rather a nuisance that we keep on running into the King and Queen, but nevertheless we enjoy it uproariously. It is the most intelligent exhibition that I have ever visited. I have never seen people so cheered up or amused, in spite of a fine drizzle of rain.'

In an essay for the occasion Michael Frayn wrote that 'it quickly became clear that the South Bank, conceived in austerity and shaped by expediency, was a knockout. For two or three evenings the police had to close the streets round the Embankment to traffic, as the crowds poured down to gaze at the floodlit dream-world breathing music on the other side of the river. The *Manchester Guardian* reported that 'people making for the South Bank begin to smile as they come close to it'. The newspaper also suggested that 'on bright sunny days it seems likely that a trip across the Thames to the South Bank will be as invigorating as a trip across the Channel.'

This was also a world of display. It was as if colour had entered the monochromatic world of the past decade. Murals had been created on the walls of the Dome, together with paintings of notable figures such as Edward Lear, Florence Nightingale and Lewis Carroll's Alice. Carnival rides, fireworks and coloured balloons filled with helium, contributed to the setting. The entertainments were illuminated at night, and the Skylon was lit from its interior. As the art critic, William Feaver, put it, a landscape was introduced of 'indoor plants, colour-rinse concrete, lily-of-the-valley splays of light bulbs, canework, aluminium lattices, Cotswold-type walling with picture windows, flying staircases, blond wood … all these became the Festival style.' A correspondent for *The Sunday Times* reported that:

… for many years now Londoners, when wishing to introduce a note of colour into description of their city, have fallen back on the famous red omnibuses. Delightful they are too, but when massed colour, all skilfully designed and harmonised, is suddenly spread before the eyes, the idea comes that London can take it exceedingly well. The Festival gardens are full of beautifully graduated colour, and it is very refreshing. The riverside theatre in particular is exquisite, light, gay, perfectly suited to its purpose; if the weather is kind, evening performances there, poised on the edge of the Thames, should be memorable.

Another journalist commented that 'clean, bright and new … It caught hold quickly and spread first across London and then across England …. In an island hitherto largely given up to gravy browns and dull greens, "contemporary" boldly espoused strong primary colours.' Dull russet had given way to vivid green. And that image of green, as the token of hope and celebration, persists. It is now universally recognized that green is the colour associated with

Right: A view of the Festival of Britain site on the South Bank, 1951.

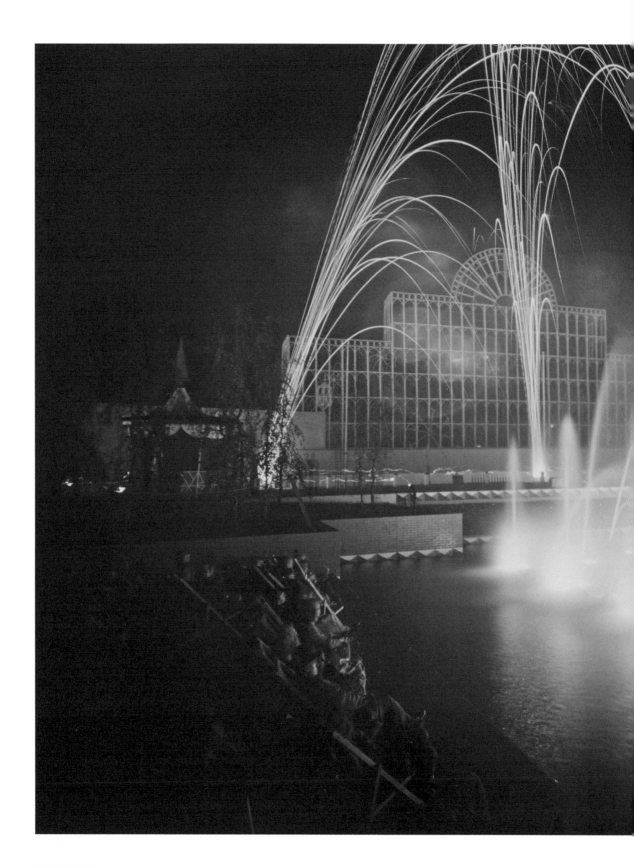

those who wish to preserve the natural world. It has come a long way.

The Festival of Britain may not have been as magnificent or as successful as its predecessor in 1851, and it may not have quickened national enthusiasm in the manner of grandiose royal spectacles, but it brought a little cheer to a country that was still badly damaged by the recent war and still struggling under the burden of food rationing. A nation that had endured six years of conflict, with the attendant gloom and apprehension, revealed that it had not lost its appetite for display and celebration. A people curbed by years of total war and half-crushed by austerity and gloom, showed it had not lost the capacity for enjoying itself.

Dylan Thomas was ecstatic about the experience when he remarked that 'what everyone I know likes most in it is the gay absurd irrelevant delighting imagination that flies and booms and spurts and trickles out of the whole bright boiling'. *The Daily Telegraph* struck a more sour note when it noted that 'it may perhaps be likened to a moderately successful party, but one held on the wrong day and at far too great a cost. We are none the sadder for it, but we might have been wiser to have kept the money in our pockets.' The actual cost was just over a relatively modest figure of eight million pounds. Some eight and a half million visitors attended in the five months of its existence. It was considered to be a pageant of enterprise and of celebration, which, it was hoped, would act as a mirror for the future and a perspective of the past. It has now largely been forgotten, but is commemorated in the Royal Festival Hall, which at night still lights up the South Bank.

Left: The illuminated fountains in the Battersea Pleasure Gardens, created as part of the Festival of Britain celebrations, July 1951.

RED

...

'Am I red tonight?'

Charles Dickens, *The Uncommercial Traveller*

Red has often been considered to be London's true colour. It is the colour of power and the colour of avarice. 'Red' was the Cockney slang for gold itself, and is highly appropriate for a city established upon money and finance. Red is the colour of fire, to which the city was for many centuries susceptible. Red was also the colour of violence, for which the city has always been known. It is emblematic of pomp and war. It is also suggestive of sin or transgression, as if moving forward in the face of a red light.

The cabs of the early nineteenth century were red. The pillar boxes and the remaining telephone boxes are still red. The buses are red, and the underground trains were until recently of that colour. The first-class stamps on letters are red, and so are the vans that collect them. There is a deep affinity between red, blood, communication and circulation. Red is the obvious visual indication of the link between the physicality of the human body and the physicality of the city. Laboratory tests have demonstrated that if a subject is wearing a blindfold, his or her pulse will quicken in the presence of red and decrease in the presence of blue. Red may increase the heart rate and quicken the functions of the brain. Waitresses wearing red are likely to be given larger gratuities. Red is the emblem of 'reality' and blue of 'ideality'.

Red brick and terracotta lent its radiance to the streets. London may not be enhanced by red, but is partly constructed from it. The colour is even in the ground itself; the bright red layers of oxidized iron in the London clay identify conflagrations that occurred over two thousand years. Red is aggressive. Red is in earnest. It was the first colour to be discovered and named. The animal blood of cave paintings suggests this. Because the focal point of the colour lies just behind the retina, red always seems closer than it is.

The buses of London have been red for longer than anyone can remember. When the first tramlines down Pentonville Road from Angel to King's Cross came into operation during 1883, the earliest trams were of that colour. The early motor-buses of the 1900s, with open upper decks, were also red. The red bus has been ubiquitous ever since, evinced of course by the illustrious Routemaster. Of all London buses, this red double-decker has become the most familiar. The first experimental model was fashioned in September 1954 and the last bus was delivered in 1968. Its working life was in fact much longer. It came into regular service with London Transport in February 1956 and the last were withdrawn from circulation in December 2005. Within a short time, however, it had come to represent the public transport of the city.

It was not at all unusual in design. It had a permanently open step entrance at the back as well as a driver's door at the front. It was approximately 9 metres by 2 metres (30 feet by 8 feet) and could

accommodate some sixty-four passengers, with more standing, and had what is today the luxury of a bus conductor. It was safe and relatively comfortable, with the added advantage of a street view from all angles; those on the top deck, at least those beside a window, could see the city flow a few feet below them.

The Routemaster was in fact celebrated as one of Britain's ten major design successes, along with other striking productions such as Concorde and Harry Beck's map of the London Underground, and it was put on display at the Earl's Court Commercial Motor Show in 1954. Its familiar red signified its orthodoxy as well as its novelty. It had been envisaged as a suitable replacement for the trolley-bus, which was taken off the roads in 1962 and is now only to be found in transport museums. Its only problem lay with the open platform at the rear, which allowed both entrance and exit. It was exhilarating for those with energy and speed, since it allowed the passenger to jump on and off at any convenient opportunity; a halt in a traffic jam or at a traffic light would persuade many to jump off, while it was common to see late arrivals pursuing the bus and leaping onto the platform before it gathered too much speed. This was, for many, the most interesting era of modern transportation. But in a later period, which treasured 'health and safety', it was considered too great a risk, and closed buses with a folding entrance in the front or middle became standard. The old buses did enjoy a reprieve, however, when they were refurbished and renovated; they had new engines and new interiors. Yet the Routemaster continued its withdrawal from public service with the introduction of driver-only vehicles and single-deck buses. Whether they were more suitable for urban traffic is open to question.

The last scheduled service came to an end on 9 December 2005, when *The Daily Telegraph* saluted its passing with an encomium to:

Above: Traffic on Whitehall, 1968.

Above: Harry Beck's map of the
London Underground, 1935.

… the yellowed interiors, uncomfortable seats and low ceilings that bear witness to a bygone age of small, malnourished men in raincoats smoking on the top deck. Their lurching motion and open platforms seem to salute the right of every free-born Englishman to break his ankles trying to jump off a bus when drunk. They could not long survive in the age of the Oyster card, Londoners' new electronic season ticket. What price a clippie if he has nothing to clip? For many of us, the requiem for this beloved object will be a Flanders and Swann song, hummed quietly as we pass over Westminster Bridge: 'Earth has not anything to show more fair. (Any more fares? Any more fares? Any more fares?)'. It is with affection that we'll remember 'that monarch of the road'.

Routemasters had been so popular that they were purchased second-hand by other urban authorities and were to be seen in cities as diverse as Blackpool and Glasgow, Manchester and Southampton. They were stripped of their London red, however, and were decorated in various colours to display their new local identity. Some of them were in use until the summer of 2000, but after that time they were principally employed as novelty items. In London itself a few were also reclaimed as 'heritage buses' for the tourist market. Yet the old bus was not forgotten. A new model was introduced in 2012, named as the 'New Bus for London' and subsequently as the 'New Routemaster'. By December 2017, the fleet numbered one thousand. It exemplified what may be called the Darwinian principle.

Until recent years the trains of the underground were universally red. The pillars of the underground stations were also red, as were the famous underground roundels with blue and white lettering. On the underground maps of Harry Beck, still in use, red is a dominant colour. In fact it could be claimed that the map of the London Underground resembles a painting of the capital by Piet Mondrian; with its bright colours and bold outlines, it manages to convey the stark contrasts and startling energy of the city, which it depicts in diagrammatic fashion. The abstract pattern of convergence and confluence was created by Beck in 1931, to reflect the growing complexity of the network. He worked in the Signals Office, and it is believed that his essential design was based upon the electrical circuits that he devised for the current. That is why his completed pattern of lines is simple, clear and memorable, giving an air of rationality to what is in reality a haphazard and chaotic system. The city itself is identified as a series of horizontals, verticals and diagonals with the greatest emphasis on Central London. 'If you're going underground,' he said, 'why bother with geography? It's not so important. Connections are the thing.' Nevertheless this famous 'tube map' has become the most easily recognized emblem of the city itself. The fact that it is not really a map at all is obvious, but was described by the social historian, Eric Hobsbawm, as 'the most original work of avant-garde art in Britain between the wars.'

Its significance as art is intimately linked with its assertive use of colour, combining a lucid code for following the network and a celebration of the city's variety. The Central Line is coloured red to signify its route through the most powerful centre of London, from Oxford Street to St Paul's and the Bank. The District

Line is coloured green because it begins in leafy West London and ends in the garden suburb of Upminster; it has stations in Turnham Green and Parsons Green, Wimbledon Park and Kew Gardens. The City and South London line, renamed the Northern Line in 1937, was coloured black because it was the first deep tube line and took its passengers lower than ever before. If there were space enough, explanations could be offered for all of Beck's colours. They can also be understood as a study in contrasts. The Bakerloo is a sombre brown while the Piccadilly Line is a breezy blue; the Victoria Line displays a lighter blue, while the Metropolitan is a shade of purple. Other lines, and other colours, are being added to the panoply of hues and tones.

The London 'tube', to give it the familiar name, is the oldest underground system in the world, first established by the opening of the Metropolitan Railway in 1863. There is an engraving of *The Trial Trip on the Underground Railway, 1863*, in which the open carriages are filled with men waving their stove-pipe hats in the air as they pass into a tunnel. On opening day, according to a newspaper report, 'the crowd at the Farringdon Street station was as great as the doors of a theatre on the first night of some popular performer'; the spectacle of a steam train disappearing beneath the ground, like a pantomime demon, satisfied the London appetite for sensation. It was greeted at its destination of Farringdon by a police band.

The line was built before the unification of Italy and the creation of Germany. Its wooden carriages were lit by gas and pulled by steam engines so that they looked like conventional railways beneath the ground of London. In the middle of the nineteenth century it was an astonishing innovation. Its first passengers wore top hats and frock-coats, and early photographs show horse-drawn hansom cabs parked outside the new underground stations. Oscar Wilde was one such commuter, travelling from Sloane Square station to his office at the bottom of Ludgate Hill. Charles Darwin and Charles Dickens both used the Underground, and it is more than likely that Jack the Ripper took it to Whitechapel station. The early tube was followed by the Central Line in 1900, the Bakerloo and the Piccadilly in 1906, and the Hampstead (or Northern) in 1907.

The first stations resembled vast basilicas with arches and alcoves fitfully lit by gaslight. Baker Street

Above: Chromolithograph showing the platforms of Baker Street Underground station, which opened on 10 January 1863.

BRIGHTEST LONDON

IS BEST REACHED BY

station, for example, was described as having 'a gloomy catacomb-like appearance'. But in London colour keeps bursting through. The walls of the stations were plastered with advertisements for Bartlett's Blacking, Hygenic Whiskey and Jupiter Cigars. The architecture of the early Underground was equally colourful. The City and South London Railway boasted great glass domes complete with cupola and weather vane. Other stations were built of white brick with slate roofs and stone dressing, while the Baker Street Railway erected single-storey stations faced and decorated with terracotta blocks of red known as 'ox-blood'. It confirmed the colour's association with all forms of transport. These red blood stations were in sharp contrast to the light brickwork of the District Line stations, in which the interiors were decorated with bottle-green tiles and upper walls of white plaster. In the 1920s the Hampstead Line developed a style that became known as 'suburban classical', with the stations graced by coupled Doric columns made out of Portland stone. The pitched roofs were covered with red Italian tiles in order to resemble Roman villas of a much earlier date. The City and South London Railway, however, preferred to use as its model a pyramidical shape so that the stations resembled Aztec temples. At a later date interior lighting was subtly modified to introduce a warmer mood into the otherwise bleak surroundings. Opal glass shades, and reflectors, cast a more even glow. They were believed to promote the concept of night colour, being as visible in the darkness as in the light.

The original Metropolitan Line itself was a considerable success, and carried approximately thirty thousand passengers each day. So the trains were lengthened, and the intervals between them were reduced; they stopped for twenty seconds at each station before continuing their journey. They accommodated three classes of carriage, the first class containing mirrors and carpets. By 1910 a sixpenny ticket allowed the traveller to use the Pullman cars that contained Moroccan armchairs set in the replica of a drawing room with mahogany walls. Electric lamps were placed on side tables, and blinds of green silk covered the windows. The early 'tube' was much more colourful than the conventional red or silver trains in contemporary use. And yet the colours of the underground, with its parade of advertisements and of passengers, are always fresh and always renewed.

But if the colour of London's transport was predominantly red, some variations were to be found in the earliest railway stations. There are some London scenes, sights and vistas that are so heterogeneous, and so filled with contrast, that no colour can be said to provide the key. It is now generally believed that the age of the railways began in 1815, but steam and rail have always been considered to be a quintessentially Victorian enterprise. This is not altogether surprising. Between the end of 1844 and the beginning of 1849 more than 4,800 kilometres (3,000 miles) of track were laid, and the number of train journeys rose from thirty-three million to sixty million. It is not at all

wonderful that the salient aspects of the period were universally attributed to 'speed'. And what better image of this new life than the great railway termini of London, which exemplified a life of haste and movement, of great crowds swept ever forward by the frenzy for fast transport? A popular writer of the period argued that 'it is impossible to regard the vast buildings and their dependencies which constitute a chief terminal station of a great line of railways, without feelings of

inexpressible astonishment … And then the speed!'

The new stations followed one another in quick succession, with London Bridge in 1836 and Euston in the following year. Waterloo opened in 1848, with King's Cross following four years later; Fenchurch Street and Paddington were opened in 1854, succeeded in the 1860s by Victoria, Cannon Street, Charing Cross and St Pancras. Liverpool Street was finished in 1875. These termini had at least one characteristic in

common. By the standard of the time they were huge
– cathedrals of steam and grand testaments of the age.
They symbolized the life of crowds in all their variety
and colour, the brilliance and vivacity of which can be
adduced in William Powell Frith's *The Railway Station*.
Frith's oil painting of Paddington station was executed
in 1862. It displays a platform on which passengers
are waiting to board a train, complete with family and
friends about to bid them farewell. The station itself was

Above: *The Railway Station*
(1862) by William Powell Frith.

designed by Isambard Kingdom Brunel, and was at the time the largest railway station in existence. Its great triple-spanned roof, together with the copious use of wrought iron and glass, emphasize Brunel's debt to the Crystal Palace only recently erected.

A mother bends down to kiss her child, while a well-dressed man hesitates before paying a cab fare; a man is being detained by two top-hatted policemen, one in brown and the other in black; a soldier in red uniform lifts up a small child for a final farewell while a porter in a green outfit takes charge of some luggage. A newly married couple, the bride in resplendent yellow, seems ready to depart, while a woman in a red shawl holds on to her daughter who clutches a basket. They seem agitated, as if fearful of missing their train. The luggage is being piled on top of the railway carriages. 'First Class' is visible upon one of the windows.

It is, in other words, a portrait or panorama of London life charged with all the bustle and movement of the city. Henry James wrote that:

> ... the railway-platform is a kind of compendium of that variety. I think that nowhere so much as in London do people wear – to the eye of observation – definite signs of the sort of people they may be. If you like above all things to know the sort, you hail this fact with joy ... you may see them all together, with the rich colouring of their differences.

Some of the figures were in fact acquainted with Frith, which accounts for their appearance in the painting, while one or two others were generally known to the public. One contemporary noted that 'I heard at least a score of people remark on the fidelity with which Mr. Frith had reproduced the features of the Great Western officials.'

All of them are comprehended within a picture of sweeping movement and contrast that characterize Frith's other crowd scenes. The diversity of colour and costume alone indicates the medley of London life. Space and time are here cast in a different dimension, crammed together in a vortex of paint. As *The Illustrated London News* put it:

> The railway has now infinitely varied relations with English life. It is the grandest exponent of the enterprise, the wealth, and the intelligence of our race. The iron rails are welded into every life-history, and sometimes interwoven with our very heartstrings. The steam-engine is the incarnate spirit of the age – a good genius to many, an evil demon to some.

The Railway Station was 1.2 metres by 2.4 metres (4 feet by 8 feet) in length and was sold for the then extraordinary price of £5,250. But, as *The Art Journal* commented at the time:

Upon the choice of subject being first announced, exclamations arose as to what could be done with it, so unpromising did it seem; but the painter of *The Derby Day* has answered this query most conclusively, and so fertile of material does the theme appear that the picture, large and comprehensive as it is, leaves the subject far from being exhausted. The various episodes the artist has introduced are such as whilst combining the highest amount of interest, are just those strictly applicable to the scene, and though realised with vivid, and in some instances painful force, are yet free from all exaggeration.

It added that the '*The Railway Station* is a work of immense power, not only in the variety and interest of its incident – in its fidelity of individual character – in its admirable grouping and colour – but in its conscientious elaboration of finish. The pictorial difficulty of the locale has been overcome as successfully as Art could possibly achieve.'

Since red is also the colour of blood it has always been associated with life and energy. Football teams dressed in red are more likely to be successful. Red stimulates aggression, and therefore competitiveness. It may also increase the appetite for taking risks. That may be confirmed in the most significant English football match of the twentieth century, when in the World Cup Final of 30 July 1966, the players of England and West Germany met at Wembley Stadium to play the contest of their lives. It was the most famous football victory for England in modern times, for which the English team wore red jerseys. Joking in the press about two other recent conflicts could not conceal the lack of any real anti-German animus in the population – if anything, the German economic miracle of the post-war years had attracted admiration. The two sides were similar in many respects, tending to persistence rather than flair.

The stadium, which could accommodate more than ninety-eight thousand spectators, was packed with expectant supporters; they came from both sides but the majority were of course English. It is worth remarking that the English troupes waved the Union Jack rather than the flag of St George, a substitution that would not be made in more recent times. The tension accumulated until it was released with a roar when the players came out of the tunnel onto the dark green pitch. The English team were seen at once to wear red shirts and white shorts, with the Germans in white and black. This was an unusual colour for the English, who preferred to wear white shirts and shorts.

Left: The jersey worn by Cliff Bastin of Arsenal during the 1930 FA Cup Final against Huddersfield Town at Wembley Stadium on 26 April 1930.

Right: England's captain Bobby
Moore holds aloft the Jules
Rimet World Cup, 30 July 1966.

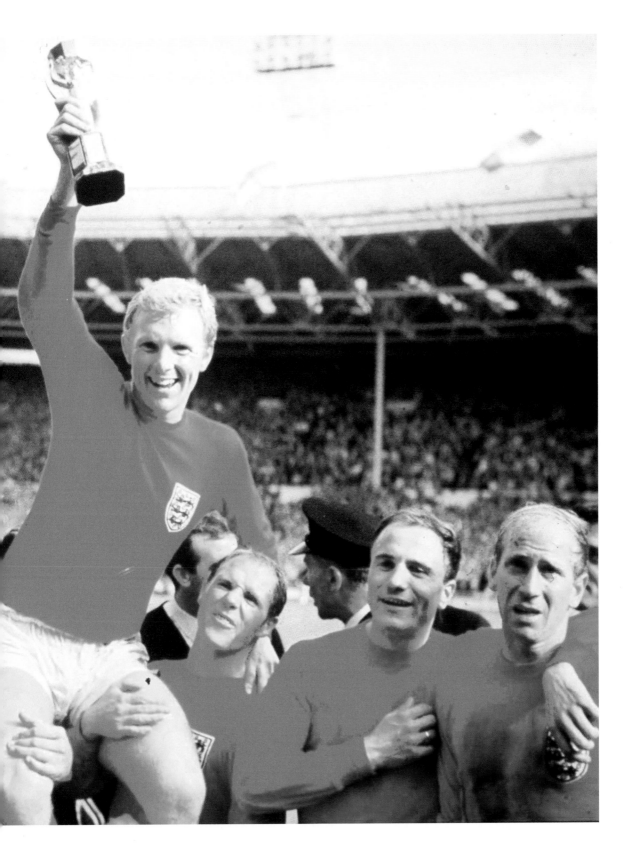

From the start it was a hard-fought contest with Germany scoring the first goal after twelve minutes of play, but then four minutes later England equalized. So it remained at 1–1 until the whistle blew for half-time. The atmosphere was now reaching fever pitch, not dispelled by the massed bands that marched during the interval. During the match itself people were throwing streamers, screaming at the referee and crying or roaring with the English and German goals.

The English team knew that they had to score at the start of the second half, but their inspired advances were stopped by a solid German defence. Their efforts finally paid off with a second goal, but the Germans managed an equalizer just seconds before the final whistle. The score was 2–2 as the teams entered extra time, leaving everyone who watched the play in a state of extreme tension. But then there came the break. The English players were almost despairing, but Ramsey recalled them to their duty. 'You've won the World Cup once,' he told them. 'Now go out and win it again.' What followed proved one of the most controversial goals in football history. The ball ricocheted between the

German goal posts and at last was given, to huge German protests. There was no debate about the next goal, however; with seconds to go, Geoff Hurst lashed the ball into the German net. The final score was 4–2. England had won the World Cup.

The players collapsed, wept and embraced. The sun blazed the brighter, fans roared and Bobby Moore, having wiped his hands before greeting the Queen, held aloft the small gold World Cup. The austere Alf Ramsey, the team's manager, delighting in his players' happiness, doffed his usual reserve and kissed the trophy. It was a famous and memorable victory that has not yet left the national consciousness, even if it has not been replicated.

The crowds celebrated the victory with a passion they had not known for twenty-one years. It had been a day as dramatically changeable as the game itself, a day of driving rain, of dazzling sunshine, and the team had survived a setback, which must have demoralized a lesser team to come through triumphantly on their merits. It was the first World Cup final to go into extra time since 1934, when Italy beat Czechoslovakia in Rome. But if it was not the only final to exceed the

statutory ninety minutes, it was surely the most dramatic in the history of the competition.

The Times reported that:

London went mad last night after England's 4–2 victory in one of the most fantastic finals in the history of the World Cup. The celebrations culminated in a jubilant demonstration in Latin American style outside the hotel in Kensington High Street where a reception was being held for the players. As the British Government entertained 480 guests from the football world in the new Royal Garden Hotel, the fans yelled the "England, England" chant which has echoed round Wembley in the last three weeks and rose to an incredible crescendo yesterday afternoon. Cars jammed all the way along the street took up the "England, England" beat on their horns. Inside the hotel, Mr Harold Wilson received the guests from FIFA, the FA, the English and West German teams, and players and representatives from the other 14 countries who took part in the final stages of the 1966 World Cup.

When the English team came out on a balcony, and tossed red carnations into the street below, the crowd could hardly be contained by the hundred policemen who were ostensibly there to direct them. The supporters were everywhere in Covent Garden, Piccadilly Circus and the fountains of Trafalgar Square; they were blowing bugles, ringing bells, sounding horns and singing 'We've got the whole world in our hands'. In some streets more crowds stood six deep hoping to glimpse members of the team as they drove past.

The Post Office issued special fourpenny stamps to signal the victory, which prominently featured a player attired in red, and it was hoped by the Labour Cabinet that it would strengthen sterling and also assist the government in its subsequent struggles with an ailing economy. But the real effects were more profound. The nation seemed to believe that it had come through, and that the failures and privations of recent years could now be dispelled by some aspect of sympathetic magic. That was of course an illusion but, for a short while at least, the relief and pleasure were unconfined.

Red is also connected to danger and, of course, to the devil. The 'red light districts' of Soho, the Haymarket and elsewhere were well known to Londoners and to the more experienced tourists. These of course were the haunts of 'scarlet ladies'. Sex has often been associated with red, which confirms that in one sense it is a celebration of life. It is a bright colour that provides pleasure. That is why on Valentine's Day greeting cards and posters red is associated with love, in particular with red hearts and red roses.

Red was the also the principal shade of the 'penny dreadfuls' of the London book stalls and the 'bloodbath dramas' of the London music halls. Sweeney Todd was as much a phantom of Victorian London as Jack the Ripper. But red is also the livery of those who protect Londoners. Firefighters were once dressed in that colour, as are the Coldstream Guards, the Beefeaters and the members of the House of Lords. Fire engines were red, as were the life buoys on the Thames.

Mauve may also be mentioned here since of all the shades of red – pink, violet, rose madder – it is one that has closely touched London. As a dye it was created by a young London scientist, William Perkin, in 1856; it was first worn by the Empress Eugenie in the following year, and was copied by Queen Victoria in 1858. In the summer of 1859 *Punch* commented upon the 'mauve measles' that had affected the capital, and even in 1906 it was being called the 'mauve madness'. It was the first synthetic dye, the first mass-produced dye and the first washproof dye. It changed the colours and interiors of the world.

If Mars is the god of war, then the red planet also marks the red of battle and conflict. This was nowhere more evident in London than in the days of the Blitz. On 10 July 1940, eleven months after war had been declared upon Germany, came the first assaults on London from the air; after an initial period of 'phoney war', the Germans had come at last. The attacks were first aimed at outer London, Croydon and Wimbledon, but at the end of August there was a stray raid on the Cripplegate area. Then, at 5 p.m. on 7 September, the German air force came in for a major attack on London itself. Six hundred bombers, marshalled in great waves, dropped their explosive and high incendiary devices over east London. Beckton, West Ham, Woolwich, Millwall, Limehouse and Rotherhithe went up in flames. Gas stations and power stations were hit.

The firemen had to race, through fire and perpetual explosion, to reach conflagrations that were almost insuperable. The Thames was described as a lake in Hell. The German bombers came back the next night, and then the next. Between September and November some thirty thousand bombs were dropped; almost six thousand citizens were killed, and twice as many badly injured. It seemed to some that the end of the world had come. The predominant colours

Right: Colourized photograph showing the aftermath of a German bombing raid on 9 September 1940. A bus lies against the side of a terrace in Harrington Square, Mornington Crescent.

were of light and fire, of searchlights patrolling the sky and of flame erupting in alleys, streets, shops and warehouses. The houses themselves glowed red, and the Thames was littered with barges of fire. The docks were all but destroyed. Gas mains exploded and the walls of shattered buildings were seen to be trembling, steaming and smoking.

Some Londoners were hysterical, filled with overwhelming anxiety, and there were several cases of suicide; others were angry, and stubbornly determined to continue their ordinary lives. But the loss of personal history was another aspect of the city bombings; the wallpaper, and mirrors, and carpets were sometimes stripped bare and left hanging in the open space of a new ruin. A contemporary recalled that 'the air felt singed. I was breathing ashes ... The air itself, as we walked, smelt of burning'.

The novelist and temporary fireman, William Sansom, described how 'by moonlight the great buildings assumed a remote and classic magnificence, cold, ancient, lunar palaces carved in bone from the moon ... when the western skies had grown already

dark the fierce red glow in the East stuck harshly ... and there was seen for the first time that black London roofscape silhouetted against what was to become a monotonously copper-orange sky.'

In the same month Rose Macaulay described an air battle over the city as 'most beautiful ... the searchlights, and parachute flares, and the fiery balls ... and the sky lit up by gun-flashes, like sheet-lightning, and a wonderful background of stars.' The Thames became a lurid red river when all the docks and warehouses, with the exception of Tilbury, were consumed in flame. Ships and barges were on fire, drifting dangerously in the tide against jetties and quays.

Many commentators wondered how London could survive such an assault. Rumours, as always, were everywhere. Hundreds of thousands of civilians would die, the radar would prove useless and the Royal Air Force was surely no match for the invincible Luftwaffe. The most notorious air raid occurred on Sunday, 29 December 1940. The incendiaries came down like heavy rain, and their principal target was the heart of the old City. The Great Fire had come again. The area

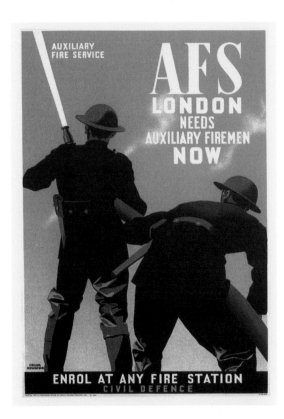

from Aldersgate to Cannon Street, all of Cheapside and Moorgate, was in flames.

The city became darkness visible. The light of destruction was white with flames of red and magnesium blue. The smoke was orange, blue, black or pearly white; the sky was illuminated by parachute flares, to guide the bombers, and by searchlights adding rays of white or a lighter blue to the night sky of purple-black. The river itself glowed red, as if it were a river of blood. Concrete and granite had been scorched umber while church ruins appeared to have acquired the tint of chrome yellow. Milton may have named Pandæmonium, but Hitler created it.

The war in Europe finally came to an end after six years of misery and suffering. It had begun at the beginning of September 1939, and continued until the unconditional surrender of the Germans on Tuesday, 8 May 1945. The news of the allied victory spread later that day and it was announced that 9 May would be 'Victory Day'. It was another day of colour.

The immense crowds gathered outside Buckingham Palace, in Trafalgar Square, and in other prominent venues. They waved the Union Jacks and held up the national newspapers that simply proclaimed 'PEACE' or 'GERMANY QUITS', but the general mood was one of relief in the expectation that the privations of war were finally over. It was hoped that there would be no more 'blackouts' or rationing.

One school teacher, Gladys Langford, wrote that 'Piccadilly was already a seething mass of people. The hoarding around Eros was overcrowded with young people of both sexes, mostly of the Forces. About one third of the people were wearing paper hats, many of them of very attractive design. People were everywhere – on shop fronts, up lamp-standards, singing and shouting.'

Young men climbed up lamp-posts or telegraph poles to celebrate, while in many streets throughout the city the people lined up to perform the conga. The music came from radios, gramophones and accordions in pleasant discordance. In the enthusiasm of the moment, stranger greeted stranger with

exuberance and even with the exchange of kisses between the sexes; others mixed a little more freely, and it was reported that the parks were filled with copulating couples. The predominant colour was once again, literally and metaphorically, red.

The crowds massed in Whitehall to greet Winston Churchill who appeared on a balcony of the Ministry of Health. He then drove on to Buckingham Palace where on a larger balcony he joined the king and queen together with their two daughters; the crowds were immense and ecstatic. Noel Coward reported that 'I walked down the Mall and stood outside Buckingham Palace, which was floodlit. The crowd was stupendous. The King and Queen came out on the balcony, looking enchanting. We all roared ourselves hoarse …'. *The Daily Telegraph* reported on the following day that:

> British family instinct inspired tens of thousands of men and women to go to the London home of their King and Queen on VE-Day to share with them the joy of peace in Europe. A vast crowd was assembled outside Buckingham Palace throughout the day and until a late hour a joyous and colourful crowd whose enthusiasm rose to a crescendo of patriotic fervour at the occasional appearances on the balcony of the smiling King and Queen and the Princesses. Eight times their Majesties came to the balcony in response to the insistent roar of the crowd. On most of these occasions they were accompanied by Princess Elizabeth and Princess Margaret.

Left: Colourized photograph of VE Day celebrations in Parliament Square, 8 May 1945.

Red, white and blue bunting was brought out of storage in order to decorate the streets and houses, while the public houses were filled to capacity with happy and raucous customers; the licensing hours were extended for the occasion, and the dance halls remained open until midnight. A contemporary diarist noted that:

> … no one seemed to bother much about getting home, for though the last trains to the suburbs had left the West End at the ridiculously early hour of 11.15 or thereabouts, there were still as many sightseers about when we started to walk home about midnight as there were when we arrived on the scene in the early evening. While outside Leicester Square station was a queue extending all the way up to Cambridge Circus waiting for the first trams in the morning!

Another contemporary recorded that he concluded his jaunt with 'a last enchanting eye-full of the floodlit splendour of St Paul's Cathedral, Houses of Parliament etc. from Waterloo Bridge' before taking 'what must have been the last 68 bus to Euston Road which was completely illuminated from end to end with its full pale-blue peace-time lighting'. The light, after years of darkness, was something of a revelation. Yet in most other areas of the city, there was still no electric street lighting, and so the evening celebrations took place in the dark, or were lit by street bonfires as well as by the headlights of vehicles. The contrasts of light and darkness, in which red was an intermediate band of colour, resembled a scene from Caravaggio.

Yet something had happened to London, too. Outside the principal areas visited by the London public, there was not much sense of joyfulness. Cecil Beaton observed that Kensington was 'as quiet as a Sunday … There is no general feeling of rejoicing. Victory does not bring with it a sense of triumph – rather a dull numbness of relief that the blood-letting is over.' Mass Observation, the organization devoted to social research, recorded that:

> … most of the crowds are concentrated in the few focal points of Central London. Away from these, people are restrained and orderly; the excitement seems to almost be entirely a result of the stimulus of the crowds and of group feeling. People had put great efforts into decorating their houses, but seemed to anticipate little further in the way of celebrations … Bonfires, street tea-parties and fireworks [were] meant in the first place for children.

The *Manchester Guardian* put it differently by noting that 'there has been none of the almost savage plunging into hectic revelry which marked the more sudden Armistice in 1918. There has been relatively little drunkenness today and still less of aggressive horseplay.'

Colour photographs of the event reveal a certain drabness or uniformity in dress, where

'I walked down the Mall and stood outside Buckingham Palace, which was floodlit. The crowd was stupendous.'
Noël Coward, 8 May 1945

before there had been bright colour and variety. The celebrations were real and enthusiastic, but there was an underlying state of weariness and exhaustion after years of fearing fire and obliteration from the sky. No one had slept well for five years, and it could be said that the majority of Londoners suffered from ill health in one form or another if only from the effects of constant and debilitating anxiety. In the phrase of the period the 'stuffing' had been 'knocked out' of the city, the metaphor suggesting a thinner and more depleted reality. Certainly it had lost much of its energy and bravura; it had become as shabby as its inhabitants and, like them, it would take time to recover.

The red poppy is the sign of remembrance for both world wars although it first came into display as the token of the first, when it was seen that after the battle of Flanders Field a host of red poppies grew over the graves of the fallen soldiers. It was the inspiration for the poem by Lieutenant Colonel John McCrae which opens:

> In Flanders Fields, the poppies blow
> Between the crosses, row on row.

Which in turn inspired a festival of remembrance for the fallen in various fields of conflict. So red became a symbol of hope as well as of memory. They were made first of silk, but the demand for them was so great that they are now manufactured of paper in vast quantities by the Royal British Legion.

But there were other colours as well. The bomb sites and derelict buildings of the city were overtaken by the natural world, so that the profusion of wild flowers became one of the sights of the post-war city; they were complemented by the birds and insects that began to congregate there. It has been estimated that 269 types of wild flower, grass and fern appeared among the ruins so that the scenes of devastation became carpets of colour.

Red has also been seen as the signal for revolution or rebellion, and there have been two incidents in the history of twentieth-century London when such fears or aspirations seemed close to realization. They were in fact quite illusory, but the image of the red flag was for a while raised above them. The nation was supposed to come to a halt at midnight on 3 May 1926. It was the beginning of the General Strike. That formidable withdrawal from work had been brewing or fermenting for five years, ever since unemployment had risen to two million and long queues of men outside labour exchanges became a familiar sight in the old industrial centres of northern England. 'The people grow discontented,' remarked King George, 'riot begets revolt and possibly revolution.' England's industrial and manufacturing sectors had long been in decline, and exports had fallen further since the post-war slump. In the country's heavily indebted and antiquated coal, shibuilding, iron, steel and cotton

industries, profits declined, and workers were laid off. The consequences were perhaps inevitable.

In 1925 mine owners proposed wage reductions of around 13 per cent, and the miners' union called a strike. The Trades Union Congress (TUC) was apprehensive about the industrial action but decided to support the miners in the hope that it might bring about a compromise; the government under Stanley Baldwin would persuade the miners to accept an accommodation if he could persuade the mine owners to reduce their demands. A strike was averted for nine months but any compromise proved to be impossible. So the miners rose again, together with the support and co-operation of the railwaymen, transport workers, printers, dockers, ironworkers and steelworkers.

Baldwin was so horrified by the prospect of an immediate general strike that he took to his bed. When he returned to the Cabinet he found it divided between those who, like himself, favoured conciliation, and those who wanted to 'stand up' to the unions. The latter prevailed.

So the national strike began on the stroke of midnight. May 1926 was seared into the nation's memory. Between a quarter and a half of Britain's workforce – the statistics were unreliable – walked out on the morning of 4 May. All union members in the specified trades ceased to work in support of the miners, at considerable cost to themselves and their families. With around 1.75 million workers striking,

the economy might have come to a standstill. That it did not was due to the government's careful planning for stocks of coal and the efforts of middle and upper-class volunteers, who drove trains, delivered food and joined the ranks of the police.

Nevertheless there were violent confrontations between the police and the strikers, especially in London and in northern cities. To Baldwin's distress the Chancellor of the Exchequer, Winston Churchill, did his best to aggravate hostility, branded the strikers as 'the enemy', demanding the 'unconditional surrender' of the 'subversives' and proposing to arm any soldiers who were asked to deal with them. But the disaffected were often successful. *The British Worker*, the newspaper especially printed for the duration, reported that:

… the silent strike holds sway in Woolwich. The great Arsenal and Dockyard are like an industrial mausoleum. No sound of a hammer breaks the stillness throughout the hundreds of shops and not a wheel is turning. The eight to ten thousand workers who in normal times inhabit during working hours this vast hive of metalworking are either at home, attending to their picket duties, playing cards or billiards at one of the many Labour clubs in the district, or chatting in the street with comrades. I was told stories of naval ratings and troops, as guards within the Arsenal and dockyards, but force is futile.

On the second day a state of emergency was called, and 200,000 special constables were marshalled to support the police; soldiers were ready to confront strikers in difficult locations such as the London Docks, where they broke up the picket lines and transported food into central London.

Yet despite these episodes of conflict, the General Strike is also remembered for the amity displayed between the strikers and the police. In many areas of the country, striking workers helped the police officers deliver food, while elsewhere the opposing sides of the struggle played football against each other. If this was class war, it was not the sort of bloody conflict that had characterized similar episodes on the continent. The strike was also remembered with fondness by many middle- and upper-class volunteers as a break from routine. Public schoolboys drove buses and lorries, while middle-class women acted as telephone operators or canteen workers. Privileged women enjoyed dressing and acting like members of the supposed 'lower orders', and for them the whole experience was, in the slang of the period, a 'lark' or a 'rag'. By keeping the economy afloat during the strike, the volunteers were also determined to demonstrate a sense of patriotic duty.

Yet the tendency of volunteers and later historians to emphasize the lighter side of the strike obscures the sense of revolution that hung over the country. *The Daily Telegraph* of 7 May reported that:

… rowdyism broke out in the vicinity of the Elephant and Castle yesterday morning. A large crowd of roughs gathered in the neighbourhood, and one section of them stopped a bus which was going along St. George's-road, ordered the passengers, driver, and conductor to get out and then set the vehicle on fire. The bus blazed furiously for some time, but the outbreak was eventually extinguished by the fire brigade.

Baldwin was acutely aware of the threat. He condemned the strike as an anarchic and Communist attack on parliamentary democracy and the liberties of the people, since the elected government had opposed the industrial action. The unelected unions, he claimed, were 'starving the country' in a bid to 'force parliament and the community to bend to its will'. Baldwin was in effect compelling the TUC to back down or rise up in rebellion. His arguments were repeatedly aired by the pro-government BBC and by the only national newspaper circulating in large numbers during the strike, the government's own *British Gazette*. The TUC could not convincingly answer Baldwin's accusations of lawlessness, and it lacked the appetite for revolution.

In private, the prime minister pressed for concessions from the unions and the mine owners. George V, meanwhile, expressed sympathy for the miners. 'Try living on their wages,' he commented, 'before you judge them'. Herbert Samuel, chair of the

'Efforts at peaceful persuasion
failed, and orders were given for
a force of mounted and foot police
to clear the thoroughfare.'
Evening Standard, 1926

Royal Commission, then proposed a compromise in which the TUC would accept his recommendations for wage cuts on the understanding that his suggestions for long-term re-organization of the mining industry would be implemented. Weary of the struggle, now in its ninth day, the TUC agreed to these terms. Many of the strikers regarded this as unconditional surrender. The *Evening Standard* reported:

> ... rowdy scenes occurred at Poplar following the announcement that the strike had been called off. Dock workers gathered near the headquarters of the local branch of the Transport and General Workers' Union, and expressed their dissatisfaction at the termination of the strike. Their numbers steadily increased during the evening, and so threatening became their attitude that police reinforcements were sent to restore order. Efforts at peaceful persuasion failed, and orders were given for a force of mounted and foot police to clear the thoroughfare. Following a baton charge, the crowd fled in all directions, leaving many of their numbers injured on the ground.

Yet the majority of strikers had no choice but to return to work. The government had won the class war; the workers had lost. The miners held out for a few months, with their slogan of 'not a penny off the pay, not a minute on the day'; but economic necessity eventually persuaded them to return to their now underpaid work.

In the aftermath of the TUC's 'betrayal' of the miners, union membership fell sharply. It had become clear that the government could not be pressured by large-scale industrial action into forcing employers to make concessions to employees. After 1927 industrial disputes declined significantly, despite worsening economic conditions. There was a decisive shift of focus in the Labour movement, away from strike action and towards constitutional socialism. Parliament became the main theatre of the class struggle and the Labour Party would be the beneficiary. Even so, the strike had demonstrated the power latent in a united working class. It is surely no coincidence that English employers would keep wages at higher levels than those of workers in other European countries.

The General Strike offered incontrovertible evidence, however, of entrenched class divisions in England. It also made a mockery of the Baldwin government's assertion that it would bridge the great divide. For while Baldwin had made conciliatory noises during the confrontation, he had deferred to the claims of the 'haves' over the 'have-nots'. He had also been either unwilling or unable fully to restrain Churchill. Armoured cars had been employed by the Chancellor to supply food, while peaceful demonstrations had been violently broken up by the police. If Churchill's coercive actions during the strike tarnished the government's reputation, it also diminished the role and status of the unions for the immediate future. It had not, after all, been a decisive moment in industrial or political

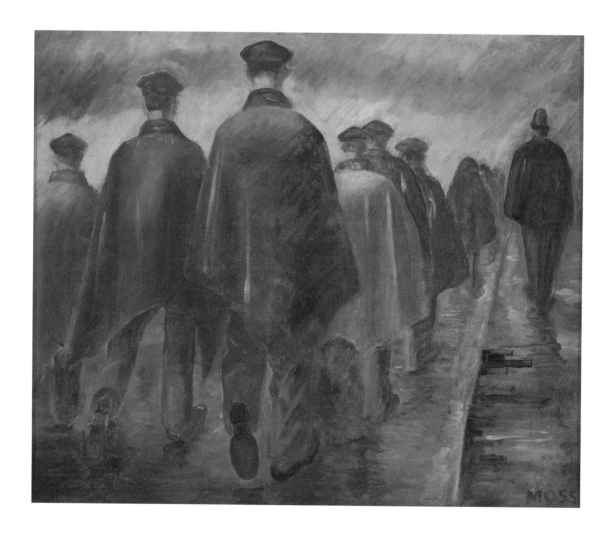

relations. But it did ensure that there would never be another general strike in British history.

The industrial crisis that inspired most sympathy a decade later, however, was the Jarrow Crusade of 1936. During the late nineteenth century, Jarrow's shipyard had flourished, and its population had increased tenfold between 1850 and 1920. By 1932, however, there was no work for 80 per cent of its adult population, many of whom suffered from ill health, with deaths from tuberculosis higher than in the nineteenth century. The town was described as 'a workhouse without walls'.

The following year, the Labour candidate for Jarrow, 'Red' Ellen Wilkinson, implored Ramsay MacDonald to help the town. The erstwhile Labour leader, and current coalition prime minister, promised he would keep Jarrow in mind. Yet MacDonald was now politically irrelevant, and was replaced at the end of 1935 by Stanley Baldwin; Walter Runciman, his President of the Board of Trade, told the inhabitants of Jarrow to 'work out their own salvation'. Antagonized by this dismissive phrase, that is exactly what they attempted.

In early 1936 Ellen Wilkinson, by now the town's MP, set about organizing the Jarrow Crusade. Funded by a popular appeal, the hunger march was intended to protest against Runciman's disregard and to publicize the plight of a 'town that was murdered'. In the autumn of the same year two hundred unemployed male inhabitants of the town marched over 402 kilometres (250 miles) to London, taking just over a month to complete the journey. The *Manchester Guardian* of 6 October reported:

> ... the march from Jarrow to London, which is being undertaken to impress upon the government the industrial position of the town, started to-day with a demonstration of enthusiasm such as Jarrow has never seen before. So densely packed were the crowds around the town hall and in the streets through which the marchers passed that traffic was held up, and for a time business was almost at a stand-still in the centre of the town.

One marcher explained that 'we were more or less missionaries of the distressed areas, [not just] Jarrow'. Some sympathizers had wanted more. The chairman of the Jarrow Borough Council asserted that 'if I had my way I would organise the unemployed of the whole country ... and march them on London so they would all arrive at the same time. The government would then be forced to listen, or turn the military on us'. But that was not practical. They marched for four weeks and were in general warmly welcomed by each of the towns and cities through which they passed. Some gave them food and shelter.

The two hundred eventually arrived in the English capital, and were greeted with heavy rain that did not dampen their spirits. *The Times* reported:

... the friendly feelings shown towards the men during the whole of their long march were equally evident in London. In Edgware Road a woman handed to one of the marchers for distribution among his comrades a dozen packets of cigarettes. The men were frequently greeted with shouts of 'Good luck!' and, from North Country people who had turned out to meet them, 'Good old Tyneside'. As they got nearer to the end of their journey the marchers were joined by many relatives and friends living and working in London and there was a good deal of handshaking.

They declined to join a Communist Party rally and instead organized a meeting attended by as many as 15,000 sympathizers at which speeches were given, songs sung and banners waved. The marchers wanted to carry a petition, containing more than 11,000 signatures, to the government asking for assistance, but the administration refused to receive their deputation. In parliament Labour MPs condemned this decision, describing the government's 'complacency' as 'an affront to the national conscience'.

Runciman, however, defended his record and pointed out that unemployment in Jarrow had improved in recent months. No central government assistance would be offered to the town. As for Jarrow's local government, its Unemployment Assistance Board stopped the marchers' benefits while they were away, on the grounds that the men would not have been able to work had any employment become available. The *Guardian* declared that 'on the whole one cannot but feel that the Government has really behaved in a rather mean spirit towards these marchers.'

Many of the marchers believed that their efforts had been a waste of time, and that their efforts had failed, yet other protestors took a more positive view. They argued that their demonstrations had 'highlighted the situation that people were in' and had 'shown the authorities we are not prepared to take things lying down'. Besides, even though the campaign may not have produced immediate results, the memory of the protests remained with those who had grown up in the 1930s, and who would come of voting age in the 1940s. That 'depression generation' would use its vote to demand the nationalization of Britain's ailing industries, and the creation of a welfare state in which hunger marches would no longer be necessary. The Jarrow March was not, after all, a failure. The red flag had not been torn down.

Red is also the colour of blood, much of which has been spilled in the city for many centuries. That is why it is considered to be the colour of anger and the colour of danger. It can even be the colour of death. When Keats coughed blood upon his pillow, he knew the worst. 'I know that colour of that blood,' he calmly told a friend. 'It is arterial blood. I cannot be deceived in that colour.' Some may be reminded of Edgar Allen Poe's 'Masque of the Red Death'.

One occasion of blood and violence occurred in the middle of the last century when some of the worst racial conflicts in London occurred in a district of West London, Notting Hill, where many families of Caribbean origin settled in the aftermath of the *Windrush* arrivals. The summer of 1958 was hot, and the tensions rose with the temperature. One black resident recalled the atmosphere of the area: 'We could feel the pressure was there … You were constantly being threatened on the streets.'

There had already been a number of attacks, predominantly by white youths on black people, but the riots of Notting Hill began with a small incident on 29 August between a Swedish woman and her black husband. The small spark caused a conflagration. Later that evening a crowd of three or four hundred attacked the dwellings of the local black residents, leading to violent confrontations. Many participants, predominantly white but also black, were arrested. Nevertheless the riots and assaults lasted for seven days.

Explicit racist calls for violence rang out on Portobello Road and Colville Road. It was not entirely unexpected. North Kensington, the borough in which Notting Hill is situated, had more than its share of poverty, crime and violence. The West Indian community had grown much larger over the previous ten years, and there was rivalry between poor black and poor white families for affordable housing.

The Union for British Freedom had established itself in the area and Sir Oswald Mosely, the founder and inspiration of the British Union of Fascists in the 1930s, inflamed the local inhabitants with the call to 'keep Britain white' at meetings in West London.

In the subsequent explosion, then, black residents were targeted, and their property ransacked. The rioters attacked them with petrol bombs made out of milk bottles, iron bars and butchers' knives. But now, after years of battening down the hatches, they could take no more. The black youth of the area took up the same weapons as their assailants and retaliated. 'We were getting the worst of it until a few of us decided to fight back,' one recalled, 'and when they came, we attacked before they did and they ran away'. It was not the Teddy Boys' finest hour; they participated gleefully in the baiting, but were then repelled after leaving five black men lying unconscious on the pavements.

The police described the race riots as the work of 'ruffians, both coloured and white', but the excuse of hooliganism contradicted the plain evidence that it had been the consequence of white working-class mobs intent upon vengeance or destruction. Crowds numbering several thousand, according to reports, wandered the local streets in search of likely victims, and the trail of violence continued over a bank holiday weekend. One police constable was told that 'we will kill all black bastards. Why don't you send them home?' Another was cautioned to 'mind your own business, copper. Keep out of it. We'll murder the bastards'.

The black response, although more scattered, was no less violent. One detective sergeant reported

'On the whole one cannot but feel that the Government has really behaved in a rather mean spirit towards these marchers.'
Manchester Guardian, 6 November 1936

that on the third night a 'large group of coloured men'
was walking along Ladbroke Grove: 'What can only
be described as a mob,' he said, 'were shouting threats
and abuse, and openly displaying various most offensive
weapons, ranging from iron bars to choppers and open
razors.' One man 'had a chopper in his hand and was
shouting "come and fight", and, "what about it now?".'
After a week the worst of the violence had diminished,
and 140 people, the majority of them white, had been
arrested and jailed. But the occasion had been a rude
interruption in the ordinary life of the city, and served
as a warning that Britain had a miserable record of race
relations comparable to that of the United States. It
was also the moment, as was said at the time, when
any British claims to moral leadership in the world
were destroyed.

The attempt of the Metropolitan Police to blame
the riots on hooliganism rather than on racism may have
been designed to cool inter-racial conflict, but their
obfuscation only served to exacerbate the distrust of
the black community. It took many years to alleviate
the major problems, and some still remain, but the
subsequent decision to launch the annual Notting Hill
Carnival was a signal attempt to foster celebration and
good will in a neighbourhood that had enjoyed very little
of either.

In the evocation of redness we cannot discount the
colouristic effects of the suburbs which, according to
Vincent van Gogh in the 1880s, 'can be so beautiful,
when the sun is setting red in the thin evening mist.'

Right: Colourized photograph
showing clashes between
protestors and the police on
Bramley Road in Notting Hill
on 31 August 1958.

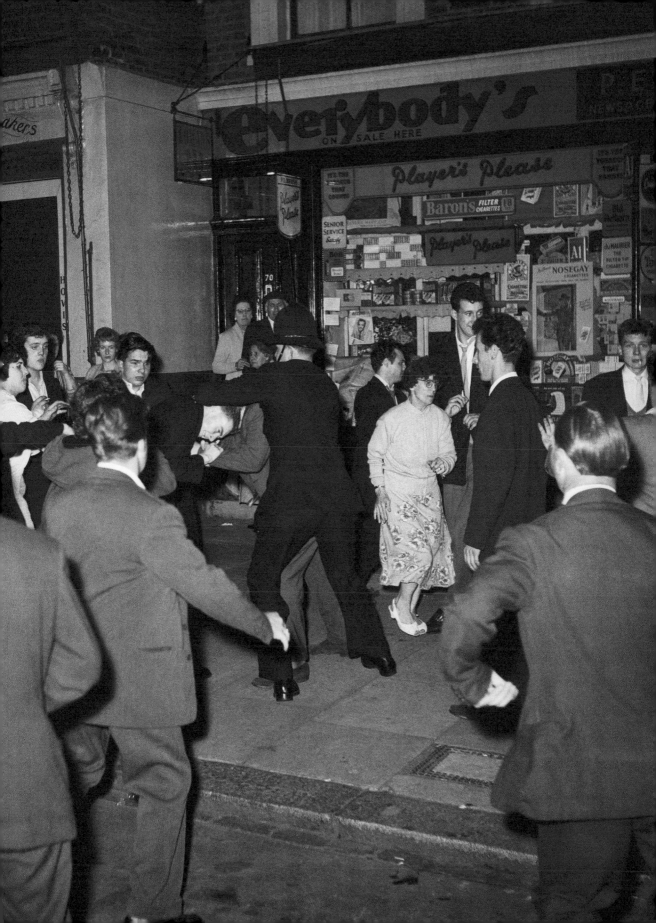

BROWN

···

'Unreal City,
Under the brown fog of a winter dawn'

T.S. Eliot, *The Waste Land*

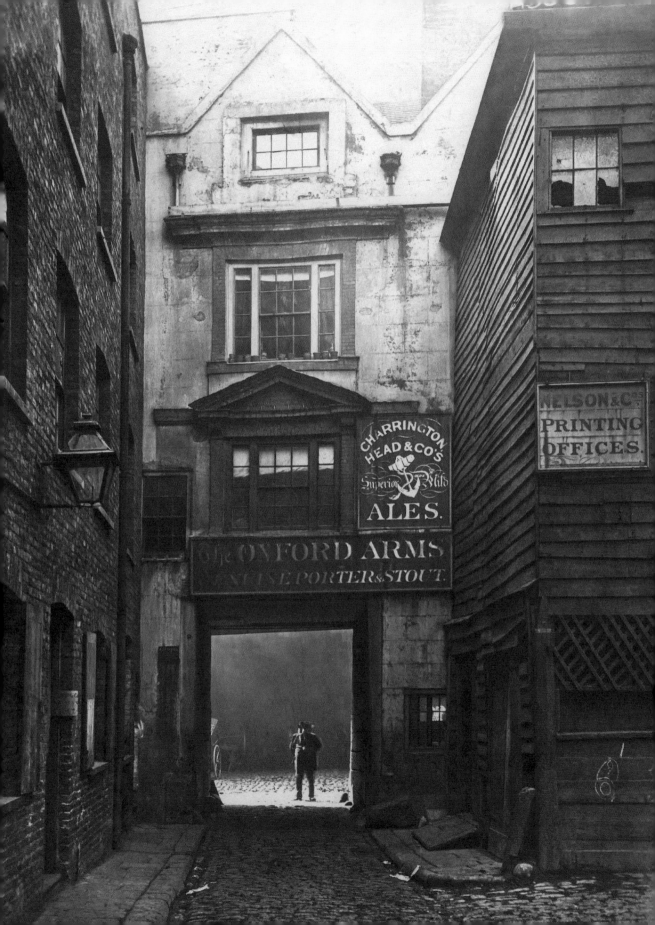

Brown is primarily associated with wood and therefore, in a city of tree-lined streets, is a dominant hue. Kandinsky considered the colour to be 'unemotional, disinclined to movement'. That is why perhaps a characteristic Victorian interior might include mahogany furniture as a sign of stability. But then brown might be associated with slowness and lethargy. It had other variants in the nineteenth century.

It might seem now that Buckingham Palace has remained unaltered, and that its facade of Portland Stone has been a permanent visual aspect. But in fact that famous front was not created until 1913. It had previously resembled a fortress or castle constructed out of soft creamy-yellow Caen stone, which quickly darkened and deteriorated in the pollution of the city. It had become brown. The brown was mournful rather than decorative.

In 1913, therefore, the decision was taken to renew the facade. Aston Webb, an architect with a number of large public buildings to his credit – including the Victoria and Albert Museum and the Victoria Memorial – was commissioned to create a new east front that surmounted the Mall. Webb chose Portland Stone, which effectively complemented the Victoria Memorial in front of it; it also transformed a rather dour and dilapidated structure into a bright and brilliant new creation. The stone itself took a year to prepare before construction could begin but, when the arduous process of re-facing and replacing the Caen Stone was undertaken, it took only thirteen weeks to complete the process that included removing the old stonework. The present forecourt of the Palace, where the Changing of the Guard takes place, was formed in 1911, as part of a complete Victoria Memorial scheme or design that was created by Webb himself. The entire work was completed just before the outbreak of the First World War. Everything else, in terms of both exterior and interior, belongs essentially to the Victorian period. Victoria herself was the first monarch actually to inhabit the palace. It was from here that she drove to her coronation.

The overwhelming impression of the interior, then and now, is one of red, white and gold; blue is more rare, but colours such as yellow and green, orange and pink, are employed to provide a welcome contrast. There are some 775 rooms, which comprise nineteen State rooms, ninety-two offices and seventy-eight bathrooms; there are also 118 staff bedrooms as well as fifty-two royal and guest bedrooms.

Amid this plethora of accommodation the names of some rooms are self-explanatory, with the Green Drawing Room, the Yellow Drawing Room, the Blue Drawing Room and the White Drawing Room as well as the Ballroom and the Picture Gallery. The general effect, however, is of faded grandeur; the extent of gold plate, gilt enamel and burnished gold hurts the eyes, which are not noticeably soothed by the vast extent of red or crimson. The palace is interesting without being impressive and, as a journalist from

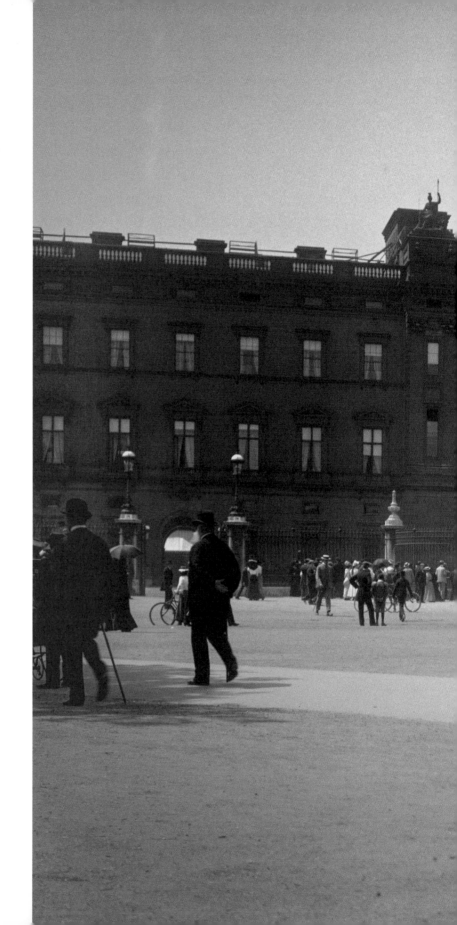

Right: Colourized photograph of Buckingham Palace, showing Edward Blore's original 1847 facade. This image pre-dates the Queen Victoria Memorial which was erected in 1911.

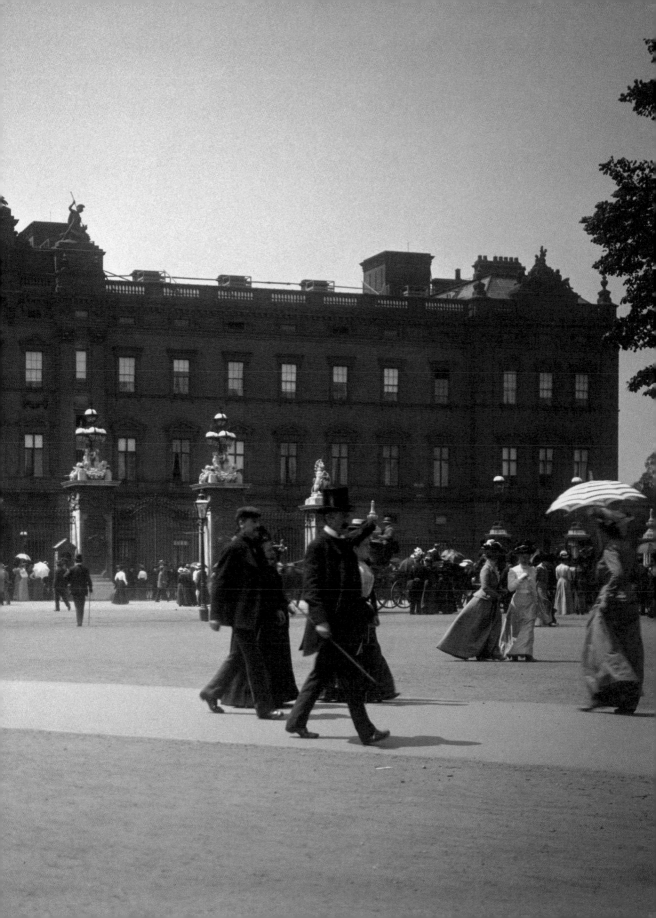

The Guardian reported, 'it feels like being trapped inside a box of Quality Street'. Yet the white facade of the East Wing is known throughout the country and the world and for that, at least, we can be grateful to the post-Edwardian improvers.

In a day free of mist the houses of the late nineteenth century might seem to be the colour of sepia or russet verging on rust red, with brown or green doorways, while the backs of houses tended to modulate between all the varieties of grey and brown brick. But these were generally the dwellings of the affluent or the middle-class. The houses of the poor were slums or tenements, obscure and brown as mud. It was a world of brown dilapidation. Some of them were still of clay walling or of rotting timber frames, which only contributed to the dank and murky aspect of these houses that were no more than hovels. The wooden frames, which may once have supported them were now stripped of anything but lathe and plaster crumbling to dissolution. They were sometimes known as 'fever houses'. The figures standing in the streets, sometimes in the middle of the road, sometimes on the pavement, seem like wraiths or tricks of the light, themselves clothed in a brown shade. The extant photographs of the period in sepia and misty brown tell their own story.

Wood will grow darker with time, while copper will become dark brown before turning into green. Pristine stone will eventually darken and finally acquire a patina of moss. Heinrich Heine noted that the streets and buildings of London were 'a brown olive-green colour, on account of the damp and coal smoke.' In the more central parts of the city large advertisements in an array of colours were plastered against dim brown and decayed walls. Some of the older shops still maintained their original pillars and bay windows with the colour of ancient wood.

John Betjeman went to school in Hampstead and he recalls the train home 'rumbling under blackened girders … and the terrace blackish brown'. Yellow brick and brown brick were known as 'London stock'; it was fashioned out of the vast quantity of London clay, but could be mingled with ash or chalk to create varieties of colour. The colour of the brick, framed by lime mortar, varied from red and ochre to purple and black. In its original tones it is inherently comforting and warm. Yellow brick, however, was the prime material; it is sympathetic to the effects of rain and mist, and by the same process its colour subtly changed. It came originally from the minerals deposited by the course of the Thames through the absorbent earth. It was originally reserved for the more affluent but, as the millions of 'stock bricks' were manufactured, the price of this hard-wearing material was lowered.

It was, of course, the primary material for house building throughout the nineteenth and early twentieth

Left: Colourized photograph of a slum clearance protest on Great Peter Street, 1930.

centuries. The houses were often constructed from an adjacent brick field before the builder or speculator moved on. Yet the brick itself was susceptible to wear and atmospheric pollution, so that the pristine yellow acquired a sooty tinge and became entirely dark brown or black. That has been the fate of many London terraces and squares.

Bloomsbury was for a long time drowned in brown brick. Lowndes Square and Cadogan Place were filled with mud-coloured brick. There are in fact many examples of yellow stock brick being blackened artificially to combat the marks of pollution and also to render house facades more fashionable. The interior of Baker Street station was once encased in brown brick. A chromolithograph of the station, from the 1860s, illustrated the vast brown canopy of a roof with brown brickwork everywhere; it is a ponderous and gloomy space, scarcely enlivened by the passengers waiting for the next train. An image of the Strand, with the Charing Cross Hotel, is similarly bathed in brown as the vista of the street stretches into the east. So we may say that London was for a long period predominantly brown. Close-fitting headscarves or hats were universal, again in a variety of colours. You need only examine a painting of crowds by William Powell Frith to become aware of the infinite possibilities for intense colour in the nineteenth century, a panorama unavailable in the sepia brown photographs of the period.

The poor and the working people could not afford such variety or display, and the familiar colours were brown, dark red, dark blue and grey. Working women, for example, were obliged to wear shawls and pinafores of various dark hues, to disguise dirt, so that many preferred the less gaudy browns and greys. George Orwell noted that the production of cheap clothes and goods helps to flatten the surface appearance of poverty, but the significance of colour coding was not diminished. The labouring classes were known as 'brown-collar workers'. It is not clear whether brown was chosen because the cloth was not dyed and therefore cheaper, or whether it had been worn for months without wash or change and thus acquired the hue of the streets.

Left: Colour postcard of
Strand and the Charing Cross
Hotel, c.1905.
Right: Colour postcard
showing a street hawker selling
his wares from a tray, c.1912.

LONDON TYPES : THE STREET HAWKER.

Below: *Work* (1952–65) by Ford
Madox Brown shows navvies
digging up Heath Street in
Hampstead.

In Ford Madox Brown's painting of 1863, *Work*, a small group of navvies, or construction workers, are seen digging up sewers in Hampstead, North London. The nature of the work suggests what the Victorians would describe as its 'low' quality. That is why the key colour is brown. It is dominant in the mud or soil that is being dug and in the workmen's clothes; trousers and an old waistcoat are brown, the colour emphasized by the ragged brown dress worn by an itinerant plant-seller on the left and by ill-defined figures in the background. Brown is manual work. Brown is poverty. Brown is London labour.

The streets were often clothed in the brown wreaths of the London fog that could become, in the words of Stevenson's *Strange Case of Dr Jekyll and Mr Hyde*, 'a rich lurid brown, like the light of some strange conflagration'. It could also be yellowish brown as in the colour of sulphur. Wilde observed that 'where, if not from the Impressionists, do we get those wonderful brown fogs that come creeping down our streets, blurring the gas lamps and changing the houses into monstrous shadows?' That brown fog was immortalized in *Bleak House* when Esther Summerson asks Mr Guppy 'whether there was a great fire anywhere? For the streets were so full of dense brown smoke that scarcely anything was to be seen. "Oh dear no, miss," he said. "This is a London particular". I had never heard of such a thing. "A fog, miss".'

Sometimes those fogs seem to drift from the river. Its waters had once been pale blue, pale green or darker green, white or grey, but by the middle of the nineteenth century its colours were undone by pollution and sewage. It became muddy brown, the colour of the faeces that tumbled into the water, or even black. The foreshores were caked with excrement and as far upriver as Teddington Lock the sewage was 15 centimetres (6 inches) thick and 'as black as ink'.

Right: A policeman on
duty during a 'pea-souper' fog
in 1934.
Overleaf: Harborow's
Outfitters, New Bond Street
in 1955.

In the early 1860s Charles Dickens wrote that
'the river had an awful look, the buildings on the
bank were muffled in black shrouds, and the reflected
lights seemed to originate deep in the water …
the very shadow of the immensity of London seemed
to lie oppressively upon the river.' The novelist
spoke eloquently and often of the fog that shrouded
the Thames.

The river does not flow in these conditions
but, rather, it drifts like fog. It settles in the valley
of London like thick brown mist in a hollow. And it
persisted longer than anyone could reasonably have
expected. As late as the 1960s there were on average
about 237 hours of dense fog in, and upon, and about,
the Thames each year. That is why it was ordinarily
described as the 'dark Thames', but darkness is not
a colour or even the absence of colour. Perhaps the
river has no colour, which is as much to say that it
partakes of all colours.

This was a world of foul brown water, discoloured
copper and rotting wood mingled with the dust of
colliers and the smoke of a thousand chimneys. The
sails of barges were a distinct reddish brown. The
exact hue was created with a judicious mixture of
cod oil, red ochre, horse fat and sea water. It became
by default the colour of the Thames, to be seen in
a hundred paintings. The barges themselves were
generally gaily painted, with a variety of colour and
ornament to accentuate their singularity. At the end of
the nineteenth century there were still 2,500 of them
plying their trade upon the river, but now there must
be fewer than twenty.

With the building of the Embankment and of
Joseph Bazalgette's sewage system, completed
by 1872, the water slowly lost its brown vesture.
Nevertheless, brown has often been considered as
the colour of the underside of London. It has been
associated with soil, dirt and faeces; it has also been
characterized as the dress of the poor. Yet this
emphasis changed with the rise of the 'environmental'
movement in the 1990s, when natural or organic
materials became more prominent. The products
of the earth were preferred and in the same period
the yellowish brown of beige became a favourite
colour. Brown may, for the first time in its existence,
become fashionable.

GREY

..

'I felt that this grey,
monstrous London of ours'

Oscar Wilde, *The Picture of Doran Gray*

176 GREY

Grey is the colour that the light and climate of London cast. The city is deemed to be grey by temperament. The stones and buildings, the houses and streets, may seem to be grey to those who pass through. Grey is often the colour associated with London, since the city can accommodate a variety of its shades. Grey is the colour of the sky. Grey is the colour of the clouds. Grey is the colour of the rain. Grey is the colour of the streets. Grey is the colour of stone. Grey is the colour of the London pigeon. Grey is the colour of the London river. Grey is the colour of smoke. All of the three primary colours – red, yellow and blue – will, with the addition of the secondary colour of green, form grey when mingled or turned on a wheel. Grey is the encompassing colour.

The city itself seemed sometimes to be drained of primary colour, leaving it with a mixed hue between sepia and grey, which gradually became darker still as a result of atmospheric pollution. The recessive colours of the city tend to be muted grey and white or tired yellow; the grey stone is manifest under a grey and overcast sky, the grey pavements and often grimy windows complement the grey features of tired commuters. In the autumn of 1933 the *Daily Mirror* stated that 'it has for long been a reproach to the first city of the empire that its outward garb was drab even to the point of being depressing'.

The stones tell their own story. The stones of London are mythical, part of a tradition and a folklore that are best embodied in the famous dark grey London Stone, now harboured behind a grille on Cannon Street that goes largely unnoticed among the press of pedestrians. It is fashioned out of oolite, is of ancient construction and was popularly supposed to mark the centre of London. Whether or not there is any truth in this, it has certainly become the progenitor of 'London stones' as an emblem of the hardness, durability and colour of the city.

But other types of stone may claim the primacy. Many of the columns, as well as much of the fabric, of London are composed of terracotta; it can be of a warm grey, and thus a notable substitute for marble, or it can be used in its original reddish-brown hue, which becomes dirty and discoloured in time. It is the perfect stone for a grey city. It is also very useful in London structures for its variations in white and grey, where deep cream or putty grey can mimic the effects of stone.

Other stones have left their mark. The Prudential Assurance Building along Holborn is exemplary for its substance and durability; its dark red terracotta and red brick lend a colourful texture to a part of London that is not otherwise distinguished for its variety. On the Bedford Estate in the environs of Bloomsbury, in the last decades of the nineteenth century, terracotta dressing was applied to Georgian houses in an attempt to render them contemporary. The red dress was seen as a welcome relief to the lengths of stucco masquerading as stone. The 'Gothic' churches of the late Victorian period were also distinguished by glazed tiles and polychromatic brick in which terracotta was the most essential component. Harrods in Brompton Road was also clothed in terracotta, which is arguably the most appropriate stone of London

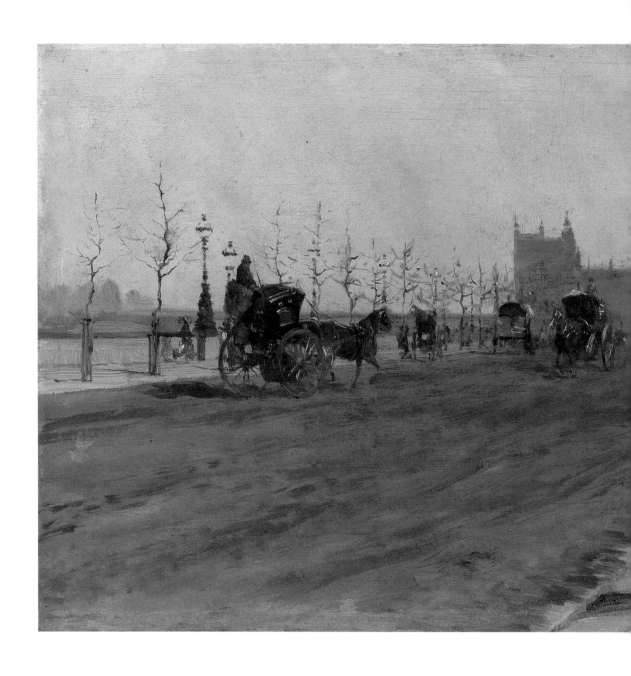

Above: *The Victoria Embankment*
(1875) by Giuseppe de Nittis.

on the assumption that red is pre-eminent among London's colours.

Portland stone is another aspect of London's architecture. This white limestone, taken from a small island off the coast of Dorset, soon became integral to the public architecture of London. Buildings that aspire to grandeur or permanence were often detailed in white rendering in order to emulate this variety of stone, while a judicious mixture of red brick and white Portland became a mark of the Edwardian era. Portland stone was the material of choice for the rebuilding of St Paul's Cathedral and the re-facing of Buckingham Palace; other London buildings that employ the stone include the British Museum, the National Gallery and Tower Bridge. This may be in direct homage to the fact that it was introduced in its earliest form for London Bridge and the Tower of London. Lutyens employed it for the construction of the Cenotaph.

Portland stone has been more recently employed in the building of Chelsea Barracks, University College and Green Park Underground station. Of all London stone it is one of the most durable, holding its colour and texture in the damp grey of autumn and winter weather. In that sense it has become perpetually associated with the city, and has been described as the stone of the imperial capital. It consists of three varieties – basebed is easiest to carve for monuments, roach for the lower level of buildings, and whitbed for cladding or paving.

It has variously been described as brown and beige, grey and green and, of course, a greyish or creamy white. Its default colour, however, was characteristically grey with all the grime of the London atmosphere. It resembles smoke in solid form. It is neither too pale nor too dark, and is therefore appropriate for the subdued anonymity of London's significant buildings. It is also easy material with which to work. A London architect, Michael Stiff, has commented that his choice of Portland stone for a new building in Bishopsgate was driven by what might be called the territorial imperative. 'It is in the centre of the city,' he said, 'and you almost start from the point that you are going to be working with Portland stone'.

This unique and attractive stone is now not generally used, and is employed instead to furnish thin cladding for less attractive stones that play a large part in London's architectural landscape. These will include cement and concrete, cement being ash-grey, and its most popular variety is known as 'Portland cement' because of its resemblance to Portland stone. 'Roman cement' had nothing whatever to do with the structural elements of Rome, but was patented by an Englishman in 1796. It was of a brown-grey colour, and was often left in its natural state as a plausible alternative to stone. Cement itself is an indispensable ingredient for concrete, of which many London buildings are constructed. It is made up of sand, gravel and crushed stone, held together by a paste of water and Portland cement.

Concrete buildings, commonly denoted as part of 'brutalist architecture', have become one of the defining appearances of the city. The material itself is fireproof and waterproof, durable and rigid; it does not require repairs or painting, and is rapidly built. It is made for London and other cities. It has been used to form the Brunswick Centre and the Royal College of Physicians, Centre Point and the Trellick Tower, the Barbican and the Southbank Centre, the Brunel University Lecture Centre, the Ministry of Justice and the Alexandra Road Estate. These exercises in monumentality and massiveness now make up a significant part of the cityscape; their natural colours seem to range from white to grey, from tan to pale brown.

Concrete itself has the gift of complementing the London sky, and the clouds that drift above it. Marble has also been one of London's stones, from parts of the Royal Exchange to Marble Arch itself. It can come in various colours but the assumed whiteness of marble soon fades into a disconsolate grey. White was indeed the dominant colour of large public buildings, at least in their pristine appearance.

A painting of the Embankment in 1874, just after its completion, depicts a glistening city; Somerset House, the steeple of St Bride's, the columns and pilasters beneath the dome of St Paul's, are of white Portland stone, which in more recent days are all reflected by the glass roof of Cannon Street station lying in the near distance. Yet it was well enough known that the condition of the city would change all that, and the white gleam would eventually be blackened by smoke and age. Borough halls and local courts were often dressed in grey rusticated masonry. Even the aggregate personality of Londoners has been adduced to explain the preference for one colour over another; it is inclined to fixed habits or customs and as a result averse to variety; it tends to be gloomy or sombre and thus prefers colours that complement that mood; it is averse to ornament and prefers candid business qualities; it elevates the signs of prosperity over those of beauty. Anything that might be considered to be too recent or too 'newly made' was covered with a patina of false age, which suggests subdued or darker tones. The colours were variously described as 'mud and blood' or 'true rust'. But essentially they merged with the greyness of their surroundings.

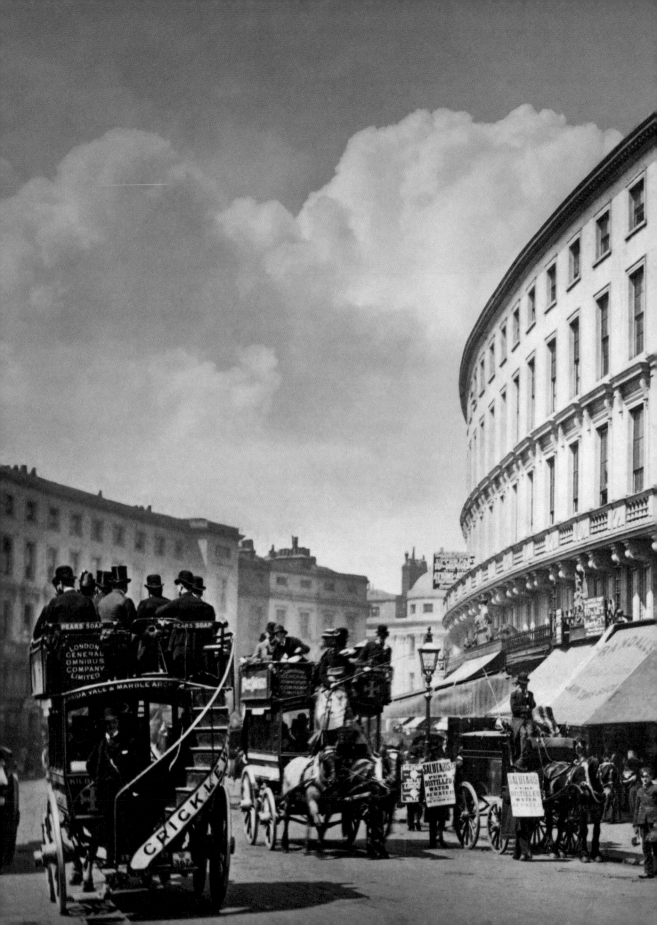

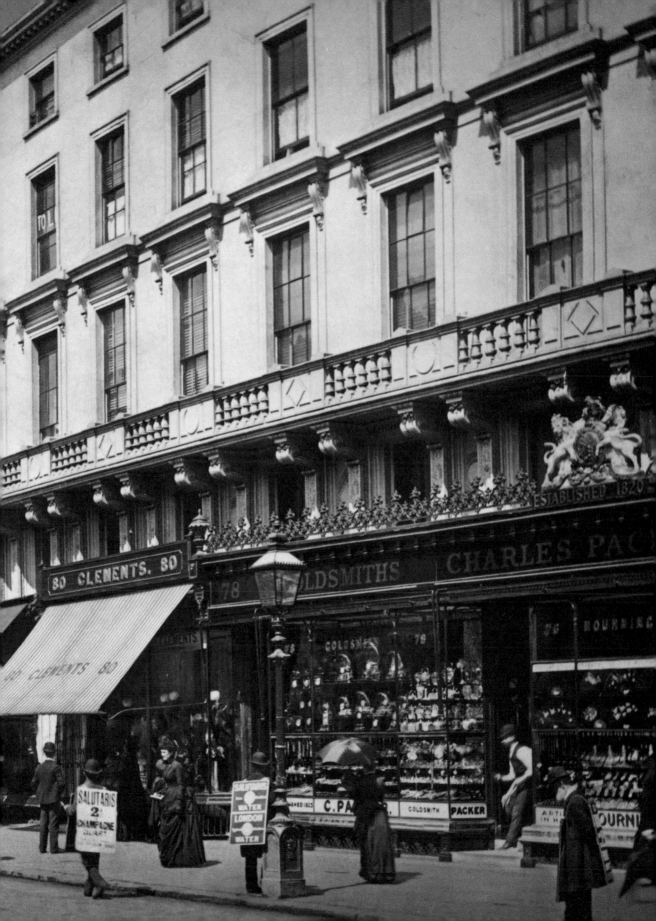

BLACK

..

'Packed to blackness with
accumulations of suffered experience.'

Henry James, on Craven Street

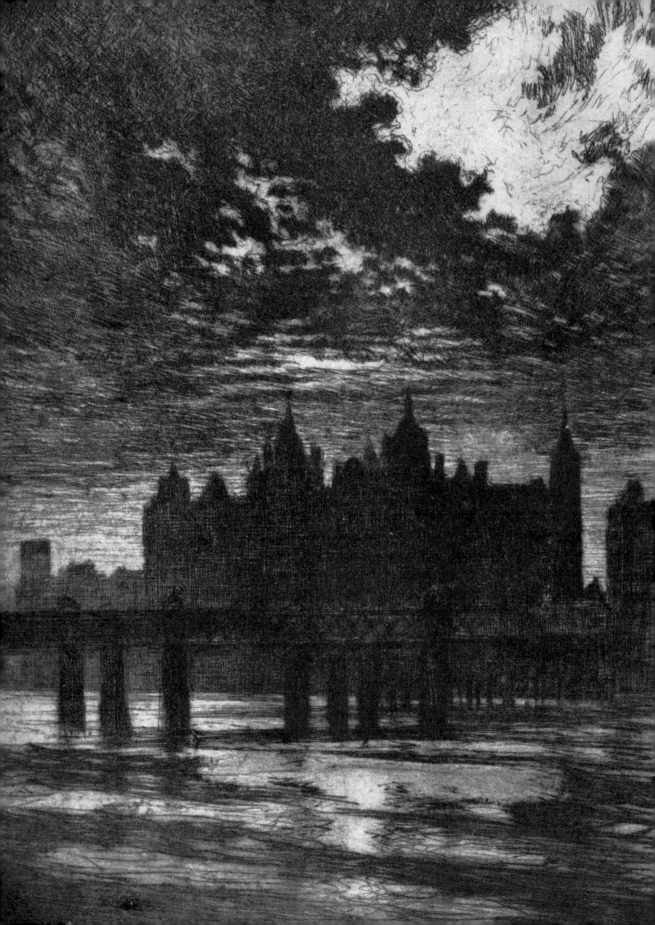

Black is a London colour in more than one sense. It is, of course, the emblem of death and mourning, with which the city is intimate. In essence it represents the convergence of all colours. It absorbs adjacent colour and reduces form. In many cultures, the gods of death were depicted as black. Black has therefore been associated with the devil and with nothingness or emptiness. It is the darkness that brooded over the face of the deep, in the second verse of Genesis.

Yet it has also been associated with piety and scholarship. It has often been fashionable in female dress, and obligatory in male. There are more specific associations with London. The bottoms of post boxes are black, the frames of the doors of underground trains are black. The ravens of the Tower of London are black, as are the hats of the Royal Guards. It was said that St Paul's had the right to be black because it was built on a tax from coal.

The name is common in the capital with Blackheath, Blackfriars, Blackwall, Black Prince Yard, Blackhorse Lane, Black Swan Yard and a score of others. There was once a Dark Lane in the medieval city, and a tavern known as the Darkhouse was erected there. On the same site now is Dark House Wharf, which is dominated by the dark massif and dark tinted glass of the Northern & Shell Building. Blackness is of the city's essence. It partakes of its true identity; in a literal sense London is possessed by blackness in the form of grease, muck, filth, mud, gloom and night. It aspires to Milton's 'darkness visible'.

London always dressed in black for royal death. It could not be said that Prince Albert, the husband of Queen Victoria, was a universally popular figure, but with his death on 14 December 1861, *The Times* did its best. 'Never in our remembrance,' the newspaper remarked, 'has there been such universal sorrow at the death of an individual'. On the cold days that succeeded, the more dedicated mourners attended churches in order to hear sermons in memory of the dead prince. Church bells tolled and the London shops were shut. Black crepe was everywhere. The theatres in the West End felt obliged to cancel the pantomimes and other festive celebrations announced for this time of the year and, on the Thames, the ships of all nations lowered their flags to half-mast.

A London correspondent for *The Bury Times* in Lancashire reported that he had found a 'dense mass of mourning' in the capital, with people shuttering their homes and standing around gloomily in black. He added that 'they made such an effort on their outfits it was difficult to tell the rich from the poor … The signs of mourning are almost universal here … Very few people came to town and these were listlessly walking, with nothing to attract their attention, while the bells were tolling and the solemn cannons were distantly roaring.'

After her husband's death the queen retreated altogether from public life, and swathed herself in mourning as if she were the chrysalis for a black butterfly. She had written in her usual vivid and almost explosive style that 'I am also anxious to repeat *one* thing and *that one* is my firm resolve, my *irrevocable decision* viz that *his* wishes – *his* plans about everything, *his* views about *every* thing, are to be my *law*!'

It was an Arthurian, or perhaps Tennysonian mourning; she had developed a fondness for Tennyson's elegy entitled 'In Memoriam'. She lamented the fact that there was no one to call her Victoria now, and she had lost the one bulwark on which she wholly relied. She became a little ball of black, of piteous face, to be glimpsed in the back of a landau. She would do nothing, appear nowhere, until there were some who wondered if she had any real purpose at all.

That black vesture reappeared among the people with the death of Victoria herself. On 21 January 1901, she seemed confused and on the following day she took to her bed in Osborne House on the Isle of Wight. At about four in the afternoon the queen's doctor, Sir James Reid, announced to her family that she was slowly sinking into death. A little while later she opened her eyes and whispered 'Sir James, I am very ill.' She was later heard to murmur, according to her daughter, Princess Louise, 'Oh I don't want to die yet.

There are several things I want to arrange.' But there was no time left. There was nothing more to arrange. She died at 6.30 p.m. on the evening of that day, at the age of eighty-one.

Her death came as a profound shock to many, if only because the thread of history had been broken. The newspapers, bordered in black, revelled in a frenzy of headlines from the relatively simple 'DEATH OF THE QUEEN' to the more ponderous 'THE VICTORIAN ERA HAS ENDED'. Her funeral therefore, marked the passing of an age as well as the demise of a monarch. The last burial of a reigning sovereign had taken place sixty-four years before, and no official knew precisely what to do. Fortunately, the queen herself had outlined the provisions for this state occasion. Victoria wanted no embalming, no lying-in-state. She did not wish to lie within Westminster Abbey, and so became the first monarch since George I to be buried elsewhere, but insisted that she be laid to rest beside her late husband, Prince Albert, in the Royal Mausoleum at Frogmore by Windsor Castle. Nicholas Pevsner remarked of the mausoleum that it was the 'finest piece of Victorian funerary architecture in Britain'; but it contains only two bodies interred within a granite sarcophagus.

On the morning of Friday, the first day of February, the coffin was carried from Osborne House, placed on a gun-carriage and drawn with a military escort to Trinity Pier, East Cowes, all the royal mourners following on foot. *The Times* reported

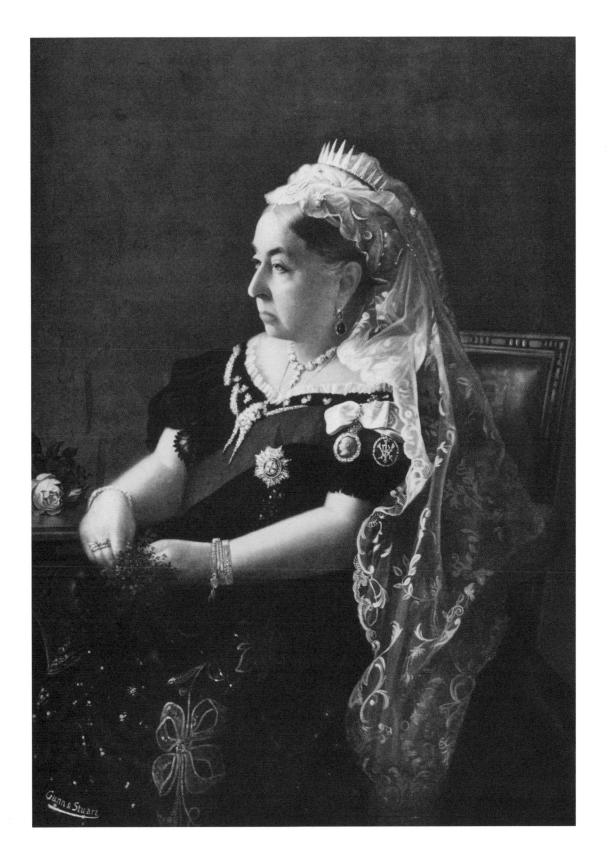

'the sky was cloudless and blue; the Solent looked like the Mediterranean itself'. The coffin was placed on a crimson dais on board the royal yacht *Alberta*. In the coffin itself, among other memorabilia, was a plaster cast of Albert's hand and one of his dressing gowns; also included were a photograph of John Brown, Victoria's companion after her husband's death, together with a lock of his hair.

The royal yacht started its short journey to Gosport, steaming slowly between forty British warships, a flotilla that stretched 16 kilometres (10 miles) across the Solent. Immediately afterwards, guns were discharged from all the ships, the salute being fired from the sides of the vessels facing the shore. It was preceded by a flotilla of torpedo destroyers, passing through the lines of warships ranged in order of battle, the British fleet on the one side and the warships of other nations opposite them. The mourners, dressed in black, followed in their yachts.

It is reported that along the sea edge in Old Portsmouth, 'piers, ramparts and beaches were black with crowds of people in mourning'; for two hours the great bell of Portsmouth Town Hall tolled, and ships' bands played funeral marches by Chopin and Beethoven. The firing of guns did not cease until 4:40 p.m., as in the winter afternoon the body of the queen arrived at Royal Clarence Yard, Gosport, 'her yacht gliding solemn and stately up a harbour which had not a ripple in the dead low water, and berthing quietly in the fading light alongside the old familiar landing-place.'

The night was passed at Portsmouth, and early on the morning of Saturday, the queen's body was landed and taken by special train to Victoria station in London. On arrival at Victoria it was placed on a gun-carriage and drawn through what contemporary reports described as 'dense and silent throngs of mourners' past Buckingham Palace,

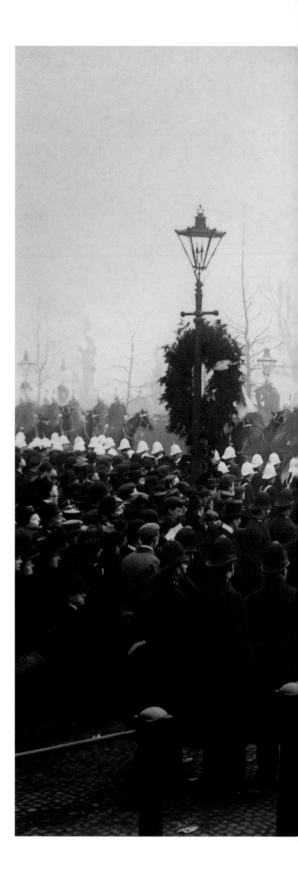

Right: A colourized photograph showing Queen Victoria's funeral procession, 28 January 1901.

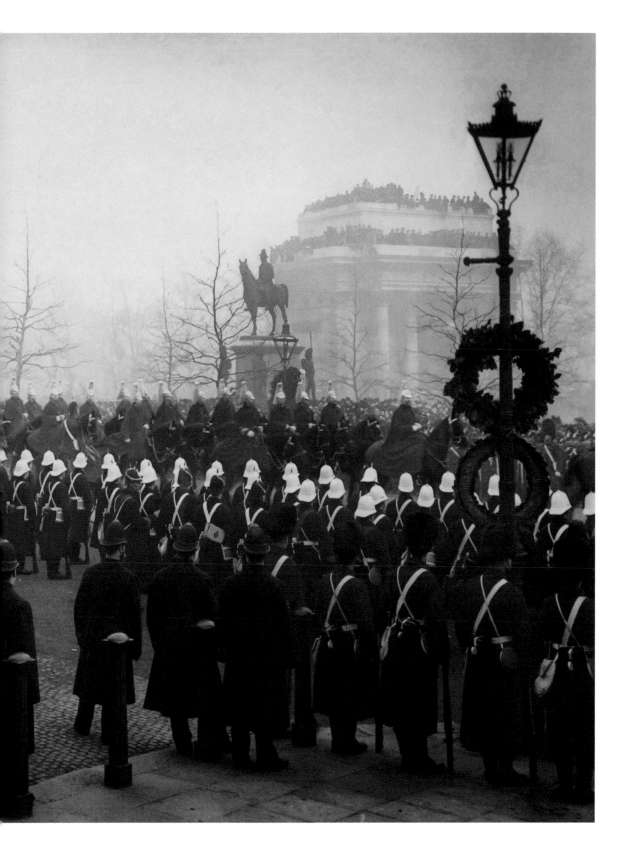

up Constitution Hill, and through Hyde Park to Paddington station, and thence by train to her destination, Windsor. Immediately behind the coffin rode the new king Edward VII. With him were the Duke of Connaught, the German Emperor, the King of Greece, the King of Portugal, the King of the Belgians and a number of crown princes. It was a cold, misty February morning, which turned bitter with a strong wind.

The scene was naturally one of silence and solemnity but, according to accounts, what was more remarkable than the spectacle itself was the sorrow of the multitude. The king and his fellow sovereigns passed almost unobserved, so intent was the gaze on the coffin draped with the royal standard. It was said that 'never had the streets and Hyde Park contained so reverential a throng. The Jubilee multitudes were there to mourn for her with whom they had rejoiced three years before.' The cinematic portrayal, by Pathé News, was naturally in black and white, leaving the spectator to imagine the colours of the military and of the assorted royalty gathered for the occasion. Some thirty-three thousand soldiers were on parade that day. But there was at least one enlivening moment, when a stray dog was seen to be trotting along with the procession.

There were similar scenes on the train's arrival from Paddington but, as the cortege was leaving Windsor Central station, there was a difficult moment when one of the horses attached to the gun-carriage got out of hand, and the others became so restive that a spill seemed probable. The horses were freed from the gun-carriage, and the king directed that a body of naval ratings should draw the remains up the Castle Hill to St George's Chapel. So 138 bluejackets, as they were known, propped up their weapons, attached ropes to the carriage where the harnesses had been and dragged the gun carriage to the chapel by hand.

Left: A colourized photograph showing porters at Smithfield Market reading a newspaper announcement of the death of George V, 1937.

A funeral service was held there, and the
body was then taken to the Albert Memorial Chapel
where it lay in state, watched by the Grenadier
Guards, until Monday when it was finally borne by
the Royal Horse Artillery to its resting place in the
mausoleum. It had been a long and winding journey.

It was sometimes said that monarchism was
the true religion of the English, but by no means
all of them were believers. The death of the queen
was in itself no surprise and the novelist, Arnold
Bennett, considered that Londoners in particular
'were not, on the whole, deeply moved, whatever the
journalists may say'. Many of the country's artists and
intellectuals in fact celebrated the end of Victorianism
and eagerly devised plans for a brave new world. H.G.
Wells compared Victoria to a 'great paper-weight that
for half a century sat upon men's minds … when she
was removed their ideas began to blow about all over
the place haphazardly.' She had reigned for almost
sixty-four years.

Black has been the sign of death and despair
elsewhere in London. It is reminiscent of Henry James's
depiction of Craven Street, leading down from the
Strand, as 'packed to blackness with accumulations
of suffered experience'. In the autumn of 1831, an
epidemic of cholera ran like wildfire through London.
One physician noted that 'the disease generally began by
relaxation of the bowels without pain, the evacuations
being colourless'. This was followed by spasmodic
pains in the bowel, by which time the condition rapidly
grew worse with 'excessive torture and prostration of
strength'. The onset of death, which generally came after
thirty-six hours, was heralded when the body turned
blue or livid and the vital powers waned with 'occasional
evacuation of a chocolate-like fluid'. It was believed by
many that it was a visitation of divine providence on
the corrupt and the vicious, striking those who were
addicted to spirits and, more unfortunately, on those
who lived in the hovels of the new industrial districts.
They were the unwitting victims.

As the epidemic progressed, however, the blame
was transferred to outdoor lavatories, cesspools in

BOARD OF WORKS
FOR THE LIMEHOUSE DISTRICT.
COMPRISING LIMEHOUSE, RATCLIFF, SHADWELL & WAPPING.

In consequence of the appearance of **CHOLERA** within this District, the Board have appointed the under-mentioned Medical Gentlemen who will give ADVICE, MEDICINE, AND ASSISTANCE, FREE OF ANY CHARGE, AND UPON APPLICATION, AT ANY HOUR OF THE DAY OR NIGHT.

The Inhabitants are earnestly requested not to neglect the first symptoms of the appearance of Disease, (which in its early stage is easy to cure), but to apply, WITHOUT DELAY, to one of the Medical Gentlemen appointed.

The Board have opened an Establishment for the reception of Patients, in a building at Green Bank, near Wapping Church, (formerly used as Wapping Workhouse), where all cases of Cholera and Diarrhœa will be received and placed under the care of a competent Resident Medical Practitioner, and proper Attendants.

THE FOLLOWING ARE THE MEDICAL GENTLEMEN TO BE APPLIED TO:--

Mr. ORTON,
56, White Horse Street.

Dr. NIGHTINGALL,
4. Commercial Terrace, Commercial Road, (near Limehouse Church.)

Mr. SCHROEDER,
53, Three Colt Street, Limehouse.

Mr. HARRIS,
5, York Terrace, Commercial Road, (opposite Stepney Railway Station.)

Mr. CAMBELL,
At Mr. GRAY's, Chemist, Old Road, opposite "The World's End."

Mr. LYNCH,
St. James's Terrace, Back Road, Shadwell.

Mr. HECKFORD,
At the Dispensary, Wapping Workhouse.

BY ORDER,

BOARD OFFICES, WHITE HORSE STREET, 26th July, 1866.

THOS. W. RATCLIFF,
Clerk to the Board.

> 'It would only be necessary for all persons attending or waiting on the patient to wash their hands carefully and frequently.'
> John Snow, 1849

the alleys or back streets, and malodorous slums. A vicar wrote that 'the pestilence was literally sweeping everything before it, neither age, nor sex, nor station escaping … To describe the consternation of the people is impossible. Manufactories and workshops were closed; business completely at a standstill; women seen in a state of distraction running in all directions for medical help for their dying husbands, husbands for their wives, and children for their parents; the hearse conveying the dead to the grave, without intermission either by night or day'. In London itself there were more than five thousand fatalities, and the national death toll reached more than twenty thousand.

But there was no real understanding of the causes of the infection, which was variously attributed to bodily emanations, to the weather and to the fetid atmosphere on the common principle that 'all smell is disease'. As a result, no sufficient preventive measures were taken. There was a general demand for more sewers, but it was not realized at the time that they were the principal cause of the epidemic. One remedy was known as 'the cold-water cure', by which the infected person jumped off Waterloo Bridge into the Thames.

Another epidemic followed in 1848, which resulted in more than fifty-three thousand deaths or more than twice the number of the previous epidemic. This deadly infection prompted one London doctor to investigate more carefully the causes of the disease. In 1849 John Snow wrote a pamphlet, *On the Mode of*

Communication of Cholera, in which he suggested that cholera was not transmitted by some human contact or mysterious 'effluvium' in the air. It was in fact connected to the polluted and often brown or black water of the Thames, which was piped into various neighbourhoods without any understanding of the consequences.

In his concluding paragraph Snow noted that:

… it would only be necessary for all persons attending or waiting on the patient to wash their hands carefully and frequently, never omitting to do so before touching food, and for everybody to avoid drinking, or using for culinary purposes, water into which drains and sewers empty themselves; or, if that cannot be accomplished, to have the water filtered and well boiled before it is used. The sanitary measure most required in the metropolis is a supply of water for the south and east districts of it from some source quite removed from the sewers.

He tested his theories with the onset of the disease in the area of Soho, where he was a general practitioner. It took him to Broad Street, now known as Broadwick Street. He wrote:

… on proceeding to the spot, I found that nearly all the deaths had taken place within a short distance of the [Broad Street] pump. There were only ten deaths in houses situated decidedly

nearer to another street-pump. In five of these cases the families of the deceased persons informed me that they always sent to the pump in Broad Street, as they preferred the water to that of the pumps which were nearer. In three other cases, the deceased were children who went to school near the pump in Broad Street.

Here was the key to the mystery. Snow had found that the centre of the 'cholera field' was this particular well-used pump, and the field of the disease itself was for practical purposes bounded by Great Marlborough Street, Dean Street, Brewer Street and King Street. In this small area there were over five hundred cholera deaths in ten days. Snow called it 'the most terrible outbreak of cholera which ever occurred in this kingdom'. The Board of Guardians for the district ensured that the handle of the pump was broken off, and the incidence of new cases came to an end.

In pursuit of this insight, which may be said to have initiated the discipline of epidemiology, John Snow devised a cholera map of the entire city. He began to track every manifestation of the disease with black marks or lines. There were in fact two maps, produced in 1854 and 1855, but they share the distinction of being the first epidemiological maps. They are stark diagrams of disease, roughly if skilfully drawn with rectangles, bars, lines and circles in black. The pumps are carefully circled and registered. The number of bars represents the number of deaths in one house. Just beside the black circle representing the pump in Broad Street is a house that bears the load of many victims. In the Victorian era, of course, death was depicted in black. The map is a montage of blackness, an intense and fascinating study in monochrome. Snow's map was one that changed the face of medicine.

London in the late nineteenth century was a city of grades and distinctions, the most vivid and obvious being the gap between the rich or 'middling' classes and the poor. There were areas where they lived in close proximity so that a rich man's dwelling might be around the corner from a tenement, but in general those citizens of a certain type or class tended to congregate in specified neighbourhoods. In *The Voyage Out* Virginia Woolf noted of a character that 'Mrs Ambrose understood that after all it was an ordinary thing to be poor, and that London is the city of innumerable poor people.' But it was a ship-owner and social reformer who plotted the extent and location of urban poverty. In 1889 and 1891 Charles Booth published two volumes of his survey, *Life and Labour of the People*, which was then extended into nine volumes as *Inquiry into the Life and Labour of London*.

These books heralded the most influential and significant contribution to urban sociology in his 'poverty map' of the metropolis. His early survey of 1889 was revised ten years later when, as Booth and

his team put it, 'every street, court and alley has been visited … changes have been most carefully considered … [most changes are] the result of the natural alterations of ten years of demolitions, rebuilding and expansion involving changes in the character or distribution of the population'. The members of the survey would walk through the specific streets and areas assigned to them, generally in the company of a policeman to avoid undue attention from the inhabitants. As a result, there were in fact twelve maps, all completed between 1898 and 1899, which covered the city from Hammersmith in the west to Greenwich in the east and from Hampstead in the north to Clapham in the south. The first map, that of the East End, had been published in 1889; it gave a local habitation and a name to an area that had been described in journalistic terms as 'the abyss', 'darkest London' and 'the nether world'.

Booth employed seven colours as tokens for streets ranging from those of relative affluence to those of direst need. They began with black for 'the lowest class. Vicious and semi-criminal'; this was followed by dark blue for 'very poor, casual. Chronic want', succeeded by light blue for 'poor. 18s to 21s a week for a moderate family'. The streets marked in purple signified 'mixed. Some comfortable others poor' while pink marked out those who were 'fairly comfortable. Good ordinary earnings'. Red conveyed the streets inhabited by the 'middle class. Well to do' and yellow signified 'Upper-middle and upper classes. Wealthy'. In the first of the maps, displaying the East End in diagrammatic fashion, there were distinct areas of black such as Dorset Street and the end of Flower and Dean Street as well as the area marked out by Thrawl Street and George Street. But the general pattern is one of mixture and variety with a preponderance of light and dark blue together with purple. There is no yellow in the East End.

The maps, as an entire survey, reveal that contrary to popular belief poverty was not concentrated in

Right: Charles Booth's detailed 'Descriptive Map of East End Poverty' (1889) shows the most deprived streets in black.

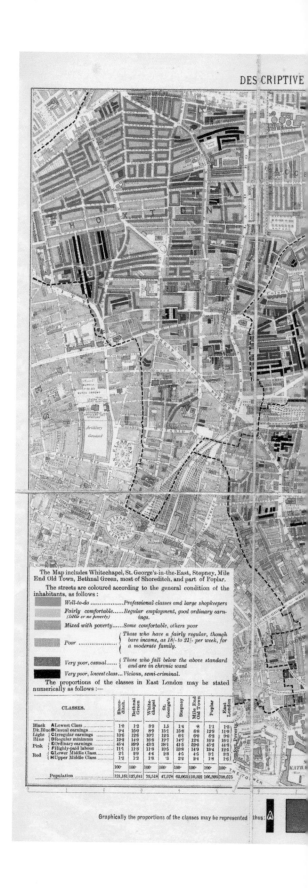

The Map includes Whitechapel, St. George's-in-the-East, Stepney, Mile End Old Town, Bethnal Green, most of Shoreditch, and part of Poplar.

The streets are coloured according to the general condition of the inhabitants, as follows :

Well-to-doProfessional classes and large shopkeepers

Fairly comfortable......Regular employment, good ordinary earnings. (little or no poverty).

Mixed with poverty......Some comfortable, others poor

Poor { Those who have a fairly regular, though bare income, as 18/- to 21/- per week, for a moderate family.

Very poor, casual....... { Those who fall below the above standard and are in chronic want.

Very poor, lowest class...Vicious, semi-criminal.

The proportions of the classes in East London may be stated numerically as follows :—

CLASSES.	Shoreditch.	Bethnal Green.	Whitechapel.	St. George's.	Stepney.	Mile End Old Town.	Poplar.	East London.
Black A Lowest Class	1·0	1·2	3·3	1·5	1·4	·8	1·1	1·5
Dk.Blue B Casual earnings	9·4	16·0	8·2	15·1	15·8	6·8	12·9	11·9
Light C Intermittent earnings	10·6	12·6	10·7	12·5	6·1	6·0	6·3	9·0
Blue D Regular minimum	19·2	14·9	16·6	19·7	14·7	12·6	10·3	16·1
Pink E Ordinary earnings	45·4	39·9	43·8	39·1	41·5	53·0	45·2	44·3
F Highly-paid labour	11·1	11·3	11·8	10·5	10·8	14·9	19·4	12·5
Red G Lower Middle Class	2·1	2·9	4·4	2·8	4·5	4·5	2·1	3·3
H Upper Middle Class	1·2	1·2	1·8	·3	2·2	2·4	1·8	1·6
	100·	100·	100·	100·	100·	100·	100·	100·
Population	121,161	127,041	78,518	47,576	62,065	110,321	166,305	708,675

Graphically the proportions of the classes may be represented thus: A

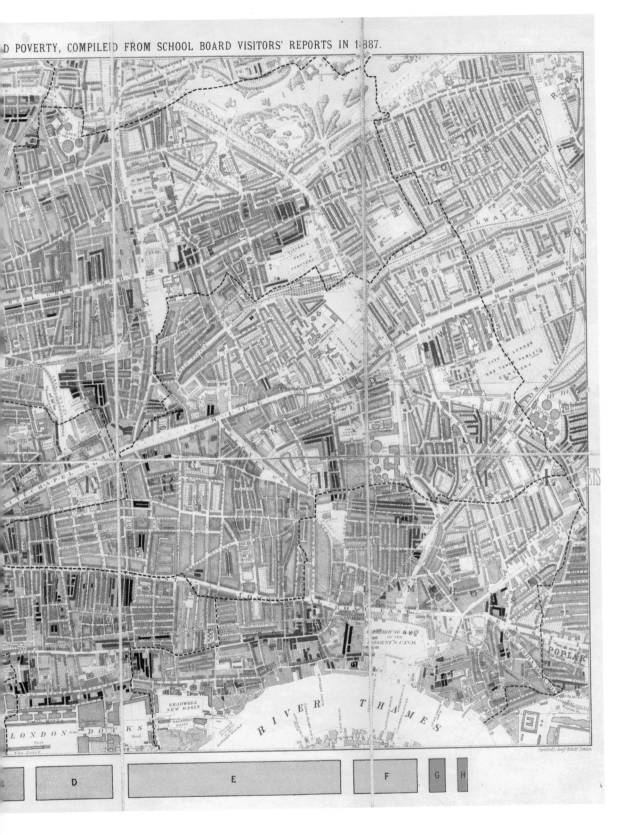

specific areas. It was more conspicuous in East London and south of river, but it is evident that the poor lived throughout London, and often in relatively affluent areas. They shared the same neighbourhood as the wealthy, often living in an adjacent street or even in the same street. So the poor and the well-to-do lived side by side. Black was in all quarters of the city. The maps do show there was more poverty in the east of London than the west, but, until the suburbs were reached, most London areas had a mixed character in social and economic terms; this is the distinguishing characteristic of the city, comprising its essential identity.

The choice of warmer, brighter colours for wealthier areas (red or yellow), and colder colours (blue or black) for poorer districts, is noticeable. The associations are obvious. Black has been characteristically connected with evil and ignorance. Red, however, is the most vibrant colour on the maps; it is as though the middle class pronounced it to be the best, and it represents the most characteristic economic status for a Victorian Londoner. Yet Booth had also discovered that 33 per cent of Londoners were living in poverty, with an even greater proportion, 35 per cent, among those living in the city's East End.

The survey and its maps received much attention from the newspaper writers. The *Manchester Guardian* commented that the poverty maps had raised the 'curtain behind which East London had been hidden' and revealed to the nation a 'physical chart of sorrow,

suffering and crime'. Booth's work came in a period when the plight of the poor was fully described and assessed. One of the more influential surveys, *The Bitter Cry of Outcast London*, depicted the 'pestilential human rookeries' in which the poor were living. Its author, Andrew Mearns, wrote:

> We do not say the condition of their homes, for how can those places be called homes … Few who will read these pages have any conception of what these pestilential human rookeries are, where tens of thousands are crowded together … To get into them you have to penetrate courts reeking with poisonous and malodorous gases arising from accumulations of sewage and refuse scattered in all directions and often flowing beneath your feet.

The colour codes of Booth's survey emphasize the experience of travellers to London who noticed impoverishment in the most unlikely places, and commented how degrading and degraded were the London poor, quite different from their counterparts in Rome or Berlin or Paris. This may or may not be true but the maps reveal that there were cities of want and despair within the larger city. The multi-coloured maps are a mosaic of suffering.

It is appropriate, then, to note that Booth ends his extensive survey with a memorable paragraph.

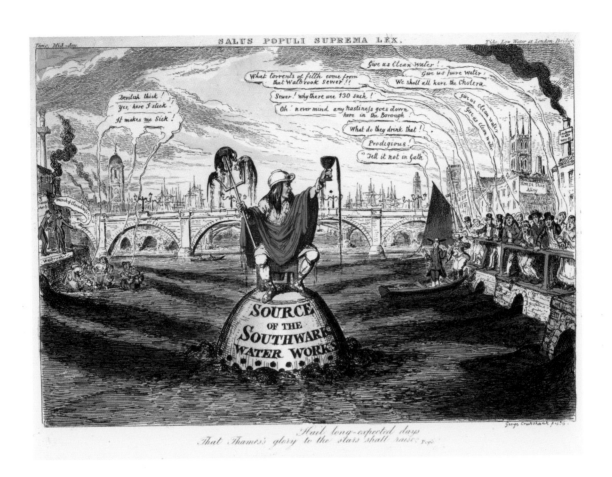

Above: George Cruikshank's 1832 cartoon 'The welfare of the people is the supreme law' highlights growing public concern over the pollution of the Thames.

'The dry bones,' he wrote, 'that lie scattered over the long valley we have traversed together lie before my reader. May some great soul, master of a subtler and nobler alchemy than mine, disentangle the confused issues, reconcile the apparent contradictions in aim, melt and commingle the various influences for good into one divine uniformity of effort and make these dry bones live, so that the streets of our Jerusalem may sing with joy.' Only on that day will the stain of black be removed.

Left: *East London* (1908) by Joseph Pennell.

THE
NIGHT

...

'One thing about London is that
when you step out into the night,
it swallows you.'

Sebastian Faulks, *Engleby*

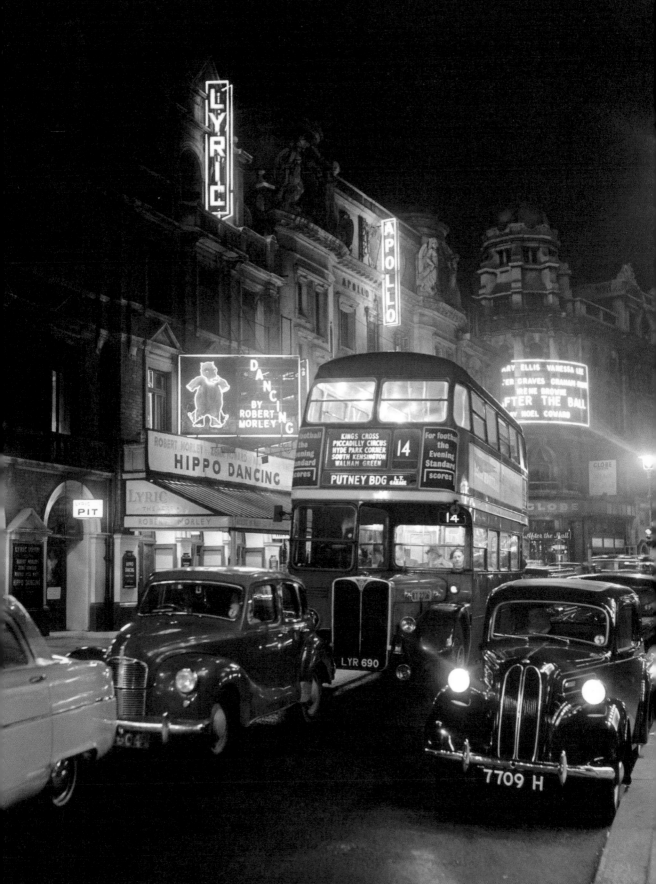

One of the great scenic masterpieces, whether of triumph or horror, became that of London by night. It may be that the city is truly itself, and becomes truly alive, only at night. That is why it has exercised a constant fascination, from Whistler's *Nocturnes* to James Thomson's 'The City of Dreadful Night'. It was as if the inhabitants of the city were haunted by its presence and its fateful possibilities so that in the words of Rudyard Kipling, recently arrived in London, 'here, for the first time, it happened that the night got into my head.' In the nineteenth and twentieth centuries, the night encompassed the shadows of London.

But for some, the night of London is filled with colour. In 1840 Flora Tristan wrote in her *London Journal* that 'it is really at night that London must be seen! London, magically lit by its millions of gas lights, is resplendent! Its broad streets disappearing into the distance, its shops, where floods of light reveal the myriad sparkling colours of all the masterpieces conceived by human industry.' For others it is the city of dreadful darkness. In 1868 Henry James noted that:

> ... the low black houses were as inanimate as so many rows of coal scuttles, save where at frequent corners, from a gin-shop, there was a flare of sight more brutal still than the darkness ... A sudden horror of the whole

place came over me, like a tiger-pounce of home sickness which had been watching its moment. London was hideous, vicious, cruel, and above all overwhelming.

The notion of pitch darkness applies to the night; it may be smeared upon you, like pitch; it may fasten itself to you and drag you down, like pitch; after the London night, you may never be clean again.

The days are long gone when certain streets, or alleys, were cast in semi-darkness by the absence of lamps and when London itself could be described half in earnest as the city of night. Gaslight, once the standard light of Victorian London and the crepuscular setting for a thousand tales of crime and passion, was for much of the nineteenth century celebrated as a wonder of urban civilization so that 'its shops, were all brightness and wonder'. For others gaslight became more glorious for the shadows which it cast; it created a city of softness and mystery, with sudden pools of light fringed by blackness and silence. One of the great images of Victorian London is that of the gas lamp flickering in the fog.

The fitful gaslight of the streets lent the appearance of direct flame, and this was amplified by those domestic interiors, which were still illuminated by candles or oil lights created from olive oil, beeswax, fish oil, whale oil or nut oil. The single most significant force of light was derived of course

from the moon, which was then not obscured by the glow of London itself; its iridescence was reflected in the river and in the smooth surfaces of water in the squares and parks. One prominent colour was known as 'gas green' or 'gaslight green'. Whistler's *Nocturnes* are a rich and evocative study of London in moonlight and the enveloping darkness.

In fact the gaslight soon began to appear dim and flickering beside its successor. The first employment of electric light was upon the recently constructed Embankment in 1878, which was followed by the illumination of Billingsgate and the Holborn Viaduct as well as two or three theatres. 'The golden tint of the electric light' was apostrophized when 'the gold and silver lamps' emerge from the twilight. By the early 1890s the first electric advertising signs were placed in Piccadilly Circus, and the new electric light ensured that 'the shops shine bright anew'. This may be the context in which to place the theatres and music halls of London, once beacons of colour and brightness spilling over into the streets. The Strand Music Hall was a pioneer of light and shade, just as the Palace Theatre in Cambridge Circus now fulfils a similar role. Walter Sickert's paintings of the music halls display all the colour and variety of their interiors, with blue columns, red and green scenic displays, shining chandeliers and, of course, the sometimes coarsely dressed audience. The crepuscular gloom of London was lightened. In the autumn of 1931 the most significant public and commercial buildings were for the first time illuminated by floodlighting.

Left: A colourized photograph showing various types of gas lamp-posts on display on the road running through Wandsworth Gasworks, 5 November 1934.

Right above: *Buckingham Palace by Night* (1920s) by Yoshio Markino.
Right below: *Piccadilly Circus, London* (c.1911), London by George Hyde-Pownall

Overleaf: Early-twentieth-century poster advertising 'Wotan' and 'Tantalum' lamps.

'Anyone who has ever visited London must have been at least once in the Haymarket at night.'

Fyodor Dostoyevsky, 1863

The search for colour and novelty was always intense and the passion for posters blossomed into the 'electric advertisements' when Vinolia Soap, for example, was hailed in illuminated letters above Trafalgar Square. Advertisements in lights, to general astonishments, began to move. At Piccadilly Circus could be seen a red crystal bottle pouring port into a glass, and a car with turning silver wheels. Yet some Londoners complained about the unfamiliar brightness. It was suggested that electric light lent 'a corpse-like quality' to the skin while in the floodlit streets 'the crowd looks almost dangerous and garish'. This particular light was more 'cruel and clinical' than the familiar gaslight.

The great totem of London at night is, of course, the places of amusement. They are London's glory perhaps, and full of colour. Dostoyevsky remembered many things about London, but his recollection of the gin palace strikes us most.

He wrote:

… the beer houses are decorated like palaces … Anyone who has ever visited London must have been at least once in the Haymarket at night. It is a district in certain streets of which prostitutes swarm by night in their thousands. Streets are lit by jets of gas – something completely unknown in our own country. At every step you come across magnificent public houses, all mirrors and gilt … It is a terrifying experience to find oneself in that crowd. And, what an odd amalgam it is. You will find old women there and beautiful women at the sight of whom you stop in amazement.

Two images of Piccadilly Circus point the paradox of gaiety and gloom in the London night. One is a colour lithograph of 1926 advertising the services of the London, Midland and Scottish Railway for transporting customers to the capital; it shows a brightly lit crowd of revellers, or passers-by, with a newspaper boy and a flower seller as

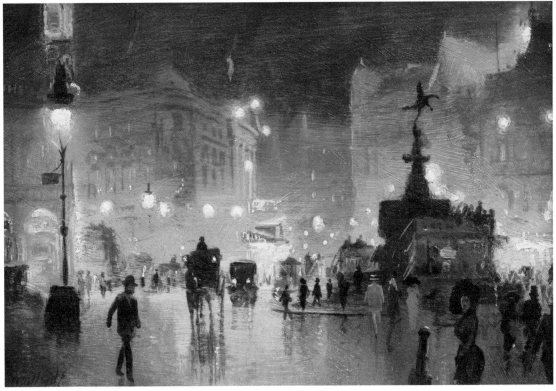

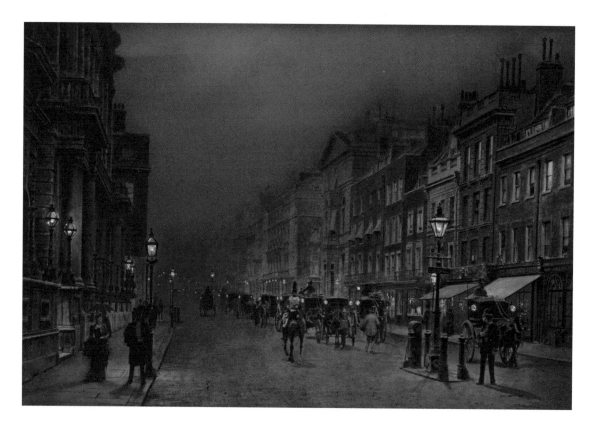

well as the ubiquitous red buses. It is incandescent with radiance and colour. The other is an oil painting of 1910 by Arthur Hacker, *A Wet Night at Piccadilly Circus*, that depicts a yellow mist of rain or drizzle drenching the carriages and pedestrians passing by; the lights and buildings are blurred by dampness, and the moisture seems almost to permeate through the canvas. Yet even here there is the saving glow of illumination, to demonstrate that this is really how London ought to be.

Electricity was followed in turn by sodium light and LED. The wavelengths of green light shorten, softening the shades of yellow to a warm orange glow. The city at night unfolds through the sunset into deep blues, and the array of phosphorous street lighting is high enough to be distinct from the amber indicators of vehicles. Perhaps the real colours of London are only visible at night. It is a magnificent paradox. Night does not merely reveal colour, it *is* colour, the mother of colours. H.V. Morton wrote, in *In Search of England*, that 'I opened my window to an April night and, looking down

into the London square, saw that new leaves were silver-white in the lamplight …. The top boughs of the trees were etched against the saffron stain of a London sky, but their boles descended into a pool of darkness, silent and remote as the primeval forest'. The city may show itself best at night. Now London has perhaps reached the limit of over-brightness, where the night sky is scarcely visible.

Above: *St James's Street* (oil on a photographic base) by John Atkinson Grimshaw. Right: Neon advertising signs illuminating Piccadilly Circus, *c.*1965.

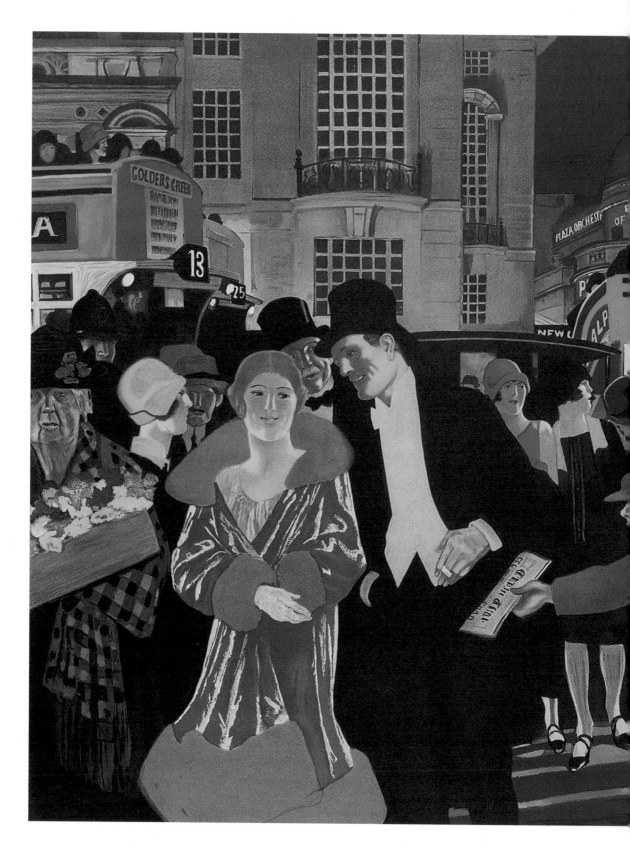

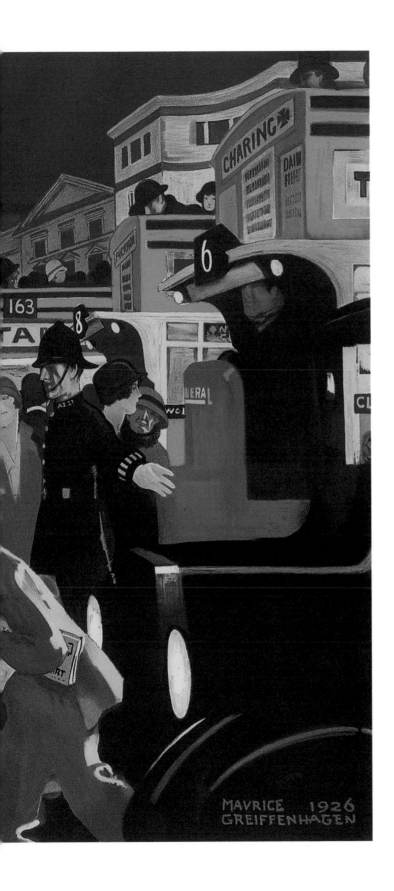

MAURICE 1926
GREIFFENHAGEN

Left: *London by LMS* (1926), an
advertisement for the London,
Midland and Scottish Railway by
Maurice Greiffenhagen.
Overleaf: Christmas lights on
Regent Street in 1963.

THE FULL SPECTRUM

..

'a city of music, of colour, of gladness.'

Jerome K. Jerome, *All Roads Lead to Calvary*

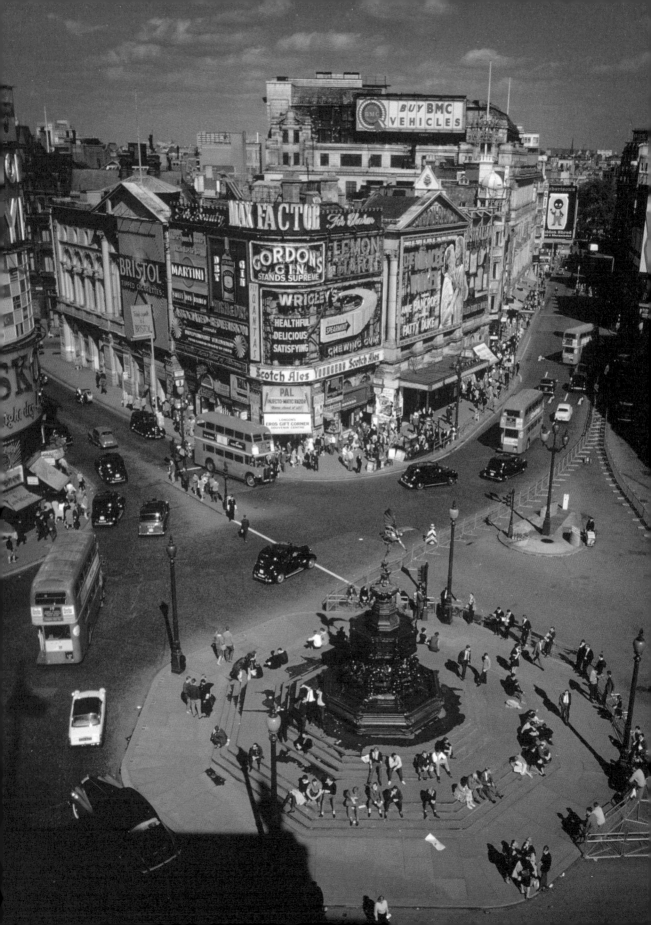

The shops and houses, the distinct areas and streets, and, more particularly, the clothes of ordinary Londoners make up the colour spectrum of the city. It has justly been assumed that London took its form as a number of villages, each with its own separate identity, which may account for the fact that contemporary maps of London boroughs are often outlined and named in different colours. Their 'logos' and coats of arms are designed to be distinctive. Newham is pink, Hillingdon green and Havering is blue; Westminster is indigo and gold, while Bexley is purple or dark blue. Camden is turquoise and Richmond is naturally green. The boroughs along the river have naturally chosen various hues of blue, but none prefers yellow, orange or white. There was a time when the different parishes of London coloured their lamp-posts and dust carts with their distinctive colours, while the train carriages and buses wore the colours of their own local companies. They suggest that specific areas display a local colour affinity in terms of spectacle or display, in the energy and melodrama of contemporary life. In an earlier era the British Colour Council also offered a variety of local colours including Thames Blue, Vauxhall Rose, Chelsea Blue, Mayfair Lilac and of course London Pride, which was classified as a 'brave pink'.

Certain areas of London seem to attract colour as their particular ambience or atmosphere. Piccadilly Circus is, for obvious reasons, one of the warm zones of colour; the ever-moving advertisements above,

and the ever-circulating traffic beneath, render it incandescent. These areas of colour in some way mimic the 'heat islands' or 'hot spots' of the capital where temperatures are highest. A pilgrimage from Buckingham Palace to London City Airport will take in the London Eye, Waterloo station, St Paul's Cathedral, the Tower of London, the Shard and Canary Wharf where the colours of London will be most prominent.

Charing Cross has always been a site of picturesque bustle and busy humanity. It was once known for its jewellers, hosiers, instrument makers and saddlers as well as for the imposing shapes of Northumberland House and the Golden Cross Inn; now it is best known for Charing Cross station, small restaurants, fast-food outlets, supermarkets and public houses with their own distinctive hues. Villiers Street, running alongside it from the Strand to the Embankment is one of the busiest thoroughfares in London and still merits Charles Lamb's eulogy on gazing upon Charing Cross when he wrote that 'I often shed tears in the motley Strand, for fullness of joy at such a multitude of life'. Motley used to mean multi-coloured, like the dress of a harlequin. Lamb's observation is also a celebration of the scenic and the playful, the energy and display, which comprise the great general drama of the human spirit best expressed in the variations of colour.

Other areas provided zones of colour in the city, among them Southwark and Borough Market, Notting Hill and Petticoat Lane, Exmouth Market in

Clerkenwell, the first 'garden suburb' of Bedford Park
with its red brick and steeply pitched roofs, as well
as the endless movement of pedestrians and traffic
along the Strand and into Fleet Street. In the environs
of Hampstead Heath every shade of organic green
proliferates, even though the heath itself was the
product of careful urban planning.

If there was one great quarter of London that was
once overlooked or neglected, it was that of the
East End. That side of the city was condemned
as 'base' or 'filthy' for many centuries; its colour
was supposed to be that of dirt and mud, with its
tenements and cottages and inhabitants sharing the
general corruption and darkness. It was assumed that
the long lines of low houses were constructed of the
same tarnished yellow brick, all begrimed by the same
smoke; but the desolation and dreariness in truth had
no part of the quarter's life, which always broke into
colourful cheerfulness. Every street and lane still has
its own colour and atmosphere.

Markets can be found in all neighbourhoods –
among them Rosemary Lane, Spitalfields, Chrisp
Street and Watney Street – and by the 1850s the
East End contained some hundred and fifty music
halls. It was known, perhaps somewhat patronisingly,
as the quarter of 'glitter and gas' with its chop houses,
public houses, gin shops and cook shops. The colours
were bright to the point of dazzlement with the
flares of naphtha, tallow candles and gas. Some shops,
of various shapes and sizes, could be found squeezed
between the tight little houses; one might sell
musical instruments and another might specialize
in parrot cages.

One of the most surprising aspects of the
contemporary East End lies in the extent to which
it has reproduced its old street life, populated by
small two-storey businesses (the owners or lodgers
living upstairs) ranging from television repairers
to newsagents, upholsterers to fruiterers, cabinet
makers to money exchangers. The reddish-grey
streets are enlivened by doors red and green,
by yellow fencing, by blue sign-boards and by

SUMMER SALES
QUICKLY REACHED BY

pubs decked in yellow, white and red. The
Whitechapel Road and the Mile End Road are a
mass of discordant hues and textures, with striped
awnings and cabmen's shelters and market goods
spilling out into the traffic.

Some pubs are decked in red and white insignia
while others are covered in green tiles. Corner pubs
often display white brick on the first floor and violet
paint on the lower. A line of shops may create a
kaleidoscope of colour along a narrow street. Large
advertisements in an array of colours are plastered
against dim and decayed walls. Hoardings for
Guinness or Truman's Beer break up the vistas of red
brick while some dwellings seem to have turned quite
violet with age and wear. Metal barrels of various
hues are piled up against warehouses of corrugated
iron. It is impossible to avoid the green and gold of
the Hovis advertisements as well as the red, blue and
white of the Underground signs. With so many low-
lying streets, the sky seems larger here, while the
blue, red and white carriages of the Docklands Light
Railway help to embroider the horizon.

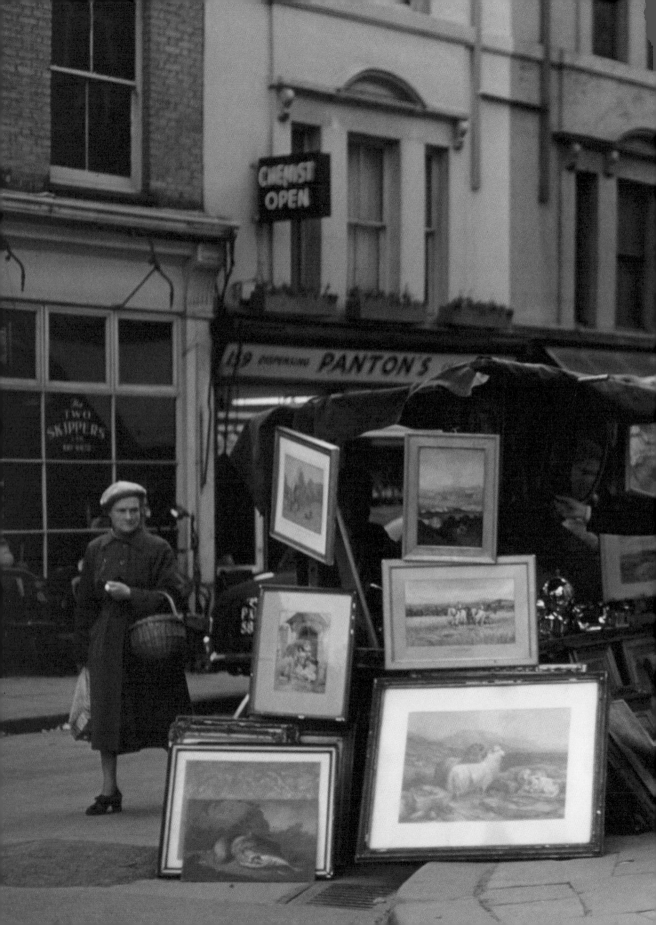

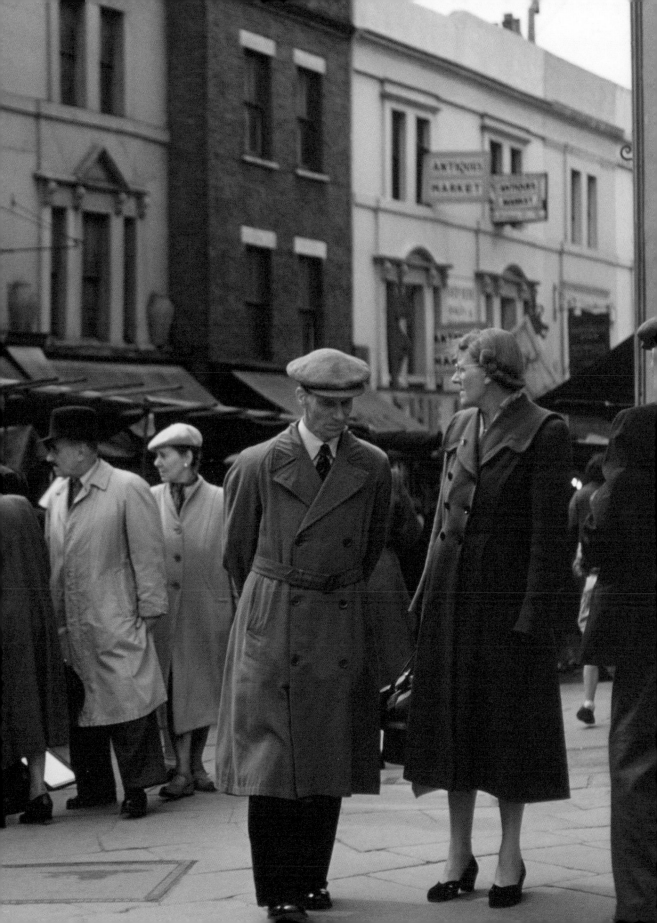

The chaotic graffiti on the walls and railway bridges, words slurring into one another, provide much of the colour in antic red and blue and yellow making up indecipherable scrawls or names. Fences or boarded building sites provoke a passion for colour and display among a band of regular East Enders fully armed with paint or aerosol. It is a riot of passage, albeit temporary.

Signs blaze out in white or pink, red or black: 'Shit House to Penthouse', 'Please Sir, Can I Have Some More?', 'Future Ghosts'. The lock-up garages become canvases, revealing the fury and activity all around them, while the barks of trees in roads and parks and neighbouring woods are bathed in artificial colours as if to emphasize their urban provenance. Some railway bridges, however, their arches reminiscent of earlier times, are often ignored with their dusky interiors and their grim or grimy brick.

Other areas have distinct hues and shades. In Little Venice the scarlet glow of the lamplight can be seen from the barges in the evening. This is an area of dark, rich magenta and gentle greens, as well as the still predominant red. Iris Murdoch recalled Goldhawk Road in *Under the Net* when she wrote that 'he lived off the Goldhawk Road, in one of those reddish-black buildings which for some reason are called mansions. It was in such contexts, in my dark London childhood, that I first learnt the word, and it has ruined many pieces of prose for me since, including some Biblical ones.' Turnham Green, London's first garden suburb, is similarly red but, unlike the 'mansions', it is the abode of the more affluent. However, the cumulative effect of so much dark crimson is unsettling rather than cosy.

The corner of Hammersmith that abuts Shepherd's Bush shows houses friendly, fat and greyish brown. Brighter colours begin to assert themselves once the traveller moves closer to Hammersmith Broadway itself. From Wellesley Avenue and Brackenbury 'village' eastwards, emerge the first pastels and the first attempts to fend off uniformity. In these houses there are not only more colours but also greater height and more decoration; in short, they display more evidence of wealth. It would be tempting to suggest that colour indicates wealth in London, but that assumption would be misleading. The poorest neighbourhoods may be the more various.

In Fulham, at first glance, red predominates. But it also has many of the pastel, stucco houses familiar from Primrose Hill or Portobello Road. At the centre of Fulham Broadway stands a splendidly picturesque public house, all green and gold. It is indeed remarkable how this supremely bourgeois city, this city founded by burghers, revolts against its own respectability in the most unlikely places.

South of the river is Putney, which has one central thoroughfare, like Highgate, and some elegant offshoots. But above all, it has the river, and the sunset on the river. Anyone who has stood on Putney Bridge and seen the first pools of sunset on the gentle eddies of the Thames, the clouds growing petals of rose, the

Right: *Putney for River and Heath* (1932), an advertisement for London County Council Tramways by R.F. Fordred.

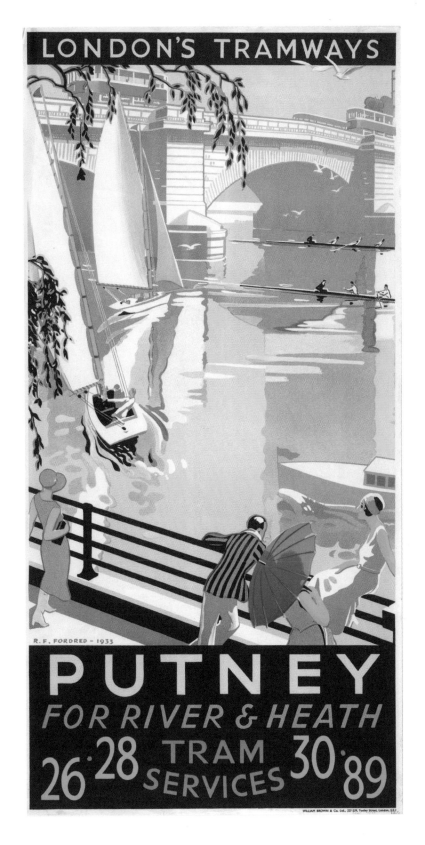

weeping willows, and the native willows, and their trunks twisting crazily over the flood, must stop, must wait, must look and forget all else. This, too, is London after all.

But Putney was not always regarded in that light. The gentle, grey-yellow houses were once considered quintessentially suburban. When he went to visit Swinburne, A.C. Benson commented in *Edwardian Excursions*:

> … the day was dark and gloomy. I got to Putney about 1.15 and walked into the street … I was standing in a very common suburban street, with omnibuses and cabs, and two rows of semi-detached houses going up the gentle acclivity of the hill. I suddenly saw I was standing opposite the house, a perfectly commonplace bow-windowed yellow-brick house, with a few shrubs in the tiny garden … I was taken into a dining-room on the right looking out at the back. To the left the tall backs of yellow-brick houses; the gardens full or orchard trees in bloom. A little garden lay beneath with a small yew hedge and a statue of a nymph, rather smoke-stained, some tall elms in the background.

What was once the colour of suburbia is now the colour of affluence.

Harlesden has an abundance of colours with burnt ochre, raw umber and light crimson among them. There are all the colours of the south, and its inhabitants match them, whether they come from West Africa, the Caribbean or Portugal. But in Camden Town the pedestrian will meet London's first unabashedly colourful district. From the moment they leave the station, they are assailed by colour. There is the great hoarding that announces Camden Lock, blue and yellow and very large. There are the vast, polychromatic sculptures that adorn the local shops. There is the lock itself, glittering green and blue and black. The paintings and lithographs of David Gentleman depict this general area. The artist shows us the red of St Pancras, the honey-coloured stone of King's Cross and, everywhere, London's little mascot of the red telephone box.

And then of course the green thoughts and green shades of Hampstead define one part of London. There is a notion peculiar to Londoners, or perhaps to all metropolitans, that somehow green can save you from grey, that nature can rescue you from the troubles of the city; it may be believed by some that misery might itself be only an emanation of the city to be dispelled by a breeze in the branches. Michael Wharton acknowledges this in *The Stretchford Chronicles* where he writes that 'I have hated Hampstead for her Left-wingery, but I have loved her for her strange, secret, leafy soul. Nowhere in London are green thoughts so green, especially in a rainy June, when the grass grows high in her innumerable gardens tamed and wild.'

Close to Hampstead is Highgate, which was once the gateway to London. For all its Georgian gentility, it still carries the feel of an outpost. After all, it is only a small promontory poking into a mass of untamed green. Coleridge once lived in Highgate, in honoured semi-retirement. Thomas Carlyle invites us to imagine 'the mage' enthroned in that 'waving blooming country of the brightest green, dotted all over with handsome villas, handsome groves; crossed by roads and human traffic … and behind all swam, under olive-tinted haze, the illimitable limitary ocean of London'. Thus an English green gives way to a Mediterranean green, which in turn gives way to blue. But the areas of London, each with its own particular shade or colour, are themselves illimitable.

The streets of London have always been its most varied and colourful aspect. Some are wide, and others are narrow; some are straight and others are circuitous. But all of them lead into colour. The confusion of dirt, refuse and over-hanging signboards had been removed by the 1780s from which emerged the first navigable thoroughfares. Yet in the last decades of the nineteenth century, the filth and mud were everywhere. 'Mother!' one fictional character calls out. 'Bury me in the open fields -anywhere but in these dreadful streets … they have killed me.' In the slums of London, with their rookeries and penny lodging houses, every type of crime and sexual deviancy were to be found. In the extant sepia-tinted photographs of the period, black and misty brown tell their own story. The stray pedestrians, or standing figures, seem like wraiths or tricks of the light beside the enduring realities of brick and stone.

The detritus of the streets, broad or narrow, consisted of the litter of orange peel and oyster shells, broken crockery and faded cabbage leaves, rubble and animal droppings, surmounted by posts, scraps of tarpaulin and broken barrel staves, all of them coated in soot or damp. But all was not lost. In 1925 the German architect, Bruno Taut, wrote that 'everything in the world has colour of some sort. Nature has colour, even the grey of dust and soot, even gloom has colour of some kind. Where there is light, there must be colour. All man has to do is give this phenomenon form.' Pristine brick will eventually darken and finally acquire a patina of moss. Heinrich Heine noted that the streets and buildings of London were 'a brown olive-green colour, on account of the damp and coal smoke.'

In certain districts the neighbours leaned from open windows to watch the passing scene, while in others the unobstructed windows revealed the interior life of each dwelling under gas or electric light. An evening journey down London streets still offers a hundred different vistas of lives caught in a moment of illumination, as if they were in some sense interlinked.

In the streets themselves the multiplicity of signs and instructions break up the colours with red barriers, yellow lines, white lines complementing the

In Camden Town the pedestrian will meet London's first unabashedly colourful district. From the moment they leave the station, they are assailed by colour.

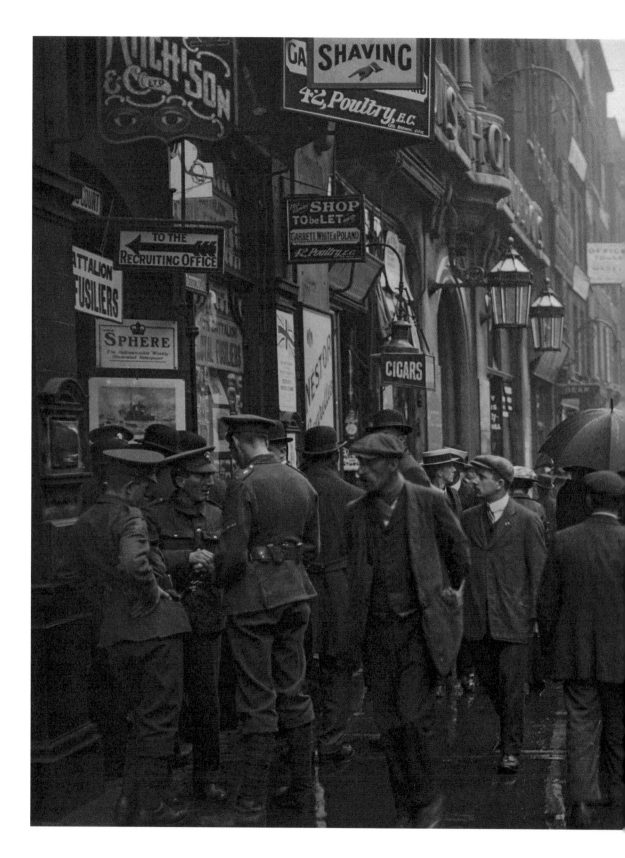

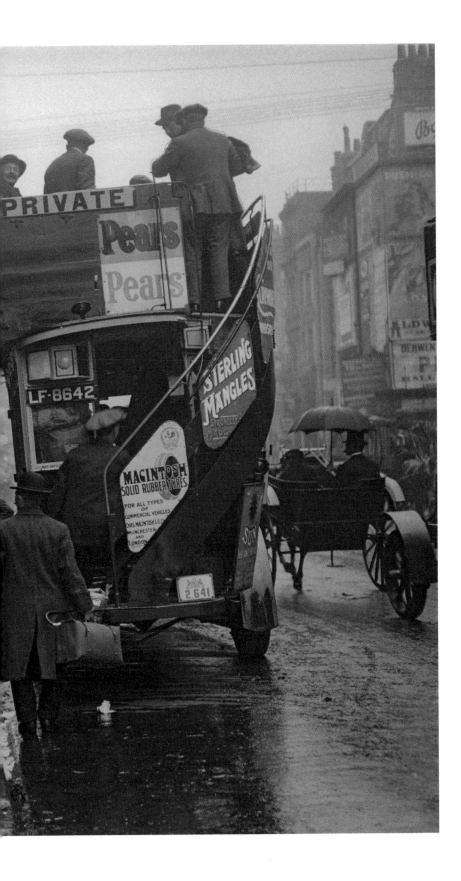

Left: A colourized photograph showing a rainy day on Fleet Street in October 1915.

white, yellow and red lights of the signalling. Some streets seem always to be in shadow from the scale of the buildings along their routes, while others are bathed in sunlight with buses, lorries, taxis, trucks and cars providing a kaleidoscopic whirl of activity.

The fabric of London streets is characteristically composed of Victorian buildings, Edwardian housing and modern blocks of shops or offices. The bank is beside the chemist, the menswear store is next to a newsagent. The shop signs are coloured white and blue, red and violet, green and yellow; Nakoda is next to Cuckoo Fashions, Whitechapel Fried Chicken is beside Coral Bookmakers, Poundbusters is next to Budgens. The adjacent advertising hoardings collide or collude with the bright signs in a panorama of expressive colour, and the constant tread of pedestrians is a reminder that such streets may have been active from time beyond memory.

The passion for street art can be attributed in part to the ubiquity of advertising. There had always been papers wrapped around the wooden posts of the street to publicize the latest auction or the latest play, but only after the demise of street signs hanging from every lintel or cornice did other forms of advertising art and colour properly emerge. By the middle of the nineteenth century London had 'grown wondrously pictorial' with a variety of papier-mâché ornaments or paintings to denote the trade of the occupant. Many coffee houses had a symbol of a loaf and cheese together with a cup, while fishmongers painted the

walls of their premises with 'a group of fish in the grand style'. Boots, cigars and sealing wax, in gigantic form, were also suspended over the doors of various shops while the destruction of Pompeii seemed a fitting advertisement for a patent cockroach exterminator.

One great innovation of the nineteenth century, brought to full fruition in the 1860s, was the advertising hoarding, and in early photographs they can be seen lining the streets and the new railway stations offering everything from Bovril to Pear's Soap. Colourful advertisements were in that sense very much part of the ideal of 'progress', since the hoardings themselves had first been erected to protect the streets from the myriad building sites and railway improvements. Once posters had been enlarged to cover these wooden frames, then advertising images appropriate to the city itself – large, gaudy and colourful – began to emerge. According to Charles Knight's *London*, published in the middle of the nineteenth century, the streets were brightened by 'rainbow-hued placards vying in gorgeous extravagance of colour with Turner's last new picture … pictures of pens … spectacles of enormous size'.

By the closing years of the nineteenth century, the ground-floor shops provided the bursts of colour and variety on the London streets with signs such as 'Café and Restaurant', 'Cigars and Tobacco', 'City Bicycle School', 'Dining and Refreshment Rooms', 'The Old Bell Tavern', 'Depot for Musical Books', 'Hair Cutter and Wig Maker'. Dickens wrote that

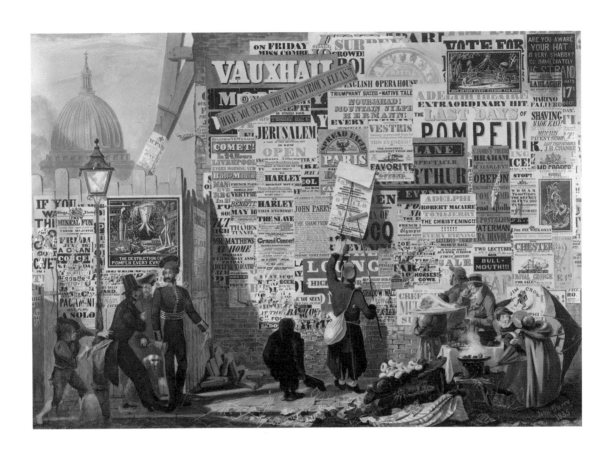

Above: *The Poster Man* (1935)
by John Orlando Parry.

'draw but a little circle above the clustering house-tops, and you shall have within its space, everything with its opposite extreme and contradiction close beside'. The details reflected in certain novels provide a clue to this lost world, from the stags' horns made of plaster of Paris and painted brown to the blue wool mats on which vases were placed in *The Diary of a Nobody* in 1888. Yoshio Markino was a Japanese artist of the early twentieth century who specialized for a while in London scenes. His *Posters in the Strand* of 1907 displays a wall covered with posters of varying shades of red, blue, grey, yellow, white and mauve against a darkening purple sky. These are surely some of the forgotten colours of London, even though they can be seen as part of a general and constantly flowing stream.

A walk down contemporary Oxford Street or the King's Road will throw up a riotous display of coloured goods, confectionery, clothes, shoes, books, toys and jewellery displayed like paintings framed in the Royal Academy. This is the city proclaiming its chromatic exuberance where joy and spectacle are mingled. Alongside them are the cars, whose colours are rarely noticed or acknowledged but whose various shades contribute to the polychromatic tone and texture of London.

No street is without colour, and no building material is devoid of it; but there are so many variations and modifications that a minute inspection would not yield any predominant tone. Offices, houses, public buildings, churches, factories, warehouses, hospitals, shops, arcades, pubs, prisons, tenements, high-rise flats and low walls confound the all-seeing eye of an imaginary observer. Nothing is fixed or certain. The rods and cones of the eye are designed to organize the principles of vision, the rods registering light and dark with the cones registering colour. If you were to bring together all of these hues in one 'London colour' there

Above: Traffic on Oxford Street, *c*.1965.

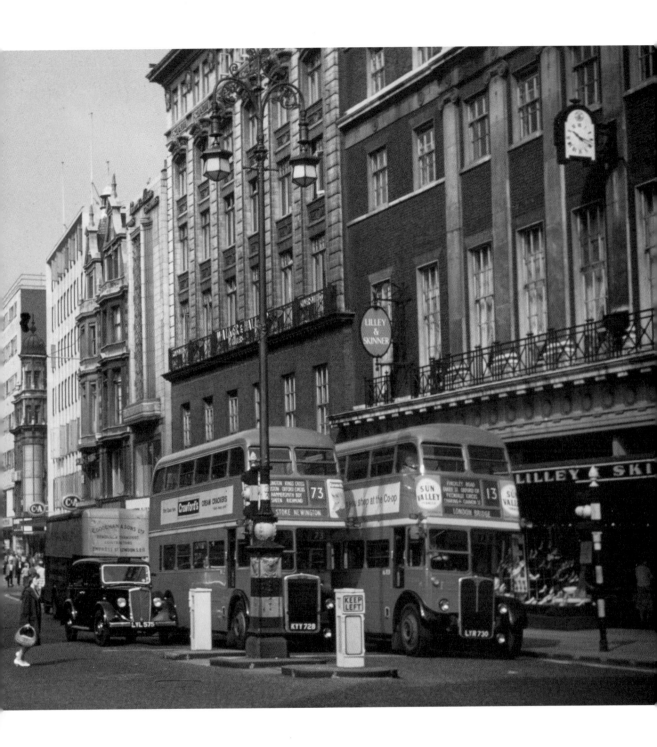

A walk down contemporary Oxford Street or the King's Road will throw up a riotous display of coloured goods, confectionery, clothes, shoes, books, toys and jewellery.

is nothing in any one of them that is peculiar to the city. Only in combination do they manifest a recognizable unity. They also draw their peculiar strength from the powers of historical association.

No account of the colour of London's streets could be complete without a reference to the trade of the pavement artist, or screever, who once filled the pavements with chalk images of battles and sunsets, religious scenes and sentimental domestic situations. They employed the crudest and most garish colours to arrest the attention of the passers-by; orange and purple, green and crimson, were part of their palette. In *Down and Out in Paris and London,* George Orwell struck up a conversation with a screever, Bozo, whose pitch was close to Waterloo Bridge. The street artist had a taste for the brightness he laid over the city pavements. 'Say,' he said to Orwell, 'will you look at Aldebaran! Look at the colour. Like a – great blood orange … Now and again I go out at night and watch the meteors.' For one moment the city and the cosmos were united by the perception of colour.

A whole street might be comprised of pale grey brick and dark grey brick houses, with every shade of faded yellow between; its closed windows are often veiled in off-white curtains or blinds. Some houses, perhaps extended over various decades, provide a variety of bricks from red to white to grey to brown and back to red again; other houses have white stucco on their ground floors and yellow brick above. Window frames are sometimes green and sometimes

blue; front doors are often red. The yellow brick of neighbouring dwellings has often been stripped by rain and wind so that it has become a pale beige.

The houses of London were characteristically narrow and dark. In the nineteenth century they were considered murky, or streaky, with damp and soot. The Adelphi Buildings, for example, the first neo-classical block of terraced houses in London, was very close to the coal barges of Adelphi Wharf along the river; it was not considered to be incongruous. There were stretches of London, such as the Pentonville Road, packed with two-storeyed houses of dim red or grimy yellow, sometimes with shops occupying the ground floor and with the ends of terraces plastered with advertising slogans. Yoshio Markino remarked:

Perhaps the real colours of some buildings in London might be rather crude. But this crude colour is so fascinating in the mists. For instance that house in front of my window is painted in black and yellow. When I came here last summer I laughed at its ugly colour. But now the winter fogs cover it and the harmony of its colour is most wonderful.

Monet asked 'how could the English painters of the nineteenth century have painted bricks that they did not see?' But they did see them, in all their dim or dusky manifestations. They did not imagine the yellow brick, or the red brick, or the mottled brick, and many

of them did not essay the urban panorama or the grand cityscape; they turned their attention to what was close or minute, to the exact translation of a painted window frame or of a door cracked with age and use. On surprisingly bright days, the assortment of London bricks simulated a yellow or even golden colour. But there were obvious discrepancies. In late Victorian London one contemporary noted that many houses 'had plastered or painted windows, which looked like scenes in pantomime'.

Commercial buildings were based on different principles of colour. In a study of 1895 a modern commercial building was described as constructed entirely of steel framing 'fantastically masked with playful and flamboyant designs in terracotta, heightened with glass mosaic, cheap stained glass and iron work – the whole mass apparently supported upon sheets of plate glass'. The tall commercial buildings of a later date were often composed entirely of glass, which absorbed the blue, grey or white of the sky and of its cloud cover. Yet at the same time they were statements of triumph over the elements; they were intended to radiate strength of purpose, substance and security.

The building of high-rise flats obeyed the same imperatives, from the Golden Lane Estate completed in 1962 to the Barbican Estate constructed between 1965 and 1976. These tend to be vertical columns of dull colour, with glass reflecting the urban surroundings. The buildings then possess a life of colour, which is controlled and conditioned by the variegated sprawl in which it stands and which becomes woven into its fabric. By night they can be partly transformed by the myriad of small lighted interiors against the darkness of the mass, like the lamps of travellers on the side of a mountain. Some of them are enlivened by long vertical stripes of red or blue along the sides of the buildings, and by balconies draped with washing hung out to dry. In a sense they come to resemble church spires leading our gaze upwards. The actual fate of such structures is more forbidding; the histories of Grenfell Tower and Ronan Point are sobering and instructive.

The variegated motley of London clothing defies categorization and perhaps even description. It may be true that in London of the 1860s the general tones of male clothing were subdued to the point of blandness, but even here other colours may be found. The black top hat and frock coat was often supplanted by various shades of grey or brown. White waistcoats and white trousers were not uncommon, and the scarlet jackets of various trades or professions were commonplace. The double-breasted coat might be grey, dark blue or bottle green. The colours that others wore contradict the impression of dullness. Hippolyte Taine, during his visit to London in that period, noticed the 'outrageously crude' colours of English clothes with their propensity for 'glare and glitter'.

Every trade had its own sartorial insignia; the postman had a red jacket and chequered waistcoat, while the milkman wore a smock in the colour of milk or buttermilk or a short white coat and blue trousers. The male children of the period were dressed in striped shirts and red braces, in tartan or in grey. The females of the mid- and late nineteenth century were of course free to range over the palette of colour, with blue or green or mauve skirts in dome-shape or bell-shape and supported by variously coloured petticoats. A day dress might be manufactured of striped silk with alternating red and white fabric, while a ball gown might consist entirely of emerald green silk. Close-fitting headscarves or hats were universal, again in a variety of colours. All, or almost all, was permitted.

The 'blue-collar workers' were once distinguished from 'white-collar workers', which were in turn modified to include 'gold-collar', 'black-collar' and 'pink-collar' employment. It is intriguing to note that as the buildings grew more colourful, in painted representations of London, the inhabitants became more subdued and less noticeable. They are often to be seen as mere smudges of black or of some indeterminate colour, which may indicate the triumph of the crowd.

But some Londoners have stood out from the crowd. The youth cultures of twentieth century London have taken various forms, from the 'bright young things' of the 1920s to the Beatniks of the 1950s. Some have been more vivid than others. One group of angry young men began to appear in the early fifties; they may have been rebels without causes, but they possessed flags and war cries in abundance. In 1953, vague references to the 'New Edwardian style' sharpened to a name. The 'Teddy Boys' had arrived. And the 'Teds' of the fifties did not set out to please.

It had begun as an upper-class trend. After the war, tailors had attempted to encourage trade by resurrecting the fashions of the Edwardian era. Their market was the relatively affluent but working-class teenagers had developed a taste for the new style. The 'Teds' did not merely copy the clothing of the 1900s, they parodied it, adding elements such as the 'zoot suit' favoured by black gangs in the United States. A mirage of respectability would become the conduit for rebellion. Quickly, and cheerfully, they established a reputation for violence. The *Daily Mail* of 12 April 1954, reported:

> Cinemas, dance halls and other places of entertainment in South east London are closing their doors to youths in 'Edwardian' suits because of gang hooliganism. The ban, which week by week is becoming more generally applied, is believed by the police to be one of the main reasons for the extension of the area in which fights with knuckle dusters, coshes, and similar weapons between bands of teenagers

Right: Mod fashions on the streets of London, c.1967.

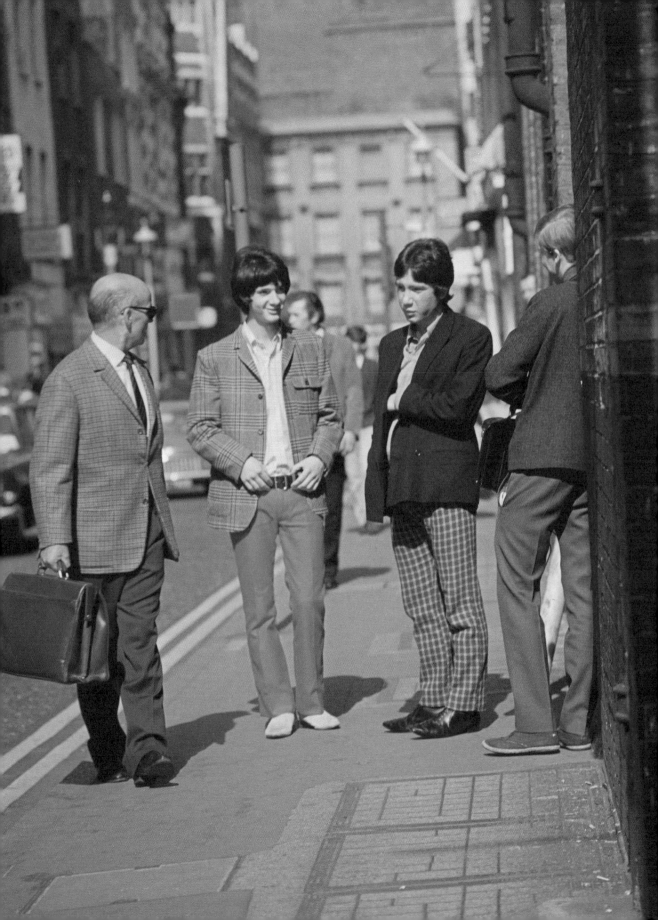

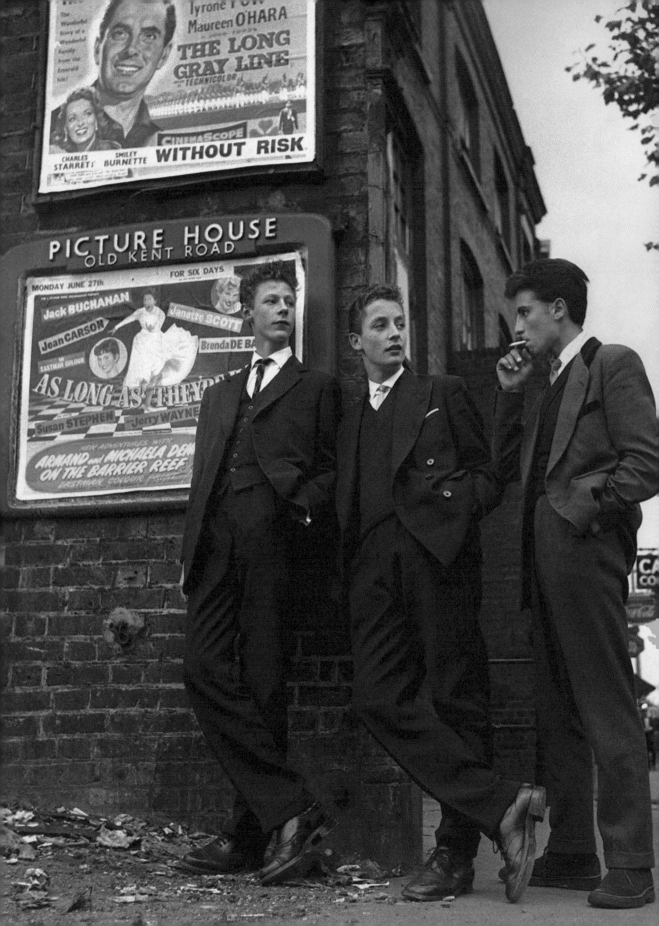

can now be anticipated. In cinemas, seats have been slashed with razors and had dozens of meat skewers stuck into them.

A film of 1955, *Blackboard Jungle*, marked a watershed. When played at a cinema in south London in 1956, the teenage Teddy Boy audience began to riot, tearing up seats and dancing in the cinema's aisles. They were particularly attracted to rock and roll. Some Teds formed gangs and gained notoriety following violent clashes with rival youth gangs as well as unprovoked attacks on immigrants.

English youth had been cynosures of disapproval since the glory days of the apprentices in the sixteenth and seventeenth centuries. The Teds were heirs to the apprentices, in spirit if not in diligence, and a fear of supposedly feral youth was again coaxed from its cave. No one who stood out in those days could be trusted, particularly when they wore a costume which was considered to be as outlandish as it was sinister. For fob watches, the Teds sported bicycle chains, their purpose unsettlingly clear. The outfit also included a high-necked, loose-collared white shirt, a narrow 'Slim Jim' tie, and a brocade waistcoat. The clothes were often expensive, and were paid for by weekly instalments. The tight 'drainpipe' trousers stopped just below the ankle. Broad, crepe-covered 'beetle-crushers' stood in place of brogues. It was a hybrid costume of dandyism and delinquency. And then there was the famous hairstyle, on which two

birds made their mark: a cockatoo's comb in front and a 'duck's arse' behind.

These new 'Edwardians' soon became described as 'spivs', 'juvenile delinquents', 'cosh boys' and 'zoot suiters'; so they were distinguished from the younger members of the 'respectable' working class as well as the more traditional offspring of the middle classes.

Swinging their chains, combing their hair, locking and unlocking their razors, the Teds paced the streets. Their uniform was their own rather than the garb of a trade, for they had no trade. Thus we may truly speak of the first teenage 'style'. Not that they were in the slightest measure revolutionary. If anything, they could show a vein of fascism. Events later in the decade were to bear this out. But in any case England turned away from them; they needed its youth to be healthy if they were not to end up in the same way, shiftless and disobedient. In the event, the Teds flourished under National Service.

They were followed in British popular culture, in the 1960s, by a surge of young people who went by the name of 'Mods'. The term itself derives from 'modern-ist'; unlike the Teds, the Mods saw themselves as the heirs to the American 'beatniks'. They were, in short, generally considered to be of the middle class. Not that they advertised the fact. Rather, they followed the trend established in the previous decade for aping the manners and mannerisms of the street. They wore their hair long, in imitation of bygone Chelsea artists. The accent, however, was all their own, comprising

a nasal drawl, and in this respect Mick Jagger was the exemplar. In the words of one radio journalist, his cadences were imitated 'by almost every middle-class public schoolboy in the land'.

The Mods themselves, however, were not always or necessarily of the middle class. They were characteristically in that grey hinterland between the upper working class and the lower middle class, in a world where such categories were still viable. Beyond the home, the prospect of pleasure was meagre. For those in their teens, the world was scarcely brighter. Simple pleasures, furtive transgressions or sporadic and apolitical violence were the recreational prospects to hand. The banality, as much as the poverty, of post-war Britain inspired the musical bloom of the sixties to which the Mods attached themselves. Elements of the Mod subculture included fashion, in sharply cut and often tailor-made suits with narrow lapels of Italian inspiration, together with thin ties and button-down collar shirts; the music of soul, rhythm and blues, and jazz, as well as the ubiquitous motor scooter of the Lambretta or Vespa brands, became part of their 'cool' image. They listened to groups such as The Who and the Small Faces, and indulged in all-night dancing at favoured clubs while encouraged by the lavish consumption of amphetamines.

During the early to mid-1960s, as the Mod subculture grew and spread throughout the UK, certain elements of it became engaged in well-publicised confrontations with members of a rival subculture; these were not the Teds, who were then largely forgotten or out of fashion, but the 'Rockers' otherwise known as 'leather boys', 'ton-up boys' or 'café-racers'. As the names may suggest, their principal accessory was the motorbike (rather than the more fragile scooter of the Mods) complete with the complementary leather jackets, heavily embossed and decorated, and greased hair.

The clashes between Mods and Rockers were on the front pages of the newspapers in the 1960s, and in terms of violent aggression the Mods themselves stood proudly in the Teddy Boy tradition. Sentencing a Mod, a magistrate offered a denunciation worthy of Cromwell when he declared that 'these long-haired, mentally unstable, petty little hoodlums … came to Margate with the avowed intent of interfering with the life and property of its inhabitants'. That may have been a little unfair, since they were more concerned with the life and property of their antagonists. The newspapers, however, seized upon the possibilities of what was called a 'moral panic'. An editorial in the *Birmingham Post* of May 1964 declared that Mods and Rockers were 'internal enemies' in the United Kingdom who would 'bring about disintegration of a nation's character'. The magazine *Police Review* argued that the two cults in collision could cause violence to 'surge and flame like a forest fire'.

But this was also the period when music, fashion and popular culture combined to create the phenomenon known as Swinging London or, more

Right: Shoppers on the King's Road, Chelsea in 1967.

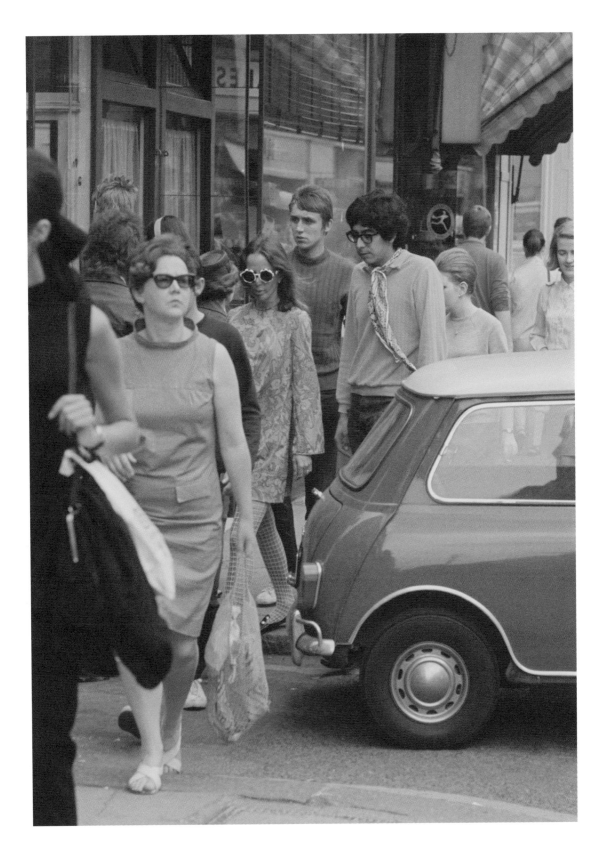

commonly, the Swinging Sixties. It was the time of discothèques, pop art and the famous London street where, according to *Time* magazine, 'perhaps nothing illustrates the new swinging London better than narrow, three-block-long Carnaby Street, which is crammed with a cluster of the "gear" boutiques where the girls and boys buy each other clothing'. A song by the pop group, The Kinks, illustrated the theme with its title 'Dedicated Follower of Fashion', the fashion embracing a wide variety of influences including Mary Quant, Jean Shrimpton, Twiggy, the Marquee Club, miniskirts and Antonioni's *Blow-Up*.

These were signs and symbols of the feeling of release and celebration when the restrictions of the post-war world were finally removed and, more particularly, when National Service for young men was abolished in 1960. The cultural freedom of the time was enhanced as the incomes of young people rose markedly under the economic resurgence of the late 1950s and early 1960s. The grey days had gone, and it was hoped or believed that a thousand flowers might bloom. This may be ascribed to the vanity of human wishes. Yet the bright colours of London were seen again in later decades and a later century. The colours never wholly fade.

Right: A record stall on Carnaby Street, photograph by Ted Spiegel, 1 September 1967.

About the colourized photographs

I hope you have found the accompanying colourized photographs to Peter's text entertaining and insightful, a glimpse into a version of London from times past, seen from a slightly different perspective.

The earliest photograph of London I've encountered was taken by the British scientist and photographic pioneer Henry Fox Talbot in April 1844, looking across Trafalgar Square towards St Martin-in-the-Fields Church. What I found extraordinary was not how much, but how little has changed; the view would be as familiar to a Londoner during the reign of Queen Victoria as it would be today. It left me with a deep curiosity about what other vistas of London would elicit a similar reaction. If *The Colours of London* is anything to go by, the answer is: a good many.

It is important to note that the digital restoration and addition of colour to the photographs for this book is a subjective interpretation, best considered a supplement to an original historical document that has existed for decades. In musical parlance, it is a cover of someone else's song. That is not to say, however, that the process is a slapdash effort created at whim. Rather, it is the result of a labour-intensive process that takes a high-resolution capture of the original and turns it into something that is at once the same but different.

Every photograph has been enlarged and digitally cleaned. Surface-level damage such as foxing, mildew, scratches and blemishes have been removed and matched to the underlying grain (if applicable) and final contrast adjustments undertaken to create a foundation for the colour. In effect, the first step is to rejuvenate the scan to present a digital version of the photograph comparable to the day it was taken.

From there, anywhere between hundreds to thousands of individual layers of colour are then digitally painted on top of the black and white information. Often the colours are incredibly garish for maximum contrast, to make sure that every detail in the photograph is rendered in colour. Next, we take those garish colour masks, changing and blending them with the existing black and white information in conjunction with whatever colour references have been acquired through the course of our own research. Such references may encompass genuine colour photographs of the same thing to contemporaneous colour postcards or paintings and written descriptions.

The exhaustive (and exhausting) labour involved to create the images you see are the result of eliminating as much guesswork as possible. Every effort is made to consult with subject experts, whose insights are invaluable to creating an authentic colour interpretation of the black and white original. I stress the word *authenticity* (rather than *accuracy*) because, like any period drama, we take clues from the real thing in order to inform a version which is not intended to be a substitute for a historically accurate original.

Jordan J. Lloyd
Essex, April 2022
www.unseenhistories.com

Index

Page numbers in *italics*
refer to illustrations

A

A to Z maps 80
Absolon, John, *The Transept from
the South Gallery, The Great
Exhibition of 1851 17*
Adam's Gate, Green Park 61
Adelphi Buildings 240
advertising hoarding 236
Albert, Prince Consort 53–4, *55,*
57, 187–8, 190
Albert Bridge 85
Albert Memorial 53, 54, *55,* 57
Alexandra, Queen 31, 35
Anderson, Tryphena 45
Angel 123
Arsenal *135*
The Art-Journal 134–5
Asquith, Herbert 31, 107, 108
Austen, Jane 105

B

Baker Street 128, *128–9,* 131,
166
Baldwin, Stanley 149, 150, 151
Balfour, Arthur 107
Bank of England 49, *148*
Barbican Estate 180, 241
Bartholomew Fair 49, *52–3*
Bastin, Cliff *135*
Battersea 80
Battersea Bridge 85
Battersea Park 115, *118–19*
Bawden, Edward, *Covent Garden
Flower Market 102–3*
Bazalgette, Joseph 170
Beaton, Cecil 146
Beck, Harry 124, *126,* 127–8
Bedford Estate 98, 177
Bennett, Arnold 194
Benson, A.C. 232
Berwick Street Market *226–7*

Betjeman, John 165
BIBA 66, 67
Birmingham Post 246
black 184–203
Blackfriars Bridge 85, 86
Blackwall Tunnel 88
Blake, William 47
Bloomsbury 166, 177
Blore, Edward *162–3*
blue 68–89
Bool, Alfred and John *160*
Booth, Charles, 'Descriptive Map
of East End Poverty' 197–200,
198–9, 203
boroughs 40, 223–4
Boursnell, Clive 99
Bozo 240
Brick Lane 93
bricks 165–6
British Colour Council 223
British Empire Exhibition (1924)
111–15, *112–13, 114*
British Institution 25
The British Worker 149–50
Broad (Broadwick) Street 196–7
brown 158–73
Brown, Ford Madox, *Work* 166,
168–9, 169
Brown, John 190
Brunel, Isambard Kingdom 134
Buckingham Palace 61, 67, 143,
145, 161, *162–3,* 165, 179, *189,*
190, *211,* 223
The Builder 54, 57
Burghley, Lord 36
The Bury Times 187
buses 123–4, *124–5,* 127
Byron, Lord 53

C

Cambridge University 88, 89
Camden Town 72, 232, 233
Camus, Albert 94
Canaletto, *The River Thames with*

*St Paul's Cathedral on Lord
Mayor's Day 50–1*
Cannon Street 132, *176,* 177,
180
Cannon Street Bridge 85
Caravaggio 146
Carlyle, Thomas 22, 233
Carnaby Street *10,* 248, *248–9*
Casson, Hugh 115–16
cement 180
Cenotaph 179, *181*
Charing Cross 132, 223
Charing Cross Bridge *13,* 88
Charing Cross Hotel 166, *166*
Cheapside *20,* 21, 143
Chelsea 80, 85, 247
Chelsea Bridge 85
Chesterton, G.K. 31, 72
Chinatown 49
cholera 194–7, *194, 195*
Churchill, Winston 64, 145, 149,
151, 153
City and South London Railway
131
Clapham Common 42
Clean Air Act (1956) 76
Cleopatra's Needle 76
clothing and fashion 241–8
Cockney 40, 88, 123
Coleridge, William 233
concrete 180
Conrad, Joseph 53
Coronation Exhibition, White
City (1911) *33*
costermongers 39–40
Costers Harvest Festival *38–9*
Coubertin, Baron de 32
Covent Garden 98–102, *99–103,*
105, 139
Coward, Noel 145
Croft, Henry 39, 40
Cruickshank, George *201*
Crystal Palace *8,* 10, 12–17,
14–17, 134

D

Daily Mail 106, 242
Daily Mirror 177
Daily News 12
Daily Telegraph 119, 124, 127,
145, 150
Darwin, Charles 128
Davison, Emily 108
Dickens, Charles 75, 91, 102, 121,
128, 169, 170, 236, 238
Dostoyevsky, Fyodor 210
Doyle, Arthur Conan 75

E

Earl's Court Commercial Motor
Show (1954) 124
East End 198, 200, 224–30
Edward VII, King 31, 32, 193
Edward VIII, King 57
electric lights 209, 210, *212–13,*
233
Elephant and Castle 150, *244*
Eliot, T.S. 159
Elizabeth, Queen Mother *56,* 58,
116, 145
Elizabeth II, Queen *60–1,* 61–5,
62, 67, 138, 146
Embankment 85, 88, 116, 209,
223
Empire Windrush 40, 42, *42–3,*
45, 155
Eugenie, Empress 140
Euston Station 132
Evening Standard 106, 151

F

FA Cup Final *135*
Farringdon station 128
Faulks, Sebastian 205
Feaver, William 116
Fenchurch Street station 132
Festival of Britain (1951) 108,
110, 111, 115–19, *117–19*
fire 18–27

Fisher, Geoffrey 64
Fleet Street 224, *234–5*
fog 72, 75, 169, 170, *171*
Ford, Ford Madox 98
Fordred, R.F., *Putney for River and Health 231*
Franco-British Exhibition (1908) *33*
Frayn, Michael 116
Frith, William Powell 166
 The Railway Station 132–3, 133–5
Fulham 86, 230

G
gaslights 207, *208–9, 209,* 233
General Strike (1926) 147–51, *148*
Gentleman, David 232
George V, King 113, 147, 151, *192–3*
George VI, King 35
 coronation *56, 57–8,* 61
 Festival of Britain 111, 116
 suffragettes 107, 108
 VE Day 145
Ginner, Charles, *Flask Walk, Hampstead, on Coronation Day 59,* 61
gold *46–67*
Grayson, Stanley Clare, *Coronation Night, The Mall 65,* 67
Great Exhibition (1851) *8,* 10, 12–17, *14–17,* 54, 57, 71, 111, 119
Great Fire (1666) 22, 36
Great Peter Street *164*
Greaves, Walter, *Hammersmith Bridge on Boat-Race Day 89*
green *90–119*
Green Park 12, 61, 96
Greiffenhagen, Maurice, *London by LMS 216–17*
grey *174–83*
Grimshaw, John Atkinson, *St James's Street 214*
Guardian 154, 161

H
Hacker, Arthur 214
Haghe, Louis, *The Refreshment Area at the Great Exhibition 16*
Hammersmith 85, 86, 230
Hammersmith Bridge 85, *89*
Hampstead 61, 165, *168–9, 169,* 232
Hampstead Heath 96, 224
Harborow's Outfitters *172–3*

Hardwick, Arthur 21
Harlesden 232
Harrods 177, 179, 224
Hartnell, Norman *122*
Hatton Garden 49
Hawkins, George *37*
Hawthorne, Nathaniel 72, 75
Haydon, Benjamin 22
Hayes, John J. *34*
Haymarket 140, 210
Heine, Heinrich 165, 233
Henrietta Street 93
Highgate 232–3
Hobsbawm, Eric 127
Holt, Edwin Frederick, *The Albert Memorial 55*
Hotel Cecil 76
houses 230, 240–1
Houses of Parliament 88, 146
 House of Commons 21, 22, 105, 107
 House of Lords 21–5
Hungerford Bridge 85
Hurst, Geoff 138
Hyde Park 57, 96, *98,* 105–6, 193
Hyde-Pownall, George *211*

I
Illustrated London News 54, *56,* 58, *62,* 134
Impressionism 76
International Olympic Committee 35

J
Jack the Ripper 128, 140
Jagger, Mick 246
James, Henry 9, 134, 185, 194, 207
Jarrow Crusade (1936) 153–4
Jefferies, Richard 10
Jerome, Jerome K. 221
Joy, George William, *The Bayswater Omnibus 96, 96–7*

K
Kandinsky, Wassily 161
Kauffer, Edward McKnight, *Forest Scene 92*
Keats, John 154–5
Kensington 139, 146, 155
Kensington Gardens 57, 96
King's Cross 123, 132, 232
King's Road 240, *247*
Kipling, Rudyard 113, 207
Knight, Charles 236
Koop, Mary, *Summer Sales Quickly Reached by Underground 225*

L
Lamb, Charles 223
Lambeth 84, *94*
Lambeth Bridge 85, 86
Lancaster, Osbert 115
Langford, Gladys 143
Lansbury, George 108
Le Corbusier 36
Liberty 106
light *6–17*
Limehouse *195*
Little Venice 230
Liverpool Street Station 132
Lloyd George, David 107, 108
London, Midland and Scottish Railway 210, 214, *216–17*
London Bridge 9, 179
London Bridge station 132
London County Council Tramways *231*
London Docks 149, 150, 151
London Marathon 32, *34,* 35
The London Market 102–3
London Pearly Kings and Queens Association 40
London Pearly Kings and Queens Society 40
London Stone *176,* 177, *179–81*
London Transport 42, 123
London Underground 124, *126,* 127–31, *128–30*
 Brightest London is Best Reached by Underground 131
 Forest Scene 92
 See Them in London's Country 95
 Summer Sales Quickly Reached by Underground 225
Lord Mayor's Show 67
Lutyens, Edwin 179, *181*

M
Macaulay, Rose 142
McCrae, Lieutenant Colonel John 147
MacDonald, Ramsay 153
Manchester Guardian 22, 42, 76, 88, 116, 146, 153, 200
marble 180
Margaret, Princess 146
Markino, Yoshio 240
 Buckingham Palace by Night 211
 Posters in the Strand 238
Mass Observation 146
mauve 140
Mayhew, Henry 39, 101
Mearns, Andrew 200

Melville, Herman 36
Metropolitan Railway 128
Millbank 85, 86
Milton, John 29, 143, 187
Mods *243,* 245–6
Mondrian, Piet 127
Monet, Claude 21, 75, 76, 84, 240–1
 Charing-Cross Bridge in London 9, 13
 The Houses of Parliament, London 23, 71
 Hyde Park 96
Moore, Bobby *136–7,* 138
Morning Chronicle 25
Morris, William 36
Morrison, Herbert 115–16
Mortlake 88, 102
Morton, H.V. 214
Mosely, Sir Oswald 155
Moss, Colin, *Hunger Marchers 152*
Mullock, D., *See Them in London's Country 95*
Murdoch, Iris 230

N
National Health Service 42
The National Union of Women's Suffrage Societies 105
Nevinson, C.R.W. 76
 The Nerves of the World 77
Nicolson, Harold 116
night *204–17*
Nightingale, Florence 105, 116
Nine Elms 105
Nittis, Giuseppe de, *The Victoria Embankment 178–9*
Notting Hill 44
Notting Hill Carnival 156
Notting Hill riots (1958) 155–6, *156–7*

O
O'Connor, John, *The Embankment from Somerset House 179,* 180
Old Compton Street *139*
Olympic Games: 1908 Games 31–2, *34,* 35
 1948 Games *30,* 31, 35–6, *35*
Orwell, George 166, 240
The Oxford Arms 160
Oxford and Cambridge boat race 88–9
Oxford Street *238–9,* 240
Oxford University 88, 89

P

Paddington station 132, *132–3*, 133–4
Pancras Square 49
Pankhurst, Emmeline 106, 107, 108
Parliament Square 58
Parry, John Orlando, *The Poster Man* 71, *237*
Pathé News 193
pavement artists 240
Pearly Guild 40
Pearly Kings and Queens *38–9*, 39–40
Pennell, Joseph: *Blue Night, London* 78–9
 East London 202–3
 Whitehall Court 186
Pentonville Road 123, 240
Perkin, William 140
Pevsner, Nicholas 188
Piccadilly Circus 139, 209, 210, *211*, *214*, *215*, 222, 223
Pietri, Dorando 32, 35
Piper, John 115
Poe, Edgar Allen 155
Police Review 246
Pool of London *73*, 84
poppies 147
Portland stone 85, 131, 161, 179–80, *181*
Portobello Road 155, 230
Portobello Road Market *228–9*
Post Office 139
poverty 197–203
Prince's Skating Club 31
Prior, Thomas Abiel, *Queen Victoria Visiting the Great Exhibition of 1851 14–15*
Pritchett, V.S. 72
Prudential Assurance Building 177
Punch 140
Putney 88, 230–2, *231*

Q

Queens Guild 40

R

railways *11*, 131–5
 see also London Underground
rain 76
Ramsey, Alf 138
red 120–57
Regent Street Quadrant *182–3*
Reid, Sir James 188
Reid, Vince 45
Richmond Park 35
Rockers 246

Rotherhithe 84
Rotherhithe Tunnel 88
Rowlandson, Thomas, *Bartholomew Fairy, West Smithfield, City of London 52–3*
Royal Academy 25, 238
Royal Albert Hall 57, 105
Royal British Legion 147
Royal Festival Hall 111, 119
Runciman, Walter 153, 154
Ruskin, John 36

S

St Pancras 132, 232
St Paul's Cathedral 12, 26, *26–7*, 49, 79, *82–3*, 146, 179, 180, 187, 223
Samuel, Herbert 151
Sansom, William 142
Scott, Sir George Gilbert 57
Second World War (1939–45) 35, 84, *142*
 Blitz (1940) 26, *26–7*, 140–3, *141*
 Victory (VE) Day (1945) 143–7, *144–5*
Selfridges 106
Shaftesbury Avenue *206*
Shakespeare, William 69
Sickert, Walter 209
slums 165, *165*
Smithfield Market *192–3*
smog 75–6
Smuth, Ethel, 'The March of the Women' *104*
Snow, John 194, 196–7
Soane, John 21
Society for Photographing Relics of Old London 160
Soho 139, 140, 196–7
South Bank 115–16, *117*
Southwark Bridge 85, 86
Spectator 25
The Sphere 76
Spiegel, Ted *248–9*
Spradbery, Walter E., *Flowers of the Season 48*
Stevenson, Robert Louis 75, 169
Stiff, Michael 179
Stoker, Bram 19
Strand 166, *166*, 223, 224
street art 236, 240
suffragettes *104*, 105–8, *109*
Sunday Times 116
Swinging Sixties 246–8

T

Taine, Hippolyte 10, 241
Talbot, Henry Fox 251

Tate Gallery 85–6
Taut, Bruno 233
Taylor, Horace, *Brightest London is Best Reached by Underground 131*
Teddy Boys 242, 244, 245, 246
Tennyson, Lord Alfred 188
Thames 31, 71, *73*, 80, 84–9, 93, 165, 170, 187, 196, *201*, 230
 Second World War 84, 140, 142, 143
Thomas, Dylan 119
Thomson, James 207
Time 248
The Times 10, 22, 32, 107, 139, 154
 1928 flood 86, *86–7*
 coronation of George VI 57–8, 61
 death of Prince Albert 54, 187
 death of Queen Victoria 188, 190
Tower Bridge 71, 179
Tower of London 64, 84, 88, 187
Trades Union Council (TUC) 149, 150, 151
Trafalgar Square *74*, 105, 139, 143, 210
tramways of London *70*, 71, 123
Transport for London 80
Tristan, Flora 207
Turner, J.M.W. 9, 49, 86, 236
 The Burning of the Houses of Lords and Commons, 16 October 1834 22, *24–5*, 25
Turnham Green 128, 230

U

Underground Electric Railways Company of London *48*
Union for British Freedom 155

V

Van Gogh, Vincent 156
Vanity Fair, 'Society Ladies Cycling in Hyde Park' 98, *98*
Variety 115
Vauxhall Bridge 85
Vauxhall Gardens 71, *94*, 115
Victoria, Queen 105, 140, 251
 Buckingham Palace 161
 death 188–93, *190–1*, 194
 death of Prince Albert 53–4, 187–8, *189*
 Great Exhibition 12, *14–15*
Victoria and Albert Museum 161
Victoria Memorial 161, *162–3*
Victoria Park 96
Victoria station 132

Victory (VE) Day (1945) 143–7, *144–5*
Villiers Street 223
Votes for Women 106

W

Wandsworth Bridge 85
Wandsworth Gasworks *208–9*
Waterloo Bridge 85, 88, 146, 196, 240
Waterloo station 132, 223
Webb, Aston 161
Wells, H.G. 194
Wembley Stadium 35, *35*
 British Empire Exhibition (1924) 111–15, *112–13*, *114*
 FA Cup Final (1930) *135*
 World Cup Final (1966) 135–9, *136–8*
West End 146, 187
Westminster 107
Westminster Abbey 57, 58, 98, 188
 coronation of Elizabeth II 61, 62, 64, 67
Westminster Bridge 85, 88
Wharton, Michael 232
Whistler, James Abbott McNeill 9, 61
 London mist 76, 79
 Nocturne in Blue and Silver 80, *80–1*
 Nocturnes 207, 209
white 28–45
White City 32, 40
White City Stadium 31, *33*
White Conduit Street 40, *41*
Whitehall 57–8, *124–5*, 145
Wilde, Oscar 49, 76, 79, 102, 128, 169, 175
Wilkinson, 'Red' Ellen 153
Wilson, Harold 139
Wimbledon 88, 140
Windsor Castle 32, 53, 54, 188, 193, 194
Women's Coronation Procession *109*
Women's Social and Political Union (WSPU) 106
Women's Sunday 105–6, 107
Woolf, Virginia 26, 197
Wordsworth, William 7, 53
World Cup Final (1966) 135–9, *136–8*

yellow 49

Picture credits

The publishers thank the following for permission to reproduce the images in this book. Every effort has been made to provide correct attributions. Any inadvertent errors or omissions will be corrected in subsequent editions.

2 Daily Mirror/Mirrorpix/Getty Images*; **4** Paul Popper/Popperfoto/Getty Images; **8** Popperfoto/Getty Images*; **10** Mirrorpix/Getty Images; **11** Swim Ink 2 LLC/Corbis/Getty Images; **13** Fine Art Images/Heritage Images/Getty Images; **14–15** Leemage/Corbis/Getty Images; **16** V&A Images/Alamy Stock Photo; **17** The Picture Art Collection/Alamy Stock Photo; **20** Topical Press Agency/Getty Images*; **23** History and Art Collection/Alamy Stock Photo; **24–25** IanDagnall Computing/Alamy Stock Photo; **26–27** Colin Waters/Alamy Stock Photo; **30** Hi-Story/Alamy Stock Photo; **33 above** Paul Popper/Popperfoto/Getty Images; **33 below** The Print Collector/Getty Images; **34** Popperfoto/Getty Images*; **35** Amoret Tanner/Alamy Stock Photo; **37** Guildhall Library & Art Gallery/Heritage Images/Getty Images; **38–39** E. Dean/Topical Press Agency/Getty Images*; **41** English Heritage/Heritage Images/Getty Images; **42–43** Popperfoto/Getty Images*; **44** Keystone/Getty Images; **48** Swim Ink 2 LLC/Corbis/Getty Images; **50–51** Ablakok/Wikimedia Commons; **52–53** Guildhall Library & Art Gallery/Heritage Images/Getty Images; **55** © Christie's Images/Bridgeman Images; **56** Universal History Archive/Universal Images Group/Getty Images; **59** © Tate; **60–61** Rolls Press/Popperfoto/Getty Images; **62 above** The Print Collector/Getty Images; **62 below** Hulton Archive/Getty Images; **63** SSPL/Getty Images*; **65** © Crown Copyright: UK Government Art Collection; **66** Elizabeth Whiting & Associates/Alamy Stock Photo; **70** Granger/Historical Picture Archive/Alamy Stock Photo; **73** Daily Mirror/Mirrorpix/Getty Images*; **74** TopFoto*; **76** The Print Collector/Getty Images; **77** © Museum of London / Bridgeman Images; **78–79** Mr. and Mrs. William Preston Harrison Collection/LACMA; **80–81** Steve Vidler/Alamy Stock Photo; **82–83** Antiqua Print Gallery/Alamy Stock Photo*; **86–87** Fox Photos/Getty Images*; **89** Artepics/Alamy Stock Photo; **92** Swim Ink 2 LLC/Corbis/Getty Images; **94** Museum of London/Heritage Images/Getty Images; **95** K. J. Historical/Corbis/Getty Images; **96–97** Museum of London/Wikimedia Commons; **98** Universal History Archive/Getty Images; **99** © Clive Boursnell; **100–101** © Museum of London*; **102–103** © Fry Art Gallery Society/Bridgeman Images; **104** Museum of London/Heritage Images/Getty Images; **109** Museum of London/Heritage Images/Getty Images; **110** Museum of London/Heritage Images/Getty Images; **112–113** Heritage Image Partnership Ltd/Alamy Stock Photo; **114** Chronicle/Alamy Stock Photo; **117** Paul Popper/Popperfoto/Getty Images; **118–119** Saidman/Popperfoto/Getty Images; **122** Bettmann/Getty Images; **124–125** Rolls Press/Popperfoto/Getty Images; **126** Shawshots/Alamy Stock Photo; **129** SSPL/Getty Images; **130** incamerastock/Alamy Stock Photo; **132–133** © Royal Collection; **135** Popperfoto/Getty Images; **136–137** Popperfoto/Getty Images; **138** PA Images/Alamy Stock Photo; **139** RDImages/Epics/Getty Images; **141** H.F. Davis/Topical Press Agency/Hulton Archive/Getty Images*; **142** Lordprice Collection/Alamy Stock Photo; **143** Hi-Story/Alamy Stock Photo; **144–145** Vintage_Space/Alamy Stock Photo*; **148** Daily Mirror/Mirrorpix/Getty Images*; **152** Collection of Mr. & Mrs. Randall Bevan/Bridgeman Images; **156–157** Daily Mirror/Mirrorpix/Getty Images*; **160** National Gallery of Art/Wikimedia Commons*; **162–163** English Heritage/Heritage Images/Getty Images; **164** J.A. Hampton/Getty Images*; **166** Culture Club/Getty Images; **167** Paul Popper/Popperfoto/Getty Images; **168–169** Manchester Art Gallery; **171** Colin Waters/Alamy Stock Photo; **172–173** Slim Aarons/Hulton Archive/Getty Images; **176** Heritage Image Partnership Ltd/Alamy Stock Photo; **178–179** Vidimages/Alamy Stock Photo; **181 above** The Print Collector/Getty Images; **181 below** Heritage Image Partnership Ltd/Alamy Stock Photo; **182–183** Museum of London/Heritage Images/Getty Images*; **186** The Print Collector/Getty Images; **189** Gunn & Stuart/Hulton-Deutsch Collection/Corbis/Getty Images; **191** Hulton Archive/Getty Images*; **192–193** George Rinhart/Corbis/Getty Images*; **194** Antiqua Print Gallery/Alamy Stock Photo; **195** Chronicle/Alamy Stock Photo; **198–199** Antiqua Print Gallery/Alamy Stock Photo; **201** SSPL/Getty Images; **202–203** Photo12/Universal Images Group/Getty Images; **206** Monty Fresco/Topical Press Agency/Getty Images*; **208–209** Arthur Tanner/Fox Photos/Getty Images*; **211 above** Museum of London/Heritage Images/Getty Images; **211 below** © Fine Art Photographic Library/Corbis/Getty Images; **212–213** Museum of London/Heritage Images/Getty Images; **214** © Christie's Images/Bridgeman Images; **215** Paul Popper/Popperfoto/Getty Images; **216–217** © Christie's Images/Bridgeman Images; **218–219** Rolls Press/Popperfoto/Getty Images; **222** ClassicStock/Alamy Stock Photo; **224** Culture Club/Getty Images; **225** VCG Wilson/Corbis/Getty Images; **226–227** Fox Photos/Getty Images*; **228–229** Slim Aarons/Hulton Archive/Getty Images; **231** Guildhall Library & Art Gallery/Heritage Images/Getty Images; **234–235** Topical Press Agency/Getty Images*; **237** Bridgeman Images; **238–239** Paul Popper/Popperfoto/Getty Images; **243** Frederic Lewis/Archive Photos/Getty Images; **244** Popperfoto/Getty Images*; **247** Rolls Press/Popperfoto/Getty Images; **248–249** © Ted Spiegel/Corbis/Getty Images); **250** SSPL/Getty Images*

* Colourized by Jordan J. Llloyd/Dynamichrome

First published in 2022 by Frances Lincoln,
an imprint of The Quarto Group.
The Old Brewery, 6 Blundell Street,
London N7 9BH, United Kingdom
T (0)20 7700 6700
www.Quarto.com

Commissioning editor: Alice Graham
Project editor: Michael Brunström
Design: Glenn Howard/Untitled

A catalogue record for this book is available from the
British Library.

ISBN 978-0-7112-6942-2
eBook ISBN 978-0-7112-6948-4

9 8 7 6 5 4 3 2 1

Typeset in Gill Sans

Printed and bound in China

Brimming with creative inspiration, how-to
projects, and useful information to enrich your
everyday life, quarto.com is a favourite destination
for those pursuing their interests and passions.